THE ART OF SEEING

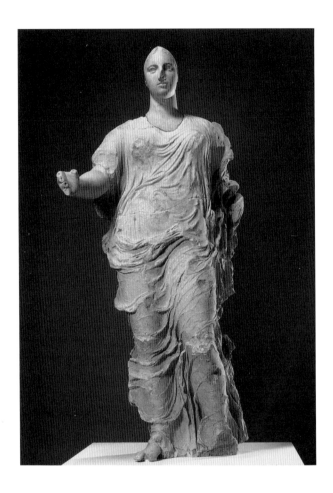

Cult Statue of a Goddess (Aphrodite?).
Greek (South Italy), circa 425–
400 B.C. Limestone and marble,
H: 2.37 m (7 ft. 6½ in.).
Malibu, J. Paul Getty Museum
88.AA.76.

Some works of art immediately strike most members of our society as exceptionally beautiful. They appeal on every level and continue to provide rich and rewarding interactions as one returns to them over and over. Monumental statues from antiquity, such as this Aphrodite, connect us to other eras and have a vast amount of historical interest. Such works stimulate us both emotionally and perceptually, providing the deepest kind of aesthetic experience.

The Art of Seeing

An Interpretation of the Aesthetic Encounter

MIHALY CSIKSZENTMIHALYI · RICK E. ROBINSON

A joint publication of the J. Paul Getty Museum and the Getty Education Institute for the Arts

LOS ANGELES, CALIFORNIA

Third printing

The Getty Education Institute for the Arts
1200 Getty Center Drive, Suite 600
Los Angeles, California 90049-1683

Library of Congress
Cataloguing in Publication Data

Csikszentmihalyi, Mihaly.
 The art of seing : an interpretation of the aesthetic
encounter / Mihaly Csikszentmihalyi and Rick E. Robinson.
 p. cm.
 Includes bibliographical references.
 ISBN 0-89236-156-5
 1. Experience. 2. Aesthetics I. Robinson, Rick Emery,
1958– . II. Title.
BH301.E8C75 1990
111'.85—dc20
90-41602

COVER: Otto Steinert (German, 1915–1978).
Study of Two Sculptures, circa 1954. Gelatin silver print,
28.6 × 22.1 cm (11 ¼ × 8 ¹¹/₁₆ in.).
Malibu, J. Paul Getty Museum 87.XM.70.1.

Contents

FOREWORD

*It fixed me like a statue a quarter of an hour, or half an hour,
I do not know which, for I lost all ideas of time, even the
consciousness of my existence.*

THOMAS JEFFERSON'S account of his response to Drouais's large canvas *Marius Imprisoned at Minturnae*, which he saw in Paris in 1787, is a classic description of what is generally understood by the term "aesthetic experience." Compare Jefferson's account with the following excerpt from an interview with a skilled rock climber discussing a "good climb":

> One tends to get immersed in what's going on around him, in the rock, in the moves that are involved . . . search for handholds . . . proper position of the body—so involved that he might lose consciousness of his own identity and melt into the rock.

Obviously rock climbing and looking at pictures are very different pursuits. Yet, at least in the two cases just cited, the mental states induced by these disparate activities have a good deal in common. Jefferson relates that he lost "even the consciousness of [his] own existence"; the climber felt that "he might lose consciousness of his identity and melt into the rock." Both describe a state of mind that others have characterized as "loss of ego," "self-forgetfulness," "loss of self-consciousness," and even "transcendence of individuality" and "fusion with the world." The heightened state of consciousness of which this egoless condition is a central feature has long been a subject of interest to Mihaly Csikszentmihalyi. In *Beyond Boredom and Anxiety: The Experience of Play in Work and Games* (1975), Csikszent-

mihalyi reported on an inquiry into the nature of autotelic (self-rewarding) activities.

> The goal was to focus on people who were having peak experiences, who were intrinsically motivated, and who were involved in play as well as real life activities, in order to find out whether I could detect similarities in their experiences, their motivation, and the situations that produce enjoyment. (xiii)

Looking at art was not one of the autotelic activities examined in this pioneering study, but Csikszentmihalyi and his associates at the University of Chicago did investigate a broad range of skill-based activities including (in addition to rock climbing) chess playing, musical composition, dancing, and playing amateur basketball. They discovered that despite the vast differences among the outward forms of these activities, at the experiential core of each (insofar as that can be glimpsed through accounts by participants) there is a cluster of related sensations that is essentially the same for all. This cluster constitutes a heightened state of consciousness Csikszentmihalyi calls "the flow experience" or, simply, "flow," "a term used frequently by the informants themselves to describe the experience."

The evident similarities between "flow" and aesthetic experience as traditionally conceived were what first drew our attention to Professor Csikszentmihalyi's work. Both the J. Paul Getty Museum and the Getty Center for Education in the Arts are concerned with finding ways of helping non-specialists understand and enjoy art. Insight into the nature of aesthetic experience is central to those efforts. Anecdotal accounts, like Jefferson's, of powerful aesthetic responses are not difficult to find in the literature of art, but they tend to be tantalizing fragments that do not lend themselves to systematic analysis. We felt that if the apparent parallels between aesthetic experience and flow could be shown to be more than mere analogies, Csikszentmihalyi's research might shed new light on an issue of great importance to art museums and art education. For if aesthetic experience is taken to be

something real and valuable, it follows that one of the primary functions of an art museum is to serve as a place where such experience is fostered. But before it can be fostered it must be understood. What is its nature? Of what value is it? What enables one to have it? Is receptivity to aesthetic experience inborn or learned, and if learned, can it be taught? If it can be taught, who should do the teaching and where is it best done? Under what conditions is aesthetic experience likely to occur? We hoped that Professor Csikszentmihalyi's research might suggest answers to some of these questions.

Csikszentmihalyi's interest in art and artists did not begin with the flow research that brought him to our attention. For a time in his youth he was a painter. In 1976 he and J. W. Getzels published *The Creative Vision: A Longitudinal Study of Problem Finding in Art.* In this project, begun in 1963, they followed the careers of a group of young artists— graduates of the Art Institute of Chicago—from their student days through the first several years of their post-academic careers in an effort to identify personal characteristics, attitudes, working methods, or other elements that might be taken as predictors of future success. In *Talent and Achievement: A Longitudinal Study of Artists* (1984), Csikszentmihalyi, Getzels, and Kahn reported on follow-up research that gathered new data on three-quarters of the participants in the original study of two decades earlier. The project archives constitute the most extensive body of material of this kind ever assembled—an extraordinarily rich resource for future investigation.

In *The Meaning of Things: Domestic Symbols of the Self* (1981), Csikszentmihalyi and E. Rochberg-Halton explored another phenomenon somewhat related to aesthetic experience. This investigation attempted to discover what kinds of objects people own that they regard as personally meaningful in ways that go beyond utility or monetary value. While few of the objects considered in this study would be conventionally regarded as works of art, the investigation revealed a variety of ways in which objects take on meaning for people and showed the complexity of those relationships. Then, in 1986, Csikszentmihalyi and Rick E. Robinson, coauthor of the present study, published

"Culture, Time, and the Development of Talent" in *Conceptions of Giftedness*.

In view of his long involvement with questions about art and artists, objects and perceivers, it is perhaps not surprising that Professor Csikszentmihalyi responded positively to the suggestion that he consider the matter of aesthetic experience. With support from the Getty Museum and the Getty Center for Education in the Arts, he and Robinson, together with a team of graduate students from the University of Chicago, undertook the research that has led to the results published here. We agreed that, following the model of the flow experience studies, the investigation should focus on people whose professions or avocations might give reason to expect them to be more or less highly skilled art perceivers: artists, critics, art historians, art collectors, museum professionals. In the end the last group was chosen. It was felt that collecting significant amounts of information from a single group would produce more reliable results than might smaller samplings from a number of fields. The research undertaken on museum professionals prompted a further study focusing on art collectors, the results of which can be found in Robinson's *Aesthetic Frameworks: Rethinking Adult Development through an Analysis of Collectors of the Fine Arts* (1988).

A basic assumption implicit in this approach should be acknowledged here. All of the activities discussed in *Beyond Boredom and Anxiety* are skill based. That is, some mastery of fundamentals is required of participants. Chess, musical composition, dance, basketball, and rock climbing all have implicit or explicit rules as well as traditional practices that one must learn and follow in order to participate successfully. Individual aptitudes may determine the ease or difficulty with which one learns, but mastery is acquired, not inherited. The assumption underlying this study is that, while rules and practices for looking at art are less overt and less completely codified than are those for playing chess or basketball, they nevertheless exist and must be mastered if success is to ensue.

Unlike much of the research previously done on art perception in

museums, which has tended to focus on general visitors, this investigation looks at the responses of skilled art perceivers. This may strike some as an elitist approach, far removed from the capabilities of the average museum-goer. But if the ability to derive pleasure from the contemplation of works of art is indeed an acquired skill, it only makes sense to study the practices of those who may be presumed to possess it. If we wanted to teach novices to ski we surely would begin by studying the techniques of experts. We might also study non-skiers to find ways of helping them master the techniques we observed being employed by experts, but we would not expect to discover what these essential skills are by studying the behavior of people who lack them.

There are, of course, significant differences between skiing and looking at art. The most important, for our purposes, is the fact that while many of the skills involved in skiing manifest themselves in directly observable actions, most of those required for art perception do not. The novice skier crosses his skis and falls down; the novice art perceiver looks pretty much like everyone else in the gallery. His successes and failures are hidden. This means that if we are to get at what goes on in the minds of novice or expert art perceivers we will have to rely to some degree upon their own testimony. This is what Csikszentmihalyi and Robinson have done. Their approach, using semi-structured interviews and subjecting them to rigorous, systematic analysis, is one often employed by anthropologists. While it may not produce a plethora of charts, diagrams, and formulas, it has the virtue of dealing, or attempting to deal, with a phenomenon in its entirety instead of dissecting it and analyzing bit by bit its component elements. This approach also allows unforeseen aspects of the phenomenon under study to emerge. By giving respondents latitude to say what they have to say in their own words at whatever length they choose and by attending closely and systematically to what is actually said, the investigators acquire insights and discover nuances that could not have been anticipated at the outset.

As readers will discover, this is not a how-to-do-it book. We did not ask the authors to tell us how to apply their findings to our concerns.

It is the job of museum professionals and educators to determine the relevance of the information presented here to their pursuits. It does seem to us, however, that the implications of these findings are far-reaching and potentially of great benefit to those concerned with education in the arts.

The correspondent to whom Thomas Jefferson addressed his lines on Drouais's painting was a Mme de Tott, whom he regarded as a woman of artistic taste. He urged her to go and see the picture, "for I think it will give you great pleasure," and he begged her to give him the benefit of her judgment, explaining "it will serve to rectify my own, which as I have told you is a bad one." Jefferson was aware both of the benefits art holds for those who know how to engage it and the need for guidance in the acquisition of the relevant skills. This self-described "savage of the mountains of America" became, in his own words, "an enthusiast on the subject of the arts" in order to "improve the taste of [his] countrymen, to increase their reputation, to reconcile to them the respect of the world, and to procure them its praise." Those who are concerned today with education in the arts may couch their ambitions in rather more modest terms, but the aim of providing access for the broadest possible range of people to what one respondent to this study called "a transcendent experience [that] takes you out of the realm of everyday life" is no mean aspiration. To the extent that this report contributes to that end it will have fulfilled our hopes and expectations.

Bret Waller

PREFACE

Early in 1985 Bret Waller, who had just accepted the position of Associate Director for Education and Public Affairs at the J. Paul Getty Museum, contacted us about our doing a study of the aesthetic experience. Both John Walsh, Director of the Museum, and Leilani Lattin Duke, Director of the Getty Center for Education in the Arts, were strongly supportive. Aware of our interest in the arts and in the understanding of optimal forms of experience, they thought that a contemporary psychological investigation might shed new light on this ancient topic. The questions proposed were both basic and broad: Is there such a thing as an aesthetic experience? If yes, what are its distinguishing characteristics? Can people be helped to experience it more often? Given the interests of the Museum and the Center, these questions were raised with a particular focus on visual aesthetic experiences.

These were challenging questions, even though it was clear from the start that at best we could provide only provisional answers. The very first question—whether such an experience exists—cannot be answered in a way that would satisfy strict criteria of scientific objectivism. Experiences are subjective phenomena and therefore cannot be externally verified. Either one trusts the words of the person who reports the experience or one does not. Moreover, whether we are to call a particular experience aesthetic or not ultimately depends on cultural conventions that could change with time and place. Nevertheless, we accepted the challenge, partly because we are convinced that whatever people report in their encounters with art is an important dimen-

sion of human existence and partly because studying anything connected with art is fascinating and enjoyable.

But what methods were the most appropriate to the task? One might start with measuring how people react to works of art, asking them to fill out quantifiable questionnaires or observing their physiological and neurological responses. With the help of galvanic skin response tests, electroencephalography, and positron emission tomography, one could determine whether people perspire more when they look at a work of art or whether their brain waves change or which areas of their central nervous systems are activated by the experience. Such methods, representative of the positivistic epistemology of recent years, would attempt to break down the experience into its component parts and identify the lower-order mechanisms implicated in its occurrence, in order to predict and control this particular behavior.

We did not believe that this approach was appropriate. Instead of seeking a reductive explanation, we were interested in understanding what the experience meant to the people who were having it. Such an understanding implies knowing the network of connections the experience has for them, how the thing itself is related to their thoughts, feelings, and goals. In the specific case of the aesthetic experience, we wanted to know what went on in people's minds when they encountered works of art and how the content of their consciousness at such times related to the rest of their goal-directed behavior.

The method of choice, then, was to ask people who ought to know, because of long training and professional involvement, what the aesthetic experience (assuming there is such a thing) is all about. This method in turn led us in the direction of interpretive social science, a branch of hermeneutic analysis based on empirical data and informed by knowledge accumulated in other branches of the social sciences.

In simple terms this means that the researcher's task is to describe a phenomenon from the subject's point of view as closely as possible and then to describe the connection between the phenomenon and the subject's life goals and experiences, again as seen by the subject. Yet this is only the first step. After explicating the network of mean-

ings that connects the phenomenon to the rest of a subject's life, the task of the researcher becomes that of finding appropriate generalities that apply to different subjects' reports and of developing a theoretical model that will account for the patterns disclosed, always taking into account what psychologists, sociologists, anthropologists, and philosophers have found to be true about human behavior.

The interpretive method we chose constitutes a break with current mainline psychology, but it is not a return to the so-called armchair psychology of the past, either. It is based on a close analysis of accounts given by a number of people concerning concrete events, feelings, and thoughts, and it integrates these analyses with the results of other systematic studies.

Like any written report, this one is made up of words. The words represent perceptions, feelings, ideas—in short, experiences—that people reported having. These experiences, in turn, are what we believe to be the foundation of interpretive psychology. They are basic protocol statements of what people believe is happening to them, even though words are necessarily imperfect representations of states of consciousness.

With financial assistance from the Museum and the Center, we started interviewing a number of experts whose familiarity with art indicated that they would give us an idea of what the aesthetic experience could be, if not what it typically is. The point of the study was not to understand the average viewer's response to art but to construct a model of the ideal experience based on the highest forms in which it can be expressed. We felt that knowing the outside limits of intensity that the experience can attain makes it easier to see the potential inherent in it. Only by knowing what the encounter with art can be at its fullest will it be possible to deduce from that ideal type forms of involvement that will make the experience more accessible to everyone.

The experts we chose to be respondents in this study were not visual artists, but museum professionals such as curators, educators, and directors of major collections of art. There were two major reasons for

not asking artists to describe what the aesthetic experience is like. The first was that a major study of how artists interact with their work has already been done by one of us (Getzels and Csikszentmihalyi 1976). The second was that, as we learned in the above-mentioned study, artists might not be the experts whose experience can be best generalized to the experiences of the great mass of viewers, the "average" museum-goers. Artists are so involved in the vicissitudes of the creative process that they are generally uninterested in viewing art—especially that of other artists—and are often prejudiced and idiosyncratic in their opinions, which necessarily reflect the viewpoint of the producer, rather than the "consumer" of art. For these reasons, we expected to learn more new information that might illuminate the receptive—as opposed to the creative—aesthetic experience from talking to museum professionals who spend their working lives identifying, appraising, and explicating works of art.

We could not have conducted this study without the enthusiastic cooperation of the entire professional staff of the J. Paul Getty Museum; and of James Wood, Director of the Art Institute of Chicago, and Katharine Lee, Associate Director. To them and to the many professionals of both institutions who gave so much of their time, experience, and wisdom, we are enormously grateful. We wish to thank the curatorial staff of the Museum of Contemporary Art, Chicago; Richard Born of the David and Alfred Smart Gallery; Laurel Bradley of Gallery 400; Elizabeth Shepard of the Block Gallery; Susanne Ghez, Director of the Renaissance Society of Chicago; and Deven Golden of the Chicago Cultural Center, for their time and cooperation. A number of curators from corporations in the Chicago area took time from their busy days to speak with us; these include John Neff of First National Bank, Albert Pounian of Continental Bank, Emily Nixon of The Art Advisory, Frank V. Carioti of Amoco Corporation, Malcolm Flemming, Zora DuVall of the Borg-Warner Corporation, and the curator of the Santa Fe Corporation. It is with great pleasure that we acknowledge the gracious assistance of the officers and members of the Association of Corporate Art Curators. If we have misin-

terpreted in this report anything they told us, we wish to apologize for it. Our main goal has been to represent accurately their experiences. Yet there is always something lost in every translation. We only hope that what is left will help the reader understand the fascinating complexity of human potential revealed in the aesthetic encounter, as it has helped us who have written these pages.

Obviously the two of us could not have completed this study alone. The project was planned and designed with, and half of the interviews were conducted by, the colleagues who are listed as contributors to this report. Although each of them also wrote the initial versions of one or more sections and are acknowledged there, we also wish to recognize their skills and their long hours of preparation and work here: they are Nancy Burke, Mark Freeman, Barbara Glaessner, Patricia Lorek, Jeanne Nakamura, and Daniel Schouela.

Finally, we could neither have conducted this study nor written this report without the patience, accuracy, and diligence of Elise Junn, Mardi Solomon, Deborah Guyot, Grace Lorher, and Angela Browning, who carefully transcribed the more than 250 hours of taped interviews that are its basis.

Mihaly Csikszentmihalyi
Rick E. Robinson
Chicago, June 1990

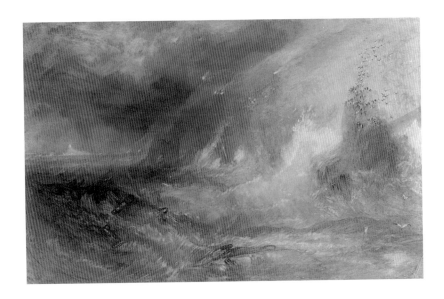

JOSEPH MALLORD WILLIAM TURNER
(British, 1775–1851).
Longships Lighthouse, Land's End,
circa 1834–1835. Watercolor,
29×44 cm (11¼×17¼ in.).
Malibu, J. Paul Getty Museum
88.GC.55.

What is the aesthetic experience? In *Modern Paint-
ers* (1843, pp. 240–241) John Ruskin admired this
watercolor by Turner, with its turbulent melding of
vaporous forms, as a powerful and moving depiction
of the forces of nature. As far back as there are writ-
ten records, we find evidence of the awe and exhila-
ration people feel upon seeing or hearing something
beautiful. The earliest poems contain loving descrip-
tions of landscapes, of the play of light on water, of
the beauty of the human form, of the proportions of
man-made structures. It is all the more surprising,
then, to realize how little we know about the reasons
for this response.

C H A P T E R 1

A Conceptual Model
of the Aesthetic Experience

THIS STUDY proposes to contribute to the understanding of how to make looking at works of art more enjoyable. The human organism has a variety of sensory links to its environment, each of them capable, in different ways, of providing pleasurable experiences. "A man possesses nothing certainly save a brief loan of his own body," wrote James B. Cabell (1919), "and yet the body of man is capable of much curious pleasure." But to translate the potential benefits of our sensory equipment into actuality, the senses must be cultivated and disciplined. For instance, the sense of taste originally evolved so that we could distinguish edible from harmful substances. Building on this basic skill, every culture has developed elaborate cuisines to heighten the sensations of eating and drinking. The capacities to smell, to hear, to touch, and to move have spawned such arts as those of the perfumer, the musician, the healer, and the dancer. The reproductive urge, codified into the ritual of romantic love, has contributed perhaps more than any other capacity to the enjoyment of life. And finally the ability to think, itself an outcome of the evolution of the brain, is a powerful source of pleasure—some say of the greatest pleasure men and women can experience—when it is exercised within the boundaries of an ordered process of thought, such as a science or a philosophy.

But how important are these pleasurable experiences? From a materialist viewpoint the answer is not very important at all. They are evanescent subjective phenomena, whose value must be discounted in comparison to serious and concrete concerns like power and wealth. But another way to look at value involves recognizing that the essen-

tial point of existence is not established by criteria such as how much people own or how much power they wield but by the quality of their experiences. According to this view, objective standards such as money are ephemeral, because they do not directly affect how we feel; in comparison with them, experiences are real. The value of a person's life—whether it was filled with interesting and meaningful events or whether it was a sequence of featureless and pointless ones— is determined more by the sum of experiences over time than by the sum of objective possessions or achievements. By this measure, aesthetic experiences are important indeed.

Among the various senses that define the parameters of human experience, the ability to see is a tremendous evolutionary breakthrough, because it allows the organism to gather detailed information about its environment without needing to be in physical contact with it (Campbell 1976; Feldman 1985). This ability has afforded possibilities for enjoyment that are unique in the repertoire of human skills. Throughout history and in every known culture, people have found pleasure and meaning in the use of their eyes. They have consciously attempted to produce objects of beauty and have delighted in them. Artists have found ways to use visual media to code pleasurable formal patterns, complex events, and subtle emotions; by decoding such information viewers could share states of being that would otherwise not be accessible to them.

But without training, the skill of seeing and of interpreting what is seen remains latent. Most people in our culture are not aware of the range and intensity of the enjoyable experiences available to them through the sense of vision. Visual illiteracy may not be a social problem in terms of economic productivity, but it does detract from the quality of life and leads to a cultural impoverishment that is very real. If the value of a society is measured by its ability to develop fully the potentialities of its members, then the making of visual beauty and learning how to enjoy it should become important items for society as a whole.

A first step in this direction is simply to understand better what hap-

pens when a person confronts a work of art. What is the nature of the aesthetic experience? Is it the same for everyone, or does it differ? Why can it be so enjoyable? Is it possible to facilitate its occurrence? On the basis of the answers to these questions, more informed steps can be taken to improve visual education in schools, museums, the media, and, perhaps most important, in personal life.

These questions have, of course, been debated intensely over the years by philosophers, art educators, and museum professionals. The reason for asking them again is twofold. First, all the important questions bearing on the quality of life have to be asked afresh in each generation, because as interpretive frameworks change with time, the old answers cease to be meaningful and the questions must be reformulated in terms of the questions current concepts and beliefs. And second, the field of psychology has developed a theoretical model for the understanding of enjoyment that again opens up the issue of the aesthetic experience, with more than a vague hope of improving our understanding of what it involves.

The present report is a study based primarily on interviews with individuals who, because of extensive training and professional involvement with art, have perfected their skills in seeing and in interpreting what they see. From these interviews with experts, we hoped to identify the salient features of the aesthetic experience as well as to discover its dynamics.

In starting with a group of art museum professionals, who spend their working lives surrounded by art and who have invested much of their time in the pursuit of works of art, we expected to discover the various forms that the aesthetic experience would take among its most skilled practitioners. Then, taking this information into account, we considered how this expert knowledge might be used to raise the general level of visual literacy, and hence the enjoyment that average persons might derive from the development of their latent visual skills.

Accordingly, this report contains six chapters. This introductory chapter presents a brief review of past accounts of the aesthetic experience and develops a way of understanding it based on the theory

of flow, or optimal experience, which cuts across a variety of cultural forms, ranging from religious rituals to art, to sports and games, and finally to various structured forms of activity. We make the claim that looking at the aesthetic experience as a form of flow reveals more clearly its structural characteristics and its dynamics. Hence it becomes easier to predict and influence the chances of its occurrence. The first chapter ends with a section on the methods used for collecting and analyzing the interviews that provided the data for this report.

The second chapter presents a descriptive summary of the dimensions of the aesthetic experience, based on the analysis of the interviews with museum professionals. Chapter 2 illustrates the richness of interactive possibilities that people have developed to extract enjoyment from their encounters with visual stimuli. Four broad approaches are discussed and illustrated with relevant quotations from the respondents: the perceptual-formal dimension, the emotional, the intellectual, and the communicative aspects of the experience. Each one of these broad categories in turn yields various discrete elements.

Chapter 3 departs from the interview approach in an attempt to examine further the dimensions discovered in the first study and reported in Chapter 2. There, we report on the results of a questionnaire study of museum professionals across the country.

Chapter 4 provides a more formal comparison between the aesthetic experience as described by our respondents and the theoretical model of the flow experience. This chapter deals with such questions as the following: What are the challenges people find in the aesthetic encounter? What are the skills that the viewer uses to meet those challenges? How are the centering of attention, the elimination of distractions, the setting of goals, the interpretation of feedback—all necessary ingredients of the flow experience—achieved in the aesthetic encounter? The chapter concludes with an expanded version of the flow experience, which takes into account and attempts to explain some of the unique properties of the aesthetic encounter.

The next two chapters focus on ways in which the aesthetic expe-

rience, and the skills involved in it, might be developed and the experience itself facilitated. In Chapter 5 we report the suggestions that our respondents made about how the aesthetic experience might be enhanced. This chapter deals with the conditions that make it easier to optimize the encounter (such things as the characteristics of the environment and the type and the placement of art objects) and finally turns to the development of viewing skills over time.

Finally, Chapter 6 attempts to bring together the various strands of this study in a statement that emphasizes its major conclusions concerning the unity and diversity of the aesthetic experience, discusses its importance in the scheme of things, and deals with the possibility of enhancing its occurrence.

WHAT IS THE AESTHETIC EXPERIENCE?

For as far back as there are written records, we find evidence of the awe and exhilaration people feel upon seeing or hearing something beautiful. The earliest poems contain loving descriptions of landscapes, of the play of light on water, of the beauty of the human form, of the proportions of man-made structures. The power of music to enthrall the senses is one of the oldest subjects of myth. And, of course, among the earliest traces of human life on earth are innumerable carvings, wall paintings, graffiti, and other decorations, all attesting to humanity's attempts to modify its environment so as to make it more "beautiful."

It is all the more surprising, then, to realize how little we know about the reasons for this response. Western philosophy only sporadically investigated humans' relationship to beautiful objects until about two and a half centuries ago. It is fair to say that the main area of inquiry in Western philosophy has been the development of the cognitive dimensions of human consciousness—the study and the justification of the rational processes of the mind. In comparison with Eastern thought, Western philosophy has neglected the emo-

tional, the intuitive, and, to a lesser extent, the volitional aspects of consciousness.

The first systematic attempts to define *the aesthetic* began during the height of rationalism in Western philosophy. Throughout the seventeenth century, the methodical principles of Cartesian reasoning replaced the last remnants of religious mysticism and literary humanism in European scholarship. The irrefutable order of Newtonian science and Cartesian logic compelled most scholars to accept the supremacy of rational thought as the only reliable process of human consciousness. Whatever else happened in the mind—feelings, beliefs, intuitions, or epiphanies—could not be taken seriously because it resisted transformation into an entity that could be studied with the tools of logic or the emerging empirical sciences.

But no sooner did the Cartesian hegemony establish itself than it began to stimulate its own antithesis. With the workings of reason so clearly exposed, many thinkers found that much of human consciousness did not fit within its ordered confines. Having codified reason, Descartes helped to show how little about human experience it actually explained. So the stage was set for generations of thinkers—from Giambattista Vico to the romantics, Schopenhauer, Nietzsche, Kierkegaard and the existentialists, and down to Freud and psychoanalysis—to explore the nonrational elements of consciousness.

One reaction to a purely rational description of consciousness was the work of the German philosopher Alexander Baumgarten, who first used the term *aesthetic* in his *Reflections on Poetry* (1936 [first published 1735]). Baumgarten himself was a member of the rationalist school, a follower of Descartes and Leibniz. In contrast to his mentors, however, he felt that to exclude sensations and perceptions from knowledge on the grounds that they were inherently confused was to sacrifice valuable forms of consciousness on the altar of reason. Thus he developed from the Greek word for perception (*aisthesis*) a description for a way of apprehending reality that was just as clear—if not as distinct—as the logical cognition Descartes had distilled from the flux of consciousness. Baumgarten concluded that the aesthetic value of a

work of art depended on its ability to produce vivid experiences in its audience.

But what constitutes this experience? Many characteristics have been described over the centuries. In a recent review Monroe Beardsley (1982) singled out five recurring themes, suggesting that any aesthetic experience must exhibit the first one and at least three of the remaining four. It is possible to paraphrase Beardsley's five criteria as follows: (1) object focus: the person willingly invests attention in a visual stimulus; (2) felt freedom: he or she feels a sense of harmony that preempts everyday concerns and is experienced as freedom; (3) detached affect: the experience is not taken literally, so that the aesthetic presentation of a disaster might move the viewer to reflection but not to panic; (4) active discovery: the person becomes cognitively involved in the challenges presented by the stimulus and derives a sense of exhilaration from the involvement; (5) wholeness: a sense of integration follows from the experience, giving the person a feeling of self-acceptance and self-expansion.

This list, which is representative of the elements philosophers of aesthetics and critics have been attributing to the aesthetic experience, is remarkable because it closely mirrors another set of conditions obtained in the course of very different investigations. We are referring here to the characteristics of the *flow experience*, which were derived from interviews with hundreds of persons deeply involved in activities that had few or no external rewards. The studies in question (for example, Csikszentmihalyi 1975a, 1975b, 1978a, 1982, 1985, 1990; Csikszentmihalyi and Csikszentmihalyi 1988) suggest that people play chess, climb mountains, compose music, and do a hundred other nonproductive activities not because they expect a result or reward after the activity is concluded, but because they enjoy what they are doing to the extent that experiencing the activity becomes its own reward. This autotelic experience, that is, one that contains its goal in itself, was called flow because respondents used that term frequently to describe the deep involvement in and effortless progression of the activity.

CRITERIA FOR THE AESTHETIC EXPERIENCE[a]	CRITERIA FOR THE FLOW EXPERIENCE[b]
OBJECT FOCUS: Attention fixed on intentional field	MERGING OF ACTION AND AWARENESS: Attention centered on activity
FELT FREEDOM: Release from concerns about past and future	LIMITATION OF STIMULUS FIELD: No awareness of past and future
DETACHED AFFECT: Objects of interest set at a distance emotionally	LOSS OF EGO: Loss of self-consciousness and transcendence of ego boundaries
ACTIVE DISCOVERY: Active exercise of powers to meet environmental challenges	CONTROL OF ACTIONS: Skills adequate to overcome challenges
WHOLENESS: A sense of personal integration and self-expansion	CLEAR GOALS, CLEAR FEEDBACK
	AUTOTELIC NATURE: Does not need external rewards, intrinsically satisfying

[a]Beardsley 1982, 288–289.
[b]Csikszentmihalyi 1975, 38–48.

Table 1. Comparison of Criteria Defining the Aesthetic Experience
and the Flow Experience

We see here the correspondences between the two sets of criteria, the first describing the aesthetic experience, the second describing flow. Although the two lists do not correspond point by point, they contain the same elements, with little in one list that is not present in the other.

What can account for this similarity? Mutual influence can be ruled out. The aesthetic scholarship on which Beardsley's list is based is completely independent of the flow research and, as far as can be established, the two authors were unaware of each other's work at the time these conclusions were reached. The most likely answer is that philosophers describing the aesthetic experience and psychologists describing flow are talking about essentially the same state of mind. This in turn means that human beings enjoy experiences that are rel-

atively more clear and focused than everyday life, a conclusion already drawn by Dewey (1934). When this heightened state of consciousness occurs in response to music, painting, and so on, we call it an aesthetic experience. In other contexts, such as sports, hobbies, challenging work, and social interactions, the heightened state of consciousness is called a flow experience.

But it may be that the quality of the subjective states is the same in both contexts, that the aesthetic and the flow experiences are in reality indistinguishable from one another. The stimuli producing the person's reaction and the content of the person's consciousness during the experience change, but the reaction itself, the structure of the reaction or state of consciousness, is the same. For example, a tennis player and a person looking at a painting are both involved in what they are doing, and in both cases they enjoy what they are doing for its own sake. They enjoy using their skills to rise to stimulating challenges in a setting that requires clarity and total concentration removed from the everyday world. This focused experience is produced, of course, very differently in the two cases: in the first, it is the challenge of returning the opponent's serve; in the second, the challenge is to respond to the painter's creation. Different stimuli are involved, different skills are required to respond to the situation, but the structural elements of consciousness that account for the rewarding nature of the experience are the same in both cases.

If it is true that the aesthetic experience is part of a larger family, all of whose members display similar elements, one wonders why such states of consciousness are so enjoyable and rewarding. A brief review of what the philosophy and psychology of aesthetics say about the functions of the aesthetic experience may help to answer that question.

THE FUNCTIONS OF THE AESTHETIC EXPERIENCE

Ever since Baumgarten identified the separate nature of aesthetic cognition, philosophers have generally agreed that the case for aesthetics must ultimately rest on the kind of experience it provides.

Reason articulates a set of rules within which the mind can follow convincing steps toward universally acceptable conclusions. But human beings have another way of apprehending reality: an experience of blinding intuition, a sense of certainty and completeness as convincing as any reason provides (Baumgarten 1936). It is this way of seeing the world that has been called the aesthetic experience. Whereas most thinkers would eventually agree on a more or less similar set of criteria for describing the aesthetic experience, such as the one proposed by Beardsley and illustrated in Table 1, there is a much wider difference of opinion concerning why the aesthetic experience is pleasurable or valuable.

From a contemporary point of view, however, it is possible to say that all aesthetic theories can be subsumed under what used to be called a naturalistic perspective. In other words, even the most idealistic and formal theories of the past can be seen as variants of a basic hedonistic epistemology, according to which the aesthetic experience is good for the perceiver.

What good the aesthetic experience does, however, has been explained in many different ways. To a large extent, it seems to depend on how one defines what *good* is. For those who believe that the *summum bonum* consists in approaching God's majesty, art brings the soul closer to God. For those who believe that the best we can do is to sublimate libidinal desires in a socially acceptable form, the aesthetic experience is an excellent way to sublimate.

In the sections that follow, we will summarize various attempts to explain why people seek out the aesthetic experience. Specifically, we will review cognitive, perceptual, emotional, and transcendental perspectives, presenting in each case brief references as to how philosophers and psychologists have viewed the issue. To emphasize these four perspectives in order to organize our discussion is a heroic—not to say foolhardy—simplification. It also results in stressing the differences among thinkers in the field. In reality, of course, no approach to the aesthetic experience relies on either purely rational or purely emotional explanations. However, for the sake of clarity and simplic-

ity, we will proceed as if the voluminous and complex literature on the subject could be reduced to these four headings.

A FORM OF UNDERSTANDING · Approaches to aesthetics based on the concept of the Platonic ideal stressed the belief that art represents not the limited particularities of the world of appearances but the underlying, eternal forms behind them (though Plato himself banished visual artists from his republic as mere imitators of appearances). Thus the aesthetic experience was seen as the satisfaction of an intellectual need to grasp that which is *really* real. But as Kant (1790), Croce (1909), Maquet (1986), and many others have said, the reality art uncovers is not mediated by concepts, as it is when reason is at work. Instead, according to Kant, aesthetic pleasure results from the union of intuition and understanding, and, according to Croce, it results from the process of expressing a formerly unformulated intuition. In any case, the good for these idealist philosophers consists in the apprehension of something that had heretofore been hidden and inaccessible to logical understanding.

In psychological approaches to art articulated since the late 1960s, the cognitivist viewpoint has become increasingly important. Based originally on the work of the philosopher Nelson Goodman (1968, 1978), cognitive psychologists have tried to describe the thought processes involved in the production of art and to explain how these abilities develop with time (Gardner 1973, 1980; Winner 1982; De Mul 1988). For instance, Parsons (1987) finds that aesthetic judgments develop through a five-stage sequence, just as other cognitive abilities do. At first, children appreciate pictorial realism, equating aesthetic value with what is beautiful. Then, they gradually learn to appreciate representation, expression, and organization. Finally, after reaching the fifth and last stage, the adult viewer learns to go beyond any existing criteria of appreciation and adopts an open-ended receptive attitude that allows him or her to respond to qualities of the work not yet encompassed by evaluation.

Important as these ways of viewing art as a rational activity are, they

generally have little to say about what motivates viewers to contemplate works of art, or about the aesthetic experience itself. Cognitive approaches have tried to reconcile aesthetics with the dominant Cartesian epistemology, validating it as a respectable activity of the mind: "the arts are treated not as forms of leisure, play, or amusement, nor as exclusively emotional activities. They are viewed, rather, as fundamental ways of knowing the world" (Winner 1982, 12). In doing so, however, the cognitive approach tends to disregard that which originally prompted Baumgarten and his followers to separate aesthetics from reason—the observation that the aesthetic experience provides visceral, holistic, and greatly rewarding sensations that are ordinarily absent from purely cognitive activities.

Thus the enjoyment derived from aesthetic encounters might be explained in part by the satisfaction of a generalized human need for knowledge and understanding that the arts provide (Arnheim 1969; Cassirer 1957; Csikszentmihalyi 1978b; Vasina 1982; Winner 1982). In other words, the "blinding intuition" one experiences in front of a great work of art is pleasurable because a great amount of knowledge about the world is encapsulated in the transaction. What we ordinarily recognize as an aesthetic experience is a cognitive rush. Other explanations focus on cognitive consonance, or the pleasure one gets from a correspondence between a mental model of perfection and an actual aesthetic specimen (Zusne 1986).

SENSORY PLEASURE · To complement the cognitive approaches to aesthetics, a perceptual perspective claims that some of the information contained in works of art shortcuts thinking and affects us because the mind is already predisposed to recognize it. In current terms, the claim would be that the central nervous system is genetically hard-wired to experience pleasure when processing certain patterns of stimuli.

In the visual arts, aesthetic pleasure is produced by qualities of the visual stimulus. These include, according to Santayana (1896), design elements that produce sensory arousal and formal qualities that produce a sense of order. In some ways this approach had been foreshad-

owed by the Aristotelian notion that unity in diversity constitutes beauty. In this version of utilitarianism, the good consists in an optimal functioning of the mind. There is a mesh between the properties of the stimulus and the potentialities of the perceiving organism, such that the latter is totally involved in the interaction.

Among contemporary psychologists, Berlyne (1966, 1977), Kennedy (1985), and Kreitler and Kreitler (1975) have done extensive research on the arousal properties of discrete stimuli, and Arnheim (1954) and Soueif and Eysenck (1972) have explored the gestalt properties of more complex forms. Both arousal and a sense of order are seen to produce a desirable condition in the central nervous system. Other perceptual approaches have focused on the perception of color (Gerstner 1986), or on inherently pleasing properties of certain stimulus configurations. For example, Samuels and Ewy (1985) claim that infants as young as three months old prefer watching human faces that were rated attractive by adults, thus evidencing innate aesthetic sensitivity, at least for facial features.

But why would some visual configurations rather than others produce a pleasant experience in the nervous system? Explanations here invoke an extension of evolutionary theory. The gestalt approach, for instance, is predicated on the belief that a preference for order is conducive to a better overall adaptation to the environment (Arnheim 1971, 1982; Gombrich 1960, 1979; Kepes 1965). In short, those individuals who derive pleasure from order—which is good for them—will seek out order and will therefore have a better chance to survive and to replicate their genes and their values than individuals who do not take pleasure in order. Thus survival pressures positively select aesthetic enjoyment, just as they select the pleasure derived from physical exercise or from the use of the intellect, and for similar reasons.

It has also been argued that the integration of consciousness brought about by aesthetic experiences leads to mental health and greater societal well-being. Dewey (1934) argued that the aesthetic pleasure arose from the recognition of organic wholeness, and as such was a model for the highest forms of organization in matter and consciousness. Jenkins (1958) and Dissanakaye (1974) held that the con-

tribution of art to survival consists in vividly portraying those elements or issues in the environment with which people must cope; thus aesthetics sensitizes society to the crucial matters of life. Peckham (1965) believed that aesthetic experimentation facilitated cultural innovation in general. Other recent approaches that attempt to develop accounts of the aesthetic experience based on evolutionary theory are those of Csikszentmihalyi (1978b) and Levy (1986).

EMOTIONAL HARMONY · Perhaps the best-known accounts of the aesthetic experience focus on what happens to the emotions in the encounter with works of art. Aristotle felt that tragedy, by evoking pity and fear, helped purge the audience's feelings—a conclusion with which many contemporary psychoanalysts would agree. The good here consists in reliving hidden impulses in such a way that they can be sorted out and brought into harmony with the more conscious aspects of life. Catharsis brings about inner balance and equanimity. The impersonal rules of reason make it a limited tool, because the private joys and fears of men are not taken into account. Art must give people an alternative approach to those aspects of consciousness reason must ignore. As Collingwood (1938) persuasively argued, art can effectively communicate many things that concepts cannot convey.

The most influential modern cathartic theory is based on the work of Sigmund Freud. Especially in his essays on Leonardo da Vinci and Michelangelo (Freud 1910, 1914), Freud explored the connection between early traumatic events in the artists' lives that required the repression of unacceptable impulses, and the form and content of their later works. Earlier he had stated that beauty is based on sexual excitation, that although we are usually not aware of it, the things we find beautiful are in truth sexually stimulating (Freud 1905). The value of the aesthetic experience for the viewer lies in the enjoyable and therapeutic vicarious expression of disguised sexual interest in art.

Innumerable analysts and critics have followed in Freud's footsteps, providing case studies in which the artist's emotional conflict was linked to his or her oeuvre. When sensitively done, such investigations have been useful in suggesting links between the emotional conflicts

of the artist and the viewer on the one hand, and the formal qualities of the work of art on the other. The early faith in the ability of psychoanalysis to provide a definitive account of the aesthetic experience, however, has been generally abandoned. The classical explanation based on the repression of sexual interest at the Oedipal stage of development has been found to be uncomfortably reductionistic by the most informed psychoanalysts (for example, Gedo 1984). The more eclectically overdetermined explanations, which take into account a much wider range of emotional conflicts, are much more plausible and sophisticated; nonetheless, their very indeterminacy has a somewhat improvised quality which makes them definitely unfalsifiable.

Psychologists have also explored the complex ways that visual preferences are related to other aspects of a person's temperament and personality. For example, compared to introverts, extroverts tend to prefer simple colors and forms, and more expressive paintings (Eysenck 1940, 1941). People with a high need for achievement prefer colors on the cool end of the spectrum as opposed to reds and yellows (Knapp, McElroy, and Vaughn 1962). Sensation seekers, on the other hand, prefer red (Nelson, Pelech, and Foster 1984). On the basis of extensive clinical interviews with subjects who expressed preferences for a wide variety of representational paintings, Machotka (1979) concluded that people liked a specific work either because it fulfilled a corresponding emotional need or because the painting supported a defense the viewer had adopted against unwanted emotions. Similar findings that link affective characteristics of the viewer to their visual preferences have been often replicated (for example, Heinrichs and Cupchik 1985). It should be admitted, however, that the literature concerning visual art preferences is contradictory and confusing (Ahmad 1985), as well as quite primitive. This field of research is still far from being able to support with evidence the exalted claims that theoreticians have made for the healing powers of the aesthetic experience.

THE TRANSCENDENCE OF ACTUALITY · An interesting feature of theories of aesthetics is that they are sometimes both reductionistic and emancipatory. For instance, the evolutionary approaches listed in the

section on sensory pleasure can be seen as reductionistic, because they try to explain the enjoyment of art in terms of selective pressures operating below the threshold of human awareness and choice, yet they are emancipatory as well, because they indicate ways in which humans have been able to acquire new skills and new sensibilities.

A similar duality can be found in some of the Marxist analyses of art (Benjamin 1968; Hauser 1951, 1982; Marcuse 1978). On the one hand, Marxist theory is reductionistic because it holds that what we consider beautiful is determined by social relations based on economic conditions. On the other hand, according to some of its interpreters, it holds out the possibility that true aesthetic experience may break through the bonds that tie people into the existing system. Emancipation from false consciousness, or the systematic understanding of alienating social forces, is the raison d'être for the existence of works of art and the ultimate criterion by which they are to be judged. Thus the most valuable contribution of the aesthetic experience to the progress of mankind consists in bringing to the fore those human potentialities that the social system has repressed and in showing the causes of repression. According to this position, the painters who have used their brush to portray the horrors of poverty and war, such as Goya, Daumier, Picasso, Orozco, or Rivera, are the most valuable purveyors of the aesthetic experience.

Another justification of the aesthetic experience is based on its purported ability to give people a foretaste of other-worldly reality. Mystical and religious approaches to art have stressed its constructive, creative aspects—the fact that art transcends reality as it is and indicates instead how it could be. Dante Alighieri thought that the order and discipline of poetry could lead the reader's mind upward, to glimpse the universal order that God imposed on nature. In *What Is Art?* (1960 [1st Russian edition 1896]), Tolstoy held that a great work of art elevated the audience and led to a belief in the universal brotherhood of mankind.

The religious approach, like the Marxist one, is impatient with the status quo and finds the transcendent aspect of the aesthetic experience to be its most valuable quality. Yet the two differ in their orientation: the first looks to a divine order for inspiration, while the second

looks toward an earthly utopia. But this distinction may be based more on superficial historical appearances than on real, substantial differences. After all, Dante was deeply involved in the thirteenth-century political struggles aimed at establishing a secular counterweight to papal authority, and Tolstoy, at the time he wrote *What Is Art?*, was involved in his experiments in communal living. Thus, the quests for divine and earthly perfection need not be mutually exclusive.

This brief review only begins to hint at the great variety of aesthetic theories that have proliferated in the last several centuries, even before aesthetics as a separate philosophical discipline came into existence. What does this diversity of explanations mean? Does it mean that in reality there is no such thing as an aesthetic experience?

THE STRUCTURE OF THE AESTHETIC EXPERIENCE

We will argue that if we expect the aesthetic experience to be a single, universal reaction, like the blinking of the eyelid under strong light or the sensation of sweetness at the taste of sugar, then there is no aesthetic experience. But very few human experiences are that simple. Most events in consciousness are built from culturally defined contents as well as from personal meanings developed throughout an individual's life. Thus two persons can never be expected to have the same experience, and the farther apart in time and place they are, the more the details of the two experiences will differ.

For instance, psychologists have shown that while people who share training in Western artistic traditions will agree in their aesthetic preferences, untutored viewers will not (Anwar and Child 1972; Haritos-Fatourous and Child 1977). Sociologists (for example, Bourdieu 1987) have reminded us that a person can never have a pure, immediate aesthetic experience—whenever we gaze at an object our reaction to it is historically grounded, inseparable from ideologies and social values.

It would be impossible for an Australian aborigine and a New York art critic to have similar reactions to an abstract painting by Jackson Pollock. The objective visual stimuli would be processed in entirely different ways by the two viewers. For the aborigine the painting

might not even contain information at all—it would be perceived as we perceive white noise or the pattern of light and shadow on a hillside— that is, as a meaningless assemblage of stimuli. In contrast, for the critic one glimpse of the painting would immediately evoke masses of structured information that include perceptual judgments as well as emotions. Art historical, biographical, sociological, technical, and aesthetic considerations would be called to mind, and these would begin to interact in consciousness with the objective details of the painting as they continued to be processed by the visual receptors.

The aesthetic experience occurs when information coming from the artwork interacts with information already stored in the viewer's mind. The result of this conjunction might be a sudden expansion, recombination, or ordering of previously accumulated information, which in turn produces a variety of emotions such as delight, joy, or awe. The information in the work of art fuses with information in the viewer's memory—followed by the expansion of the viewer's consciousness, and the attendant emotional consequences. This process of fusion we will refer to as the structure of the aesthetic experience. Whenever we are moved by the encounter with a work of art, our experiences will have a similar structure, even though their informational content might be completely different.

In the example just discussed, it would make no sense to expect that the experiences of the aborigine and the critic would be similar, either in content or in structure. The two viewers would bring to the situation entirely different backgrounds of information. In fact, the aborigine may not have any experience at all in looking at the Pollock painting, let alone an aesthetic one. The same argument holds, to a greater or lesser degree, for any two persons looking at the same object. But if two people *do* have an aesthetic experience in looking at the same object, regardless of the different thoughts and emotions they might process during the encounter, we claim that the structure of their experience is similar.

In other words, while the thoughts and emotions in response to a work of art might be different in the minds of different viewers, the structure of the experience, its quality, the way it feels while it lasts,

seems to be the same regardless of its cognitive and emotional content. These structural similarities include the conditions already mentioned in Table 1: when the viewer focuses attention on the object, there follows a sense of concentration, of freedom, clarity, control, wholeness, and sometimes transcendence of ego boundaries, a condition so rewarding as to be sought out for its own sake.

For attention to be attracted to the object in the first place, a further set of conditions is necessary. The object must contain a set of visual "challenges" that engages the interpretive skills of the beholder. The environment must be conducive to a centering of attention on the object and to a screening out of distractions. How these and other conditions of the encounter with the work of art contribute to the aesthetic experience will be developed in detail in the chapters that follow. In the process, by focusing closely on the quality of this experience it will be possible to develop and enlarge our understanding of the potentialities for enjoyment open to human beings and to refine the theoretical model of the flow experience, which by necessity will be enriched through its application to this unique body of data.

THE METHOD OF THE STUDY

Throughout most of its history, the study of aesthetics and the aesthetic experience has been, almost by definition, considered the province of speculative philosophy. With the push in the first half of this century for the establishment of the social sciences as hard sciences along the lines of physics and chemistry, the field of experimental aesthetics came into existence. This field, exemplified by the work of Berlyne (1966) and Child (1968–1969), was almost wholly dedicated to understanding the mechanics of the perceptual aspect of the encounter with a work of art, and thus it was both experimental and physiological in its orientation. The work in this field attempted to redress what was perceived as a lack of systematic observation and connection to the "real" world in the philosophical tradition. Yet it seems obvious now that such an approach was much too reductive to grasp fully the complex and integrated nature of the aesthetic experience.

As philosophers have pointed out for centuries, there is considerably more to the encounter with an aesthetic object than the visual stimulus and a corresponding optical response. While the philosophical attack on the problem may have erred in the direction of being too abstract, the experimental aesthetics approach seems to err in the opposite direction; that is, it becomes so particularistic that it, too, loses sight of the inherently human nature of both art and the response to it.

Our approach in this series of studies attempts to walk the line between the two extremes. We try to make some generalizations about the nature and conditions of the aesthetic experience and to do so in the form of interpretations of data which we gathered in a relatively standardized, though not experimental, situation, that is, in a series of interviews with art museum professionals. Several assumptions guided the course of this research. In rough order, from the most general to the most specific, they are:

1. Subjective interpretation is the key to understanding the aesthetic experience. Although physiological, perceptual, and cognitive processes are important components, they are relatively meaningless until given weight and value by the interpretation of subjective experience.

2. Most, if not all, people are able to talk about their experiences of subjective states in a coherent fashion.

3. However, the most coherent statements of the nature of subjective experiences will be those made by persons for whom those experiences are, first, a somewhat regular occurrence, and second, for whom the awareness of those experiences is an integral part of their lives.

4. Museum professionals, by virtue of the nature of their positions and pursuits, must be sensitive to the aesthetic value of objects and consequently aware of the nature of their own response to such objects. Their responses will be more relevant to understanding the nature of the aesthetic experience than the re-

sponses of visual artists would be, because the artist approaches art as a creator rather than as a viewer, and thus would experience art very differently from normal audiences.

5. Finally, we assumed that letting people talk at length about their experiences was a better way to determine what were the most important components of the aesthetic experience than asking them to answer any sort of questionnaire that we might design. We felt that this would avoid, as much as possible, the imposition of our own implicit or explicit theories of the aesthetic experience on the responses of the people we were interviewing.

The three most important elements in the study are, then, the questions we asked, the people who asked them, and the people we asked them of.

PLAN AND DESIGN OF THE CURATORIAL INTERVIEWS · We designed our interviews to be semistructured. That is, there were several general areas that were introduced with open-ended questions, accompanied by a number of optional probes for each. This structure enabled us to touch on a certain core of topics with every respondent without precluding other topics that might arise in response to the general questions. The rationale for and exact wording of each question were worked out by our research group as a whole so that each of the interviewers was intimately familiar with the protocol. A number of pilot interviews and several early interviews were analyzed in detail by the research team, and some alterations were subsequently made in the protocol to correct what were felt to be weak areas. The interviewers worked closely together so as to ensure maximum consistency and to share the insights and strategies that enabled them to obtain the broad range of responses that has resulted in this valuable body of data. The interviews were conducted by a group of advanced graduate students and faculty members from the Committee on Human Development of the University of Chicago. All of the interviewers had been involved with the development of the research project and of the interview protocol from their inception and thus were familiar with both. Moreover, all of the interviewers had some background in the

arts (either studio, art history, or art education), and all had been in-volved in an earlier project involving research on artists. Considered as a whole, this group had several hundred hours of interviewing ex-perience in a variety of settings.

The interview protocol is presented in Appendix A.

PLAN AND DESIGN OF THE PROFESSIONALS STUDY · For the museum professionals, the four general topics can be summed up as follows: (1) professional history and nature of present position; (2) personal his-tory of involvement with the arts; (3) description and discussion of one or more specific encounters with works of art that were felt to be es-pecially significant; and (4) opinions on the aesthetic experience in general and the possibility of facilitating that experience.

Each of the interviews was conducted at the institution where the curator worked and lasted anywhere from fifty-five minutes to two and a half hours. Prior to the interview the respondents were told only that we wished to discuss some aspects of their profession, not that we were interested in their theories of the aesthetic experience. The full intent of the study was discussed in detail with each person only upon completion of the interview. All of the interviews were tape-recorded and then transcribed verbatim. The analyses in the following chapters are based on these transcripts.

We interviewed primarily curators and directors (84 percent); how-ever, we also interviewed a number of persons in both conservation and education departments. We will usually refer to these respon-dents as curators or museum professionals. Altogether we interviewed fifty-seven individuals from seventeen different institutions, twenty-four from the J. Paul Getty Museum in Malibu, California, and eigh-teen from the Art Institute of Chicago. Six are curators of corporate collections in major businesses, and the remaining nine curators rep-resent various university, city, and independent public institutions. Slightly more than half the group are male, with an average age in the middle forties.

More important than these demographic characteristics is the high level of expertise embodied in this select group of people. Over 80

percent had completed a master's degree, and 40 percent had been awarded doctorates. The majority of those degrees are in art history, but nearly a quarter are in studio arts. Slightly more than 15 percent of those interviewed had some special museum training in addition to the degree programs, even if their degree was not in museum studies, and more than 50 percent had studio training of some kind, ranging from printmaking to architecture. Finally, 75 percent of these individuals had formal teaching experience in either a museum or university setting.

Professionally, this is an equally impressive group. More than half, or 57 percent, are or have been full curators, and 19 percent are currently directing or have directed a museum or gallery. On the average, their present position is the fourth post of their careers. Among them they represent experience in more than fifty museums and galleries in the United States and Europe and possess several hundred years of collective experience.

On the average, members of this group had organized sixteen exhibitions apiece; one quarter of the group had put together thirty or more exhibitions during the course of their careers. The group averaged nine scholarly publications apiece, although again, about a quarter of them had more than twenty to their credit. Finally (and indicative of the fact that these people are vitally involved in the art world), slightly less than 75 percent are currently involved in consulting or community work, including jurying shows, serving on the boards of art galleries and artists' cooperatives, and working as trustees and consultants for other museums and for state, local, or national arts organizations.

ANALYSIS OF THE INTERVIEWS

Finally, we would like to offer some introductory remarks on the ways in which we used the interview material in this report. The two types of information—percentages on the one hand and quotations on the other—have a similar basis. We did not begin with a coding system and then comb the transcripts in search of supporting instances. Rather,

separate groups of researchers read the transcripts with broad general questions in mind, such as, What are the most important elements in the aesthetic encounter? and What are the conditions under which an aesthetic experience can take place? From the initial readings, categories were derived using the terms of the respondents themselves. Then, the categories were refined as more transcripts were analyzed, until finally the entire body of material was recoded using the fully elaborated systems for each topic.

By coding, we do not mean to imply that every sentence in the entire transcript was accorded a code. Instead, we isolated passages of any length—from one sentence to more than a page—that exemplified a particular type of experience or concern on the part of that particular respondent. Thus, one transcript can have as many different codes as there are topics of importance to the respondent. Also, one statement can be included as relevant to or exemplary of more than one topic. While this method seemed to us the best way to preserve the richness and complexity of the data, it does preclude any statistical consideration of counts or mentions because, first of all, given the semistructured nature of the protocol, we would be unable to say that every respondent had an equal opportunity to discuss all of the topics. More important, under any such empirical counting system, a thought that one person might express in one succinct statement would be outweighed by an extended—even if less insightful or reflective—discussion of a different topic by another respondent. Thus, in any of the percentages we report here, we are referring to the percentage of individuals who touch on the topic in one form or another and not to the literal numerical frequency of the topic. The percentages are used primarily to give the reader an idea of how important the topic was across the entire group, that is, they indicate that most respondents touched on topic A, while only a small group touched on topic B. We do not use them in order to establish the existence of particular subjective states or to make claims about the absolute importance of one factor or another.

The categories established by the coding system thus became the

basis for the selection and grouping of the quotations that are the primary data for the majority of the report. While the quotations are grouped under topical headings from the coding system, it must be kept in mind that the codings themselves were inductively derived. The quotations thus both illustrate the theme that we feel a coding category captures and form the basis for the judgment of the importance of the coding category itself. The three-digit number in parentheses following each quote is an identification number that identifies each respondent.

Two final caveats. First of all, though we have tried to select quotes that can stand intelligibly on their own and not misrepresent either the context of their utterance or the intent of their speaker, we must caution the reader to keep in mind that these are selected and sometimes edited quotations. Our presentation may at times give the impression that the ideas discussed in the quotes are completely distinct from one another, yet the overriding opinion of the questioners was that every respondent spoke in a remarkably unified and consistent voice, that their theories of the aesthetic experience were coherent with their theories of educating for the aesthetic encounter and with their value judgments of the works they discussed. Second, for nearly every category that we were able to define and support with quotations and percentages, there was always a small number of clearly and often diametrically opposed statements by other respondents. More often than not, we have included at least one of these in the sections that discuss the thesis to which they are the antithesis. We have chosen to present these not just in the name of intellectual honesty but because we believe that this is not an arena of discourse that falls under the jurisdiction of majority rule. The nature of the aesthetic experience is a vital issue and has been so for thousands of years. To close off discussion of the issue is not the intent of this report. More than anything else, we hope that this investigation will stimulate discussion and perhaps open up new ways of thinking about the aesthetic encounter with a work of art.

For many skilled viewers, the main impact of a
work such as Rembrandt's *Three Crosses* does not
seem to come from the narrative content of its sub-
ject matter. They are not moved primarily because
they empathize with Christ's suffering on the cross.
Rather, the emotional impact derives from the tech-
nical assurance of the drawing and from the traces
of the artist's thoughts and feelings hidden between
the lines. Such a viewer gains satisfaction by re-
living the creative process that resulted in the
masterpiece.

CHAPTER 2

The Major Dimensions
of the Aesthetic Experience

AN ANALYSIS of any sort begins with a description of the phenomena under study. Yet a thoroughgoing and empirically grounded description of the aesthetic experience has been conspicuously absent from aesthetic theory—of whatever stripe—in the past. For the most part, aesthetic study has proceeded either from a priori assumptions concerning what the aesthetic experience must be or the basis of the analyst's own experiences. In this chapter we attempt to redress this omission by describing the recurring and central aspects of the aesthetic experience as recounted by the museum professionals we interviewed.

Unlike the approaches alluded to above, our only assumption was that the aesthetic experience would be qualitatively and experientially different from everyday visual encounters. Other than a focus on what was especially memorable, everything from the selection of what constituted an aesthetic encounter to the focus on particular dimensions as most salient was left open to the personal definition of the respondents. Rather than structuring the interviews around abstract questions concerning an average or typical aesthetic experience, we asked them to describe a recent encounter that they felt to be particularly significant. The analysis presented in this chapter is based on an examination of the wide range of responses we gathered through the interviews concerning personally meaningful encounters with works of art. Given the number and variety of both respondents and

This chapter was initially drafted by Nancy Burke, Patricia Lorek, and Daniel Schouela.

works discussed, we are confident that the description that emerges from our analysis is one which, at the very least, points to all the significant aspects of the aesthetic experience and defines most of them rather clearly.

The formulation of the major dimensions of the aesthetic experience is drawn from the responses to our query about these significant encounters with works of art. In asking the question, the interviewers encouraged the respondents to speak candidly as appreciators rather than as professionals concerned with possible purchases. In general, the responses were varied and tended to be complex, both in terms of the number of aspects of the encounter described and in the sophistication of the descriptions.

Overall, our attempt was to discern what modes of experiencing and responding to works of art were, if not common to all, then the most frequently described. Rather than finding either one way of responding, or one way for each curator, we found several modes that were common to a number of respondents. Perhaps even more interesting, we found that most of the museum professionals interacted with works of art in more than one of the ways described by the group as a whole.

Thus, each of the following sections represents one of the more significant ways in which these persons interacted with works of art. The majority of the respondents spoke of more than one aspect of their experience. These can be briefly described in four ways: a perceptual response, which concentrated on elements such as balance, form, and harmony; an emotional response, which emphasized reactions to the emotional content of the work and personal associations; an intellectual response, which focused on theoretical and art historical questions; and, finally, what we characterized as the communicative response, wherein there was a desire to relate to the artist, or to his or her time, or to his or her culture, through the mediation of the work of art.

The topic of each of the following sections is a global term such as "perceptual." By these groupings we do not mean to imply that the perceptual aspects of the experience were the same for all who describe them—far from it. Rather, each section describes the way in

which the umbrella term comprehends a variety of discrete but re-
lated types of experiencing.

Given the inherently visual nature of most art media, the fact that all
of the museum professionals talked at one point or another about a
perceptually oriented response to a work of art should not be surpris-
ing. This, however, in no way trivializes the importance of the per-
ceptually oriented response as a dimension of the aesthetic experi-
ence. Of all the aspects of the experience, the perceptual was most
often the first one mentioned and usually the most clearly articulated.
All the museum professionals interviewed indicated that in those en-
counters that proved to be personally salient they felt they were vi-
sually engaged by and drawn to the features of the objects immedi-
ately before them. For 23 percent (13 of 57) this was the primary mode
of response. Within this category, accounts ranged along a rough con-
tinuum from those bearing upon the object as a global entity, as a
whole, or totality, to those dealing with the object in a more analytic,
fragmented manner, as an entity constituted by an internal organiza-
tion of a variety of components.

The most general remarks reflecting experiential engagement with
works of art referred to sensing the overall physicality of the work.
One of the respondents (109) described how he felt addressed by the
"full presence" of the work, and another (107) spoke of grasping the
work's "intuitive concreteness." This kind of global sensing of the ob-
jecthood of the work also was often discussed when respondents con-
trasted experiences of actual works of art with those of reproductions.
One person remarked:

> There is no substitute at all for the actual object. A quality
> comes through, nearly a texture. There isn't any substitute
> for the actual object. It tells you things that a reproduction
> never tells you. Just the fineness of things is never conveyed

by a reproduction. Even with glass intervening, you don't
quite get just how wonderful it is. (415)

But more often, the museum professionals referred to the physi-
cality of the work in statements concerning the impact upon them of
the size or the scale of the object or its undeniable reality:

> It's just one of the most phenomenal pieces of sculp-
> ture. . . . And you look at the side of it, every aspect of it,
> because classical sculpture has implicit in it a whole tem-
> poral quality, it actually takes time to go through all the little
> bits, you have to walk around a piece of sculpture because
> the artist built into that whole idea of three-dimensionality,
> it's implicit that you will walk around to understand it. And
> what you see when you look at this is that from every angle,
> the volumes change, and you just can't really appreciate it
> completely from one point to the other. But if you sit down
> and look at it from the back, then it's different again. And
> just the contrasting movements of this drapery, it's like a cas-
> cade. It's really one of the most exciting pieces of sculpture
> I've ever seen in my life, because it's just alive. (408)

The majority of perceptually oriented statements were more dif-
ferentiated than simple remarks on the totality of the object. As is im-
plied by the category title, most remarks concerned the respondents'
appreciation of the organization of elements constituting the work,
namely, its form, line, color, and surface.

A small number of the respondents described their perceptual ap-
preciation in terms of a rather well-defined classical conception of
beauty. That is, they characterized the works with which they had
had significant encounters in terms of the ways the works reflected or
embodied certain traditional principles of order, harmony, balance,
and the like. Although most readers will be familiar with such clas-
sical conceptions, the statements made by two of the museum profes-
sionals provide concrete examples of the way in which this approach
was described:

I began to see its beauty. . . . I loved the subtlety of the carving and the modeling with the clay, the locks of hair, the simplicity of the piece. I guess what I like about it are, first of all, the simplicity of his lines, the way that the bust is cut very sharply around the torso . . . and the sharp turn of the head against the bust. . . . The delicacy of the eyebrows, the very subtle lines and the way they catch the light. . . . We're still interested in the beauty of the object. (109)

[The work] would also stimulate someone who had any kind of eye for proportion and beauty and . . . symmetry. [The] nuances of surface and the play of the heavily lidded eyes and the strong nose. . . . [T]he almond-shaped eyes and the arms shaped like elephant trunks and . . . the egg-shaped head. The image is so beautiful that you could worship that thing . . . because of the inherent beauty that has been created by the artist. (114)

Beauty was sometimes strictly formal or compositional, present even in objects that depicted unpleasant subject matter: "Many people would think that this is a repulsive painting, but I think I see [it] almost as a beautiful painting, because of the relationship of forms and colors, and I can get quite excited about it on a lyrical level" (135). There was often a related concern with the appreciation of the quality of the work, with "how well [the object] was made" (109), and with how one is drawn to objects that are "the finest examples of their type" (108), reflecting a "purity or excellence in their specific category" (114).

A classical orientation toward beauty was present in slightly less than a quarter of the responses and did not seem to be a predominant mode of considering works of art. Overall, it appears that this notion of beauty is employed by those whose attention is devoted principally to the art of earlier centuries; those whose specialty is contemporary art do not spontaneously construe works according to the classical conception of beauty, and in some cases, they even repudiate the utility of this notion in regard to the art they appreciate most.

SPECIFIC PERCEPTUAL QUALITIES OF THE OBJECT · Without invoking
or alluding to any classical notion of the beautiful, a number of re-
spondents made statements about being especially drawn to and en-
gaged by specifically aesthetic aspects of the work's composition. Pre-
eminent among these were appreciation of the form, color, and
textural quality of the object.

> I responded to the painting because of its color and forms,
> they were musical forms; it's called *Guitar on a Table*, and it
> had all the strength and beauty of a perfect Cubist picture.
> It also had all of the variety of paint manipulation that you
> associate with Cubist paintings. Some dry, chalky lines
> across the surface, that were just laid on as if with a piece of
> chalk. Other stuccolike surfaces where ashes or sand might
> have been added with paint to make it really crusty, and
> other areas of dead black, where you think the artist has col-
> laged a piece of paper to it, it is so flat. (129)

> Across the face of that painting were many surfaces. There
> were thin dry surfaces. There were lusciously worked areas in
> the painting. There were thinly washed areas that were not
> dry, that still had a shine to them that allowed a transparency
> looking through to a certain depth within the painting. (105)

Perceptual qualities extended beyond the visual to the other senses.
The following quote gives an idea of the sensual nature of this di-
mension, the appeal to the senses that goes beyond what is easy to
see, and far beyond what it is possible to relate verbally:

> You can't really appreciate them [Greek vases] without
> touching them. You don't understand half of a Greek vase
> without picking it up. There's the balance, and the way that
> you move the piece if you're going to drink out of a cup, how
> the foot reacts with the bowl. I think that's all-important in
> really appreciating ceramics. And the same with jewelry. I
> mean, what do you know about a piece of gold that was in-

> tended to go around someone's neck if you don't realize how
> heavy it is, or how beautifully the chain works? (408)

Although passages such as these were numerous, we encountered a much wider spectrum, understandably, where perceptual responses were intermediaries, vehicles, for other kinds of concerns. One of the more frequent of these was where the primary concern focused on the activity of the artist making the work, on which features within the work provided a direct access to the art-making process. Comments such as "Those are exciting pieces, the way you can see the artist's hand" (113) or "Look, look there, I see his hand moving. Look how quickly!" (115) were far from unusual. The following quote embodies the immediacy of this kind of interaction:

> It had a certain crudity which is actually enormously ap-
> pealing. You can almost see the wood carver, you know, at-
> tacking that piece of wood with the kind of fervor and crea-
> tivity of the moment. . . . You can see the cut marks of the
> chisel and the knife on the torso. (114)

Even given the breadth of the categories used to group the responses, it is apparent from these limited excerpts that the perceptual dimension of the aesthetic encounter is as varied as it is central. Were we to have refined further, there would have been even more categories. But running through all the quotes as well as the categories is the admission of the affective and interactive power of the form and the surface of a work of art. But as the above quotes illustrate, the perceptual aspects of a work often shape and express the less tangible aspects of an object. The other dimensions of the aesthetic encounter we describe explore those intangible aspects. We turn now to the one most frequently discussed, emotion.

THE EMOTIONAL DIMENSION

Museum professionals spend a great deal of time looking at and living among great works of art. And although one might hypothesize that

constant exposure might hinder their ability to respond to art on an emotional level, this was far from the case. In fact, an appreciable level of emotional involvement was reported by over 90 percent of the respondents. The emotional mode was, moreover, the primary kind of response for nearly a quarter of them. One individual's discussion of the ability of a work to create an emotion in the viewer helps to explain the importance of this mode of interaction:

> I may look at it very closely to see . . . whether I can understand that one passage in the lower left-hand corner. And that feeling comes to me . . . I guess that's what all great works of art should do. They should create some emotion. So I can feel it so often here, and that is why, as I said earlier, when we first started to talk, that after all these years I've been here, I can say one thing, I've never been bored. How could you be bored? (115)

The respondents reported a broad variety of emotional responses, including positive emotions such as joy, delight, inspiration, and love, and negative responses such as anger, hate, and frustration. A good number of respondents were most affected by works that surprised them, while others preferred familiar works evoking comfort or even nostalgia. In the latter cases, there was almost always some connection to personal feelings, to past associations and experiences:

> One of the period rooms was a very large room that was Scottish, and my father's family is Scottish. I'm not saying that this was a wonderful aesthetic experience, because I certainly wouldn't want it in my living room, but there was a couch in which the legs and everything were stag horns, really, a gruesome sort of object, actually. And a painting by Landseer hung above it, of a deer. I mean, I had tears in my eyes. I was really emotionally moved because it just reminded me of a lot of things, actual experiences from my childhood, or things I've read about or things I know. But

also, it was partly because I knew that all these things would
be so significant to my parents and to other people in my
family, and it was a way of making a connection. (401)

Some works produced tension, excitement, or intrigue. Other works
were valued for their ability to bring about a composed, contemplative
state. In a few instances a completely visceral or physical reaction
was reported:

They were so laden with the thought that created them . . .
so much involvement and so perfectly tailored, that it just lit-
erally reached out and I could almost feel something grab-
bing me. It was just this sort of [snatches at the air] physical
feeling from the form that it took. (106)

More often it was the case that people used less dramatic phrases,
such as "I was struck by the work" or "it grabbed me," and then went
on to describe a more intellectual mode of apprehending the work. In
a few instances respondents described emotions that are usually as-
sociated with people rather than with physical objects, such as, "you
get kind of passionate about some of these things, . . . lustful might
be the right word" (108) or "there is a kind of seductiveness to a work
of art that I think people do feel" (120).

More than a few of the respondents described a development
over time, from an initial reaction (which was usually an emotional
impact) to the involvement of thought—and sometimes to different
emotions as well:

When I see works that come close to my heart, that I think
are really fine, I have the strangest reaction, which is not al-
ways exhilaration, it is sort of like being hit in the stomach.
Feeling a little nauseous. It's just this completely over-
whelming feeling, which then I have to grope my way out of,
calm myself down, and try and approach it scientifically, not
with all of my antennae vulnerable, open. . . . What comes
to you after looking at it calmly, after you've really digested

every nuance and every little thread, is the total impact. When you encounter a very great work of art, you just know it and it thrills you in all of your senses, not just visually, but sensually and intellectually. (131)

It's the portrait of a woman and her little boy and a dog, and it appealed to me because it's very attractive, because I have a little boy about the age of the little boy in the painting who looks a little bit similar, and so, having been attracted to this painting, thinking, "God, how corny." I saw all these great paintings, and what do I do? I go and look at a painting of a mother with a little boy and a dog. So I started to try and analyze why—other than the sort of direct appeal to subject matter—why it was so attractive and appealing. And although the painting is a regular square format, it essentially forms a circle. The figures in the center form a circle. The way they are arranged and the way the colors are arranged, make a circle so that you're constantly pulled back into the center, and particularly to the little boy's head. It's just a very effective format. (401)

For another person, a positive emotional reaction to a work was a prerequisite for any professional involvement with it:

I always start everything with the art work. A lot of times there's this pressure just to do something because it will sell or because it's chic or whatever, but I always have to start with being inspired or excited by a work of art. You know, I've never done a show that hasn't come directly out of my being very intrigued by, or excited by, a piece of art. (106)

An initially positive reaction was not reported by all the museum professionals regarding their significant experiences with art. An

equal number of respondents were frustrated or disappointed at first, or actually hated the works they talked about at length. One curator recounted her interaction with Jackson Pollock's *Number One* as just such an encounter:

> I was just indignant, furious. And my reaction was very strong—I really was quite convinced that this was a joke. But it was interesting enough that I kept seeing it over time, and by the time I had gone through part of college I was quite enthusiastic about it and I found it very exciting. (126)

Another respondent stressed that the positive or negative aspect is unimportant; instead, it's the spark that counts:

> For a certain individual, there will be a reaction in some way. Either you like it or you don't. But you might be taken in by something, it's enough to hold your interest and get you rooted there for a while and start [you] thinking about some other things, places you might be led to from this starting point. (105)

When she described her own experience she defended her initial dislike of an artist's work:

> When I first saw it I hated it [laugh] and I thought to myself, "Hmm, that's interesting. Why do you dislike it?" . . . And so that's a good reaction to have. To not like something, it's a real reaction. And so I took that reaction and I brought myself—I remember going back to the gallery probably three times during that visit to New York, and forcing myself to look at that work. And the more I looked, the more I found, the more I liked, and the more I wanted to see more of that work. (105)

The converse was sometimes true as well: "Once in a while I make a bad mistake. I've bought something I thought was beautiful, and

then I begin to see an emptiness in it that doesn't get better, it only gets worse" (134).

A number of respondents believed that the intellect could interfere with a significant interaction with a work of art. They tended to emphasize the emotional dimension of experience over the intellectual: "It seems that . . . the most important thing is to be honest with your own feelings, to trust your own feelings. So the first approach is without any ideological background" (110).

There were others, however, who saw these two dimensions as complementary. One curator began by saying that viewing art used to be merely an intellectually enriching experience for her. Yet as she grew older, her experiential range expanded and with it her emotional range. She can now go back to her earlier experiences and feel enriched both intellectually and emotionally:

> I am able to go back and translate. I remember [that] the first time I saw Yves Klein's work, it was a very intellectual thing. But now I can go back and translate that experience, filter it through what I know now and recall that experience and get more out of it just through my own memory . . . by applying it to that greater range of emotion that I feel I have now. (106)

EMOTION AS THE PRIMARY MODE · Although emotional reactions were mentioned by nearly every respondent, some valued this aspect more than any other. It can be said that for them the feelings art produced were the central aspect of the aesthetic experience. One of these people was quoted at the beginning of this section as saying that every great work of art must have the power to produce an emotion in the viewer. As he recounted his interactions with art the most frequent feelings he described were awe and inspiration at the ability or genius of an artist:

> Truly great works of art, no matter how familiar you become with them, never fail to mean something. How often have I

> picked up something like Rembrandt's *Three Crosses*? You
> might do it automatically once or twice, and then you give it
> a look again, and you say, "My God! . . . How did he? . . .
> What? . . . How wonderful this is!" . . . I've always felt
> that, I've never articulated it except to you. But I think that
> that's truly what is rewarding. No matter what. (115)

Other respondents had a different conception of how works affected
them emotionally. For example, while the first individual emphasized
the power of the work of art to produce an emotion, another spoke of the
artist's ability to portray feelings that she could share. "We did an ex-
hibition of drawings by three Austrian artists. One of them had an abil-
ity to get down to the most primal feelings, and to portray those feelings
via a line that I've never experienced. And that to me was wonderful to
live with" (105). Still another was most impressed by the ability of the
work to evoke an awareness of the emotional being of the artist:

> Kiefer was not *making* art, was not *making* pictures, his work
> came absolutely directly and strongly out of his whole being,
> there was no artifice—you don't feel, however beautiful, if
> we may use that word, a painting might be, that it is
> contrived. (135)

When she was asked about why she wanted to own a particular work,
the curator previously quoted responded:

> It hits me on some emotional level, it's very personal. I un-
> derstand in a very profound way, more so than the next one.
> I think that it relates to some feeling states that I've had
> along the way, that are in synch, for sure, with what the artist
> is trying to portray. And then, technically, they're handled
> beautifully, color-wise they're done well, formally they're
> done well. So it all just falls in together, and you think that's
> something that you'd like to look at a lot in life, because it
> evokes those feeling states that are pleasurable. (105)

Finally, there was one respondent, with over twenty years of experience, who described an encounter with a work that bespoke the power of this dimension to affect one's whole conception of art:

> I remember standing there looking at that, and saying to myself, "That's not art, I know what art is, art is composition and order and structure, and art isn't all this melodrama and stuff—this is all playing on the emotions and this is dealing with subject matter and this isn't art." And I sat there for a while looking at it, and then I thought, "Wait a minute, you're very moved by this, you're moved almost to tears by this thing you're looking at, and you're standing here arguing with yourself about whether it's art or not!" Well, if it isn't art, then your definition of art is awfully narrow and is keeping you from some kinds of experience that obviously are important, so either art isn't important as a category of experience, or else your notion of what art is is too limited. And I'm sure it was the latter. So it was a kind of breakthrough experience where I was forced by something unfamiliar to revise my notions of what it was I was dealing with. (416)

There are of course many implications to be drawn from such a statement. As we will see, this opening up of possibility is inherent in any dimension, not just the emotional. However, this passage makes it clear that the emotional dimension, like the perceptual, lurks behind every encounter with a work of art, and if one is open to it, it can transform the experience in important ways.

In summary, this section has presented evidence that the emotional apprehension of a work of art constitutes a highly salient feature of the overall aesthetic experience. Furthermore, the comments of our respondents indicate that the emotional reactions to art objects are not homogeneous. We have seen that considerable variation exists with respect to the positive or negative valence of feelings produced and in the general level of intensity or excitation. We have also seen that the quality of emotional response may vary depending on how much time is spent with the work. Lastly, it became evident that this

variance of emotional response was related to the interplay of affective and intellectual modes of construing the art object. At this point we will turn to a direct consideration of the way in which the respondents discussed the intellectual dimension of aesthetic appreciation.

THE INTELLECTUAL DIMENSION

In the very structure of our cultural and academic institutions we tend to distinguish the arts from the sciences and to assume that our reasons for doing so stem from the relative play of emotion and intellect within them. Sophisticated members of either realm, however, tend to recognize the broad overlap between the two disciplines and to acknowledge that the two human capacities through which these disciplines have been created, emotion and intellect, are not only compatible but perhaps in certain respects indistinguishable. Given the structure of the modern museum and the importance of art historical scholarship within that world, it is not particularly surprising that 95 percent of the museum professionals made references to the intellectual or cognitive dimensions of the experience. Just over half saw the intellectual aspect as primary. Yet to a degree greater than was evident in either the emotional or the perceptual aspects, the variability in the uses to which this cognitive approach was put, in the extent to which it constituted a process that was open-ended, and in the frequency with which it was employed, was remarkable.

The extent to which these intellectual processes played a part varied greatly. Thus, while some respondents exclusively limited their discussion to aspects of the work that reflected their intellectual understanding of it, others found such an approach to be secondary, either in terms of the value they placed upon it or in terms of the order in which they employed it. One curator stressed the secondary importance she placed upon intellect by commenting:

> Sometimes I think it gets in the way, in all honesty, because when you see something and you're immediately thrown into thinking of parallels and dates and all that kind of thing,

> it stops you from just having this incredible reaction to it as
> an object. (408)

Or, as another put the same point, "Every system that you layer on top
of it is removing something from the work" (132). As noted in the pre-
ceding section, even those who gave a prominent place to the intel-
lectual experience often stressed the fact that cognitive processes
tended to come into play for them only after the work had made its
impact on a perceptual, emotional, or even decidedly visceral level.

The majority, however, felt that without knowledge, more was lost
in the encounter than a kind of naivete could possibly provide:

> Maybe it's too strong a statement to say that people who are
> totally untrained can't have an aesthetic experience, but
> generally, I think developing knowledge of technique and
> knowledge of the subject matter [is necessary]. For most
> modern people, mythological subject matter is completely
> lost. So they have very few grounds upon which they re-
> spond. I suppose people can have a kind of visceral response
> to a Gothic cathedral or the Sistine ceiling. But to proceed
> from that to a deeper understanding of technique, of the in-
> tellect behind the work of art, is for the most part learned. So
> awe is a more general response, but to really have the object
> hold for long periods of time, that's more a learned thing. You
> only see what you are taught to see. You have to be taught to
> see a certain amount before you can go from that and develop
> a more sustained and creative process of seeing. (417)

CLOSURE AND OPENNESS · Among those museum professionals who
placed relatively equal emphasis on the intellectual dimension, vast
differences in what we might call intellectual style were apparent.
Certain individuals, for example, employed intellect in the service
of achieving a kind of closure, while others used cognitive means to
open up works to more varied interpretations. Those curators who
were most concerned with closure seemed to stress the deliberate,

problem-solving aspects of coming to terms with a work, of understanding it completely and thoroughly, while those at the other end of the spectrum were enthralled by the number of new and unexpected ideas and insights arising from the significant aesthetic encounter.

Some of the curators for whom closure played an important role described what they sought from a work as meaning or understanding, broadly construed: "My reaction generally when I look at a work of art probably depends on whether I understand it" (113). Others were searching for information far more specific than that which can be described in terms of a generalized meaning or significance. "It's like solving a problem," another respondent noted, "an intellectual problem. Coming to a gratifying, operable solution" (104).

In such responses a desire is expressed "to get to the bottom" of something, to figure out a puzzle, a problem, a specific question. One curator aptly referred to such a process as "sleuthing" (108), another as "cracking the code" (106). Whatever the term, it constitutes an approach to a work of art that aims at the discovery not only of an artist's unexpressed meanings but of the work's own history, its place in the culture that produced it, and its function. Just as one can sleuth out secret messages hidden in the work, so one can sleuth out a work's history or nature. One curator, in discussing an Art Nouveau ewer, described such a mission:

> You can see that the object tells you all about itself. It's a ewer form, it's a pitcher. We know that it's made in a mold. You can see the mold marks under here, there, and right there. You can see it even coming through the glaze. When you think about what a pitcher is for, you can see how [in]efficient and [in]effective this would be as a pitcher. The lip is all curled up. Obviously it would pour in three different directions if you tried to pour anything. So it's not meant to be a pitcher to use in the conventional sense. It is a cabinet piece, a piece meant to be a decoration, meant to be looked at. So that suggests that it's not a conventional object, not

> mass-produced in the sense of pitchers of the porcelain
> works. There probably aren't going to be lots of these
> around. (108)

The stress here is upon categorizing a work, attempting to attach a label to it, to place it within a historical, art historical, or biographical context. While such an accomplishment was often in the service of developing a broader understanding or appreciation of a work, the satisfactions that the completion of such a task held in itself appeared to be as various as they were frequent. Some curators mentioned the importance of such discoveries for the field as a whole, and even more referred primarily to the collections with which they worked:

> R: It's extremely gratifying to get a beautiful object.
> I: In what way is that gratifying?
> R: Greed! [laugh] That's what you *want*, you want it, and you get it.
> It makes the collection better, the collection needs it. (124)

Others relished their experiences of mastery and accomplishment: "It's conquering the object, having the power over it, not allowing the artist to put something over on you or keep a secret from you. In a certain sense, I hate to admit it, but there is the sense of power, in having an insight, having information" (104).

For some, sleuthing after origins, meanings, or history was crucial to their appreciation of the work as a whole, so much so that if the object did not raise such questions or problems, or yielded up the answers too easily, the interaction with the work was thought to be a less satisfying one:

> A lot of pieces that you deal with are very straightforward,
> and you get them into shape and you don't find anything exciting about them, but there are pieces that have some sort
> of challenge; [they] are the ones that stay in your mind and
> are the most interesting. (113)

However, attempts to gain intellectual closure were not the only projects that engaged the intellectual resources of the curators. Many

stressed the importance of approaches leading to an appreciation of the complexity, inexhaustibility, and possibility inherent in the works rather than placing them within the bounds of one or another category. One curator described great works as "bottomless" (130), a sentiment echoed by many.

The following quotation illustrates one instance of how digging further into the history of a work can open it up, even, in this case, when it is not patently a great work of art:

> There was a sculpture that I was working on called *Hope Nourishing Love*. It's a three-quarter marble sculpture of a female allegory of Hope nourishing Love, who's this little winged putto hanging at her breast, so it's the allegorical representation of this. It's mid-eighteenth century, and it's real froufrou, and I thought, "Eeew, I don't like this." I thought the proportions were a little screwy and this winged putto was hanging in midair—how was he even attached to this breast? It doesn't make any sense at all, I just didn't like it. It is definitely part of this mid-eighteenth-century interest in veiled allegories of sexuality that's veiled into the loftier ideals of hope, that type of business, which I think is a little courtly game. Well, once I'd done a little work on it and understood a little bit more about the artist and the world that he was working in, a world with Madame de Pompadour, the lover of the king of France, Louis XV. What came out was this very human story that she was his lover, and she wasn't "putting out," and he wasn't very happy with her, so she was having allegorical representations made of her, maybe portraying her sexuality, but veiled definitely in the loftier ideals of hope and friendship. And I thought, "Gee, this is great fun, it's like reading the *National Enquirer*." It was human all of a sudden, and this object, it made it real to me somehow. And I got to like it after I did work on it. (407)

It is clear that no hard-and-fast distinctions can be drawn between such activities and the more closure-oriented, problem-solving modes

discussed above. Indeed, in terms of the model developed in the next chapter, it is obvious that a certain degree of closure constitutes the foundation from which questions can be posed, possibilities appreciated, and new elements discovered. Nevertheless, the importance placed upon the uses of intellect for such generative endeavors varied from person to person, as did the procedures, goals, and satisfactions involved.

Of the individuals who were oriented toward a search for new ways of thinking about particular works, some found their endeavors leading them to discover aspects of familiar works that they would not have appreciated or even noticed otherwise:

> This Rembrandt landscape drawing, just very small and very very delicate and very very refined and the tiniest little dots and strokes and bits of wash, and it's a small drawing to begin with. At first I thought, "Gee, that's a very good drawing," and every time I looked at it for a long time afterwards, I would see something more in it that I hadn't seen before, some element of subtlety, some particular relationship of the forms or the way they're calculated and worked out, the way the light is managed, the way the wind is shown and the way the trees are accentuated, whatever, that I hadn't completely appreciated the last time. It wasn't that I started out thinking "Gee, this is nothing," but I probably didn't start out thinking "Gee, this is a great great drawing." (410)

In addition to noticing more in the work itself, there were other open-ended approaches that stressed either other ways of looking at the whole object or entirely different ways of placing it in an intellectual context:

> I think the first time I saw it [a late Roman brooch], the impact was really greater, but now every time I come back and look at it I see it differently. The first time I saw it, I probably said to myself, "What's this?" And then I began to analyze it, the individual elements, "What's that brown material in the

middle? What's the gold? What's the glass?" But then I abstracted myself from that process of looking at the individual elements, and went back to seeing it as a whole, just as an object, focus my concentration on just the surprise or pleasure that something like this has survived, and that it is unique and that it has expanded my knowledge. I know every time I see it I still have a very positive response to it. (413)

So it seemed to me that modern studies were simply taking on the necessary responsibility of approaching art just as Renaissance studies had done, which is to put them [the objects] in the context of meaning and form and history and patronage. That everything that was applicable should be learned. So that's why I went off to do Matisse because I felt there was a lot that wasn't understood. There were a lot of problems. There were a lot of things that were either wrong or just hadn't been dealt with at all that seemed to be very critical. (103)

Several curators described the fruits of their efforts not so much in terms of the quantity of elements understood as in terms of the quality of their interactions. "I became aware of things in a much deeper and more comprehensive way than I had before" (103), one curator said, describing a memorable experience with a work. Another described a "return" to an openness that he had somehow lost along the way. Although the context and work are quite different, this passage deals with very avant-garde twentieth-century work. Note the similarity in form to the encounter in the previous section, where emotional impact was the primary vehicle for opening up different kinds of response:

I was very reluctant to open myself up to this stuff initially. In a way I was kind of worn down over a couple of days. I realized though, that I was playing it real safe in my own mind. I was saying, "Where's the representational art?" and I wasn't going to find it there, and I shouldn't have had the mind-set that I did initially. And I finally found myself really

enjoying it and really listening to the people who were talk-
ing about it. I really hadn't been giving it much attention,
but I finally realized the potential of this opportunity I was
having. I realized that I can't in good conscience say that
there is any kind of art (other than cowboy art) that I don't
like, or don't appreciate, or that I can't see any sense in, or I
can't have a response to. And that I just have to get out there
and involve myself to the degree that I can, and form those
judgments, ask those questions. And now I get a great deal
of enjoyment from that work. It was easy for me to say that
what I work with is the best. Well, it was only best in that
I'm most familiar with it. So I was kind of put in that position
where I was kind of re-turned-on to what it's all about. . . .
It kind of reopened that compartment in my thinking, that
it isn't all easy, that it shouldn't be. (130)

Others cited the fact that their openness to alternative ways of un-
derstanding works had brought home to them a sense of responsibility
for their own interpretations, allowing them to choose their accounts
of works from among a range of possibilities. They perceived this re-
sponsibility as both a freedom and a source of risk, a reminder of the
fact that their interpretations could be wrong:

I think that I like the quality of the verdict not being in. That
you look at it, and you're entitled to your responses, and
there isn't anyone out there telling you this is going to be im-
portant and this is not. There's a kind of open-endedness to
what's going on in the present that I like. (120)

Another respondent discussed the importance, and difficulty, of com-
municating this aspect to the public:

I was talking about different metaphorical allusions that
could be made to the work, and someone stopped me and
said, "Is this what the work means?" and I said, "Absolutely
not, this is just what *I'm* saying it means. It is totally up in

the air and no one can ever tell you what this work *means*. I can just hint that there is meaning here, and give illustrations of *possible* meanings." And she said, "Well, no one's ever said that to me before." She had just assumed that there was *a* way to do it, and that was that. And that it could be gotten wrong somehow. (132)

Regardless of whether the respondents felt that this flexibility enhanced the breadth or the depth of their understanding, their freedom or their responsibility, they often stressed the fact that such an open-ended strategy made them aware of the vast, if not limitless, possibilities for understanding the content and the context of works of art. They described the realization of the inexhaustibility of individual works with eloquence and, often, with great passion:

All those things make it interesting, because you have the object, and you read the object, and you get involved in the process, and you try to fit it into a career, or understand how it fits in a career. You have a larger social and intellectual context. And it's part of traditions, and oh! It never ceases to be fascinating. . . . And that work is incredible—no one's ever going to figure it all out, it's too great. (103)

So far we have examined approaches to art that could be termed intellectual or cognitive in nature, without specifying the range of material constituting the content of their thoughts, ideas, and discoveries. While all of the respondents made use of processes we would not hesitate to term intellectual, there was no consensus as to which intellectual contexts were necessary for understanding or appreciating a work, or even whether these contexts were always employed in an exclusively intellectual manner. While some individuals approached the objects in ways that might best be described as academic, others developed a broad understanding of a work through a sustained dialogue with it. The explicitly communicative aspects of their encounters will be discussed in a later section, but here we will examine a mode of interaction that seems to lie at the intersection of the purely intellec-

tual and the communicative modes. This is the mode we refer to as historical understanding. It groups together three of the most often discussed aspects of the encounter: the appreciation of a work historically, art historically, and biographically.

THE HISTORICALLY ORIENTED ENCOUNTER · Although frequent allusions to history were made by the museum professionals, the ways in which historical issues were woven into the fabric of their discussions varied enormously. One of the greatest sources of variation was that of the value of historical information: whereas some considered the historical context an essential part of their experience, others mentioned the object's historical context as an obstacle. The curator quoted at the beginning of the previous section (105) who considers intellectual information excess baggage was stressing her need to understand the object from her position in the present rather than concerning herself with the task of translating across time. This person showed a clear preference for work that has the capacity to speak to her directly, and she tended to focus upon works with which she shared a sensibility. She stressed her belief that those aspects of a work that give it its status as a work of art are, if not timeless, at least themselves not historically bound.

The majority of the museum professionals (nearly three-quarters of them) felt that achieving an understanding of a piece's place in the culture that produced it constituted an obstacle to a pure appreciation of a work, but an obstacle worth surmounting. While the struggle to understand a work's context offered certain satisfactions, the power of the timeless message inherent in a work constituted the end for which historical understanding was the means. A number of the curators lamented the general unwillingness of most people to attempt to understand a work in the context of its own language:

> People look at things and don't even recognize what's there. Certainly, they recognize that there is a cow and a farmhouse, if that's what it is. And so they see that in a sixteenth-century painting, and they think they know all about that

without knowing what that might have symbolized, or how
that fit into the society, or how that was culturally significant
at that time, and how that looked completely different—and
meant something different—to the sixteenth-century peas-
ant who might have had the chance to have seen the paint-
ing. But we have an immediate recognition, and we go, "Oh,
that's a farmhouse. That's a cow." And we think we know
about it, and we feel very self-satisfied. (112)

Perhaps the extreme version of the historical attitude is best repre-
sented in the following passage:

From an emotional point of view it's very satisfying to know
that, first of all, you are holding the past, basically. As I've
always said, I deal with dead people. I don't want to know
about living artists. From a purely academic point of view,
it's much easier if they're dead because they can't talk back
to you. So, everything that I deal with, the people who have
created it, are gone. So this is what remains of them. They
might have descendants, but what I have is the physical
proof of their existence in my hand. Not only do you have an
aesthetic reaction to it, but you have a sort of just a human
reaction to it. This is someone who once lived, and they
made this. (409)

The social and cultural context in which a work was created is an in-
tegral part of it, one that cannot and should not be slighted in appre-
hending the work at a later time. As one respondent noted, "The art
history is just as relevant, but for me, I think the social history might
be even more so" (129).

The majority of those who discussed the historical aspects of works
of art took this insistence one step further. For them, their encounter
with the work is significant precisely because of the historical dimen-
sion involved. They valued the work's historicity for many different
reasons and in many different ways, but all began with the premise
that art was an integrative activity in which the aesthetic dimension

Drug Jar (Albarello).
Italian (Faenza), circa
1520–1530.
Tin-glazed earthenware,
H: 37 cm (14⁹⁄₁₆ in.).
Malibu, J. Paul Getty Museum
84.DE.105.

Objects that were initially utilitarian, such as this
sixteenth-century drug jar, can provide what many
of our respondents characterized as "communication
with the past." Knowing that the subtle indentations
were meant to facilitate grasping the jars when they
were lined up next to one another on an apothecary's
shelves helps the viewer not only to visualize the ob-
ject in its initial context but also to grasp something
about the culture from which it comes with an im-
mediacy not usually evoked by simple descriptions.

either was not an end in itself or was in some sense inseparable from other factors that could be discussed and appreciated independently.

Some valued the work they discussed because of its power to evoke a time or a cultural context that was attractive, alluring, or fascinating. Several people spoke of valuing art for its ability to evoke the flavor of an era with which they identified:

> Actually, I love the nineteenth century because . . . it has the romantic appeal of the past, it's a very different kind of . . . experience. My involvement in nineteenth-century art history has a lot more to do with a broad range of things, from reading the literature, to imagining yourself romantically into the past. It's like being a young girl in high school who's a French major and wants to marry a French nobleman. It has some of that same kind of romantic appeal, which is very satisfying. (123)

A slightly different sentiment was expressed by those people whose fascination with the work's history was not so much based upon its ability to evoke the atmosphere of an era as to offer information from the past that was considered valuable in its own right, above and beyond the viewer's immediate experience. In such cases, the work of art was considered an artifact, a tool to assist in the development of a body of knowledge in the service of which the object took on its significance. As one individual put it:

> You can interact with a painting in the same way that you can interact with a document from the Florentine archives; you can use it as a source of information about life in Italy in the fifteenth century. And it's valid and it's a worthwhile and important and useful intellectual thing to do. I think there is a difference though; the difference between the archival document and the painting, which is also an archival document of a kind, is [that] the painting has the potential to jump the gap of time and offer these kinds of special experiences that to get from the archival document you'd have to look at

> it in the same way that you look at a sunset; in other words,
> you would have to become the artist, making it into art your-
> self. (416)

Another respondent agreed, in that he valued the historicity of the ob-
ject not merely for the aesthetic reaction it created in him, but also
because of what such works had to teach him about history. In his
case, though, it was not for the sake of historical knowledge per se that
the object's testimony was valued. Rather, he looked to the relation-
ship between the object and its historical context to provide a model
for his own personal understanding and growth. Here, the develop-
ment of art became a model for and a microcosm of a particular per-
sonal mission, and hence the lessons of history took on a specifically
personal application:

> I became more interested [in] ideas which were behind the
> objects—ideology, theory. And then the object became alive
> in a very different way. And today it is very much so that my
> own personality is being developed through my interest in
> history and trying to understand the historical development
> of certain social ideas, and specifically social reform move-
> ments . . . which today makes sense again because you can
> very much relate what's happening today to what happened
> in 1900. (110)

For some of the respondents, both of these processes were in-
volved. For them, there was a circular, almost hermeneutic, process,
wherein the work offered some key into the past, which led to a
rethinking of the context of the work, which in turn reopened the
work itself:

> I remember being just tremendously impressed by Claude
> Lorrain. And because I had been thinking about the ques-
> tion of installation and context, I was trying to think of those
> pictures in a seventeenth-century context. How would these
> pictures have been seen in the seventeenth century? I was
> saying, "Well, I know how I look at them, and I'm respond-

ing in terms of form and color, and I'm seeing these against
a background of art history and all." But then I started think-
ing, "Well, gee, these works were never installed like this as
a monograph. They were always there with dozens of other
works. People would have a few of these things rather than
a lot of them." And when I began to think of them in those
terms, to me, the works came alive in a curious sort of way.
It's a . . . it's a hard process to describe. (127)

A number of the above quotations highlight the fact that most re-
spondents concerned with the historical context of the object concep-
tualized this context in terms of the broad sweep of an era rather than
in terms of the narrower arena of art history in particular. When they
did make specific reference to the work's cultural or artistic context,
they often did so by way of the assumption that history in general was
at least representable by the history of culture, or else was not distin-
guishable from aesthetic history along any firm lines. Some individ-
uals, however, did stress the object's ability to represent the pinnacle
of a particular art historical style or period:

This piece is just terrifying. The Kouros is somehow ap-
proachable, and this piece is one of these things that you
really feel like you have to stand a distance away to really be-
gin to take in what you're looking at. It's like looking at the
Parthenon sculpture. This was created in such a short period
of time, and for just that period of time, they were able to
bring together everything. (408)

Such observations are reminders that an art capable of embodying
a given set of values, conventions, or techniques also is able to prop-
agate or to transform those values and conventions and to make its
mark within both the world of art and the larger society. It is this trans-
formational aspect of the work of art that seems, at least for a number
of the people we interviewed, to stimulate the historical aspect of the
aesthetic encounter.

In conjunction with a concern with either the procession of history

in general or the partially independent trajectory of art history in particular is the concern with the personal history of the artist. While this aspect shares many features with the previously discussed forms of the historically oriented encounter, it is also distinct enough to warrant separate discussion.

Just as no clear line could be drawn between historical and art historical considerations, so too no firm boundary separates the artist's personal history from the influence of his or her cultural milieu. Indeed, many museum professionals valued an artist's work precisely because of the artist's ability to act as an interpreter of a given time or social climate:

> [The painting] evoked an interesting sense of that culture through a more sophisticated, educated individual. . . . I think it's that ability of artists to relay their own personal experiences, or to relay, through their experience, some more general stand as an example or a part of society—contemporary, or humanity over a longer period of time or forever—which makes the most compelling and important work. (112)

In a slightly different vein, one respondent stressed not simply the artist's ability to be a skillful, refined, or insightful spokesperson for the issues of an age but stressed the artist's capacity to transform current social and historical ideas into a cohesive and innovative system. In this case, the artist was admired as much for breadth of involvement and integrative skills as for a sensitivity to the issues of the time:

> Art that I personally respond to . . . tends to be things that are visual representations, but have behind them a lot of conceptual and political and intellectual activity. And that the visual representations are really signposts to this beautiful machine that has been constructed that is unique on the earth and is not just a rehashing of visual elements but is really a new thought machine that an artist, through visual means and combining his eyes with his perceptions, has created. (106)

While several respondents noted these relations of the artist to history, others found the work to be significant within the context of the artist's own set of values and desires, that is, his or her intentions. Some indicated that their appreciation of works of art was enhanced when they sensed the artist's mission and the decisions that were made to create it. One curator spoke at length about how a knowledge of the artist's thought processes allowed her to see a whole new dimension in the object; her valuation of the work was at least partly a function of her understanding of the creative process itself:

> As you see that much of someone's work, you can see what they keep and what they leave out as they progress from one work to the other. And so, in a way, you learn about the process of selection, and you learn about what becomes very tiresome. I suppose in that way, it was learning about what you envision the artist's process to be, from what they told you about it. (125)

For some, the intention of the artist represented not only the key to particular works but to the aesthetic experience itself:

> I think the first issue is what was the aesthetic experience that was intended? See, all experiences aren't equally valid, and I think as the example of the Van Meegerens and the Vermeers pointed out, no matter whether we think we have independent aesthetic experiences or not, we don't. And it's important to know what Vermeer intended, it's important to know what Van Meegeren intended. If you don't know that, then I don't think you'll get an honest reading of what you're looking at. And for that reason I think it is important to understand the context, the purpose, why a person used a pen as opposed to a piece of chalk, and all of that. (410)

Many others, however, downplayed the issue of intention, and one person went so far as to suggest that such information was irrelevant for her approach:

> Can things take on meaning that transcends individual in-
> tention? Ultimately, that's what art should do, and that's
> what art history teaches you. You also ask the question:
> "What does the artist, what did the artist intend?" Very
> often you can't reconstruct that for past eras. Even if you can,
> you often discard, or take with a grain of salt, what the artist's
> original intention was, because a good art object . . . has to
> mean new things, it takes on new meaning with each
> generation. (123)

Emphasis here is placed upon the possibilities for interpretation that
can be opened up to those who are willing to discard the sometimes
rigid parameters to which a search after intentions can often be re-
duced—an idea to which we will turn in a later chapter. Nevertheless,
some of the testimony suggests that an approach taking into account
the intentions of the artist can yield interpretive insights.

Most of the references to a particular artist focused not upon the art-
ist's intentions or thoughts about the works but upon his or her biog-
raphy as the source for a meaningful context against which a given
work could be better understood: "You become involved in the quirks
and the overriding concerns of a great genius; it's very exciting" (126).
Interviewees who shared this orientation were interested in a given
object because of the appearance in the work of aspects of the artist's
personality, or because of its ability to give them insight into the art-
ist's life story. In instances such as these, creative activity represented
one element within a larger narrative. Interestingly, this type of in-
teraction was not only evoked by representational works but by the
works of the great abstract painters as well:

> If you stand in that room upstairs with the Pollock and the
> de Kooning and the Rothko, and you think about the fact
> that all those people knew each other, had dinner together,
> drank together, and believed that each work of art was the
> expression of their own independent personality—you look
> at those pictures and they don't any of them look alike, none

of them have any subject matter, and yet, you get a sense of personality. (120)

At times, the emphasis was placed on outside knowledge of a given artist's concerns and character or on a facility in reading the more obscure iconography present in certain works. In the following extended passage, we see quite clearly how a dialectic develops between the perceptual and iconographic aspects of the work, and the insights this curator derived from knowledge of this particular artist's biography:

> The first thing that appealed to me was the figural style, the strange pose of the man, who is Stanley Spencer, courting Hilda, his first wife. I knew from the title that it had to do with Stanley Spencer and Hilda, but again, the rather eccentric figuration, the compacting of the space, the fact that it's all chock-full of objects and bric-a-brac and these little ancillary figures [aroused] my curiosity about what it's all about. Why he's down on his knees to her, what exactly he's offering or proposing. It looks like a marriage proposal, but that doesn't quite work either, since they were married in the early twenties, and this is a painting from 1954. And then there's this curious present, in addition to the flowers, that he seems to be offering her, which looks a bit like a wedding dress. . . . As it turns out, what the picture is, really, is a recollection of Stanley Spencer's. They married in the early twenties and remained together for ten or twelve years. And then divorced and he married someone else. As it happens, however, he always remained, at least in his mind, married to Hilda. The other marriage didn't work out. . . . So, all of that I think made it richer and fuller as a consequence of knowing that. (122)

Some curators even supplied for themselves the details necessary to make a biographical reading possible:

R: So, I'm always attracted to paintings that tell stories.
 I: Mm, hmm. If there isn't a story provided . . . ?

R: Then I make one up. [Laugh] I make one up. A lot of times
it has to do with the artist's biography. Why was he inter-
ested in this particular image at this time? (104)

Some of the respondents recounted instances in which they be-
came acquainted with a living artist before they developed a famil-
iarity or sympathy with the artist's work. In these cases their interest
in the lives, personalities, or potentialities of the artists came first
and provided a ground for their later aesthetic interests, or their ap-
preciation for a given body of work was enhanced by personal contact
with the artist.

Such mentions of the artist stand in contrast to discussions by those
who looked to the biographical elements in the work per se in order
to learn about the artist's life and to evolve a richer understanding of
the work. Some of those people who expressed a particular interest in
the biographical aspects of artistic production went so far as to suggest
that they found it necessary to view a given object in biographical
terms in order to sustain an interest in it. The curator quoted below
was most interested in observing the myriad ways in which artists por-
tray themselves—their thoughts, emotions, and histories—through
the visual arts. This task, she notes, constitutes a challenge:

There is a lot of masking that goes on, evasive tactics taken
by artists who want only to deal with their work on the formal
level. I don't know if they're afraid of being discovered, or
afraid of exposing themselves to criticism, but they tend not
to talk about their works. They like to talk about paint ap-
plication and scale—and things like that don't interest me at
all; it's a very safe way of discussing a picture, you're not ex-
posing or attempting to expose anything about the artist. I
see it as a dead end. A real dead-end kind of approach. (104)

The result of meeting this challenge is an increased knowledge not
only of an artist's life but of the complex patterns of disguise and dis-
tortion that act upon personal experience as it is translated into an ar-
tistic work. The insights thus gained bear upon the understanding of

the artist's personality, either in its own right or as a model of human character. Here, aesthetic criteria are of secondary importance and are viewed as the means through which the artist's personal concerns are expressed. The viewer's ultimate task is to understand the painting in its role as a manifestation of the artist's psyche.

In the above instance, and in many others, biographical elements were presumed to be represented in some form in the work itself, and the curator's job was to discover them, and, through them, the meaning of the work. The artist's life is seen primarily as a resource to be used in understanding the work. Here, the intermingling of the various approaches is evident. Another curator described a process that is virtually the mirror image of this one, in which the work helped to develop an understanding of the life. The latter approach constitutes perhaps the most truly biographical one, for the work's content is considered to be secondary to the facts that the artist painted it at a certain time and place and that undertaking such a task had a given effect upon the course of his or her life:

> I think of that wonderful letter he [Vincent van Gogh] wrote to his brother. He is in the hospital, he says, "I look out of my window and I see this field with this tree in the middle of it. I'm doing a few drawings of that scene that I see." And then you think of the artist in the hospital. You think of this, you think of the hot sun pouring on that field. And all those things come together. It is a masterly work of art. (115)

This passage reveals that the respondent's primary interest is van Gogh's life and struggle to create art, which the work under discussion powerfully illustrates. It is the artist himself who matters here, who moves the curator to speak. Yet his appreciation of the works need not stop at the biographical level. In this case, the poignancy of the artist's life, as he looks out the window from his hospital bed, only enriches a viewing of the work.

The two approaches—searching for manifestations of the artist in the work and searching for the impact of the work upon the artist—can of course be undertaken independently, although they seem to offer

the richest understanding when seen as two sides of the same coin. Yet not all the museum professionals found these biographical dimensions to be important; indeed, one lamented the ease with which such approaches could be exploited for ends antagonistic to that of aesthetic understanding:

> Museums continue to perpetuate mythology, they tend to hype everything. So the artist is incredibly mad or incredibly gifted or the most influential or the friend of popes and kings. And in the process, people tend to mythologize the artist. Again, it's a mixing up of the two different kinds of experiences. And they can't see the painting for the artist. (112)

This curator's cautionary insight is well taken. Nevertheless, the respondents interviewed—herself included—have discovered numerous ways to turn the biographical context into a source of insight not only as an end in itself but as a tool to enhance aesthetic appreciation.

COMMUNICATION AS A DIMENSION OF THE AESTHETIC EXPERIENCE

Many of the respondents, reflecting on the events that took place when they encountered a work of art, described it as a process of communication. For example, one curator tried to emphasize the difference between the instantaneous reactions he had to specific aspects of a work and the continual exchange of thoughts and feelings that occurred over time upon exposure to the work. He summed this up by saying, "It's not just a blast, it's a dialogue" (115). He brought something to the work just as the work brought something to him. Another curator made the same point: "At least in my experience it isn't just this object that sits there, but it does have something to give to you" (101).

Communication with a work of art is, of course, often a multidimensional experience, one that integrates the visual with the emotional and the intellectual:

> I base things on what communication comes from the piece,
> whether it really communicates to me, whether there's a
> feeling coming from the piece. And that's very difficult to ex-
> plain, it's just your eye really that tells you. Your eye tells you
> what you feel about a piece and that determines the value
> you put on that piece. It's a very personal choice. (134)

For some curators the inability to establish this kind of rapport with a work made the encounter challenging, and therefore significant. When one woman felt that an artist was denying information, she felt the artist meant to do this, which for her reopened the lines of communication and she could reestablish rapport with the work. The dialogues that were described most often fell into three general categories: communication with an era or culture; communication with an artist; and communication within the viewer. Even when respondents did not explicitly refer to the process of communication or dialogue, most of them used metaphors such as "the work spoke to me," "it tells me about . . . ," or even "the museum absolutely sang to me." There were also many instances of referring to the intention of the artist by saying, "he was trying to make a statement about. . . ." The prevalence of this metaphorical language throughout the interviews indicates that the process of communication is an important part of the aesthetic experience.

Two modes of communication with an era or culture were distinguishable: one emphasized the differences between the past and the present, while the other emphasized the continuities. The first mode is exemplified by a woman in talking about her reaction to the "femaleness" of eighteenth-century art and the communication that takes place between herself and the artist:

> The nineteenth century is a very male century, and I was re-
> sponding to the femaleness of the eighteenth century. So
> what we [she and a male colleague] were fighting about had
> nothing to do with the works of art really, except that there
> were certain things there that were in the work, which pre-
> sumably were in the mind of the painter as well. Let's as-

> sume that the picture is an expression of him, as your re-
> sponse to it is an expression of yourself . . . and there's a
> kind of conversation through the ages. (120)

In this case an era or culture was embodied by a particular artist. As
her elaborations later in the interview made clear, her "conversation"
with this artist made it possible for her to span the real time that sep-
arated them. This particular curator used the communicative process
in order to appreciate eras that were very different from her own, and
perhaps it also enabled her to see the present era in a new light.

While the difficulties of communicating across the boundaries of
time are evident when considering the differences between certain
eras, other aspects of communication across the ages are based on sim-
ilarities, whether of symbolic intention and usage or on the simple
facts of its humanity:

> It is such a dynamic portrait that you know that that man
> really existed, you know that this is his likeness. The artist's
> work in cutting the die was so fine and so sensitive, you can
> see the contours of the face so well. You almost feel the por-
> trait breathe, the man is there and you'd love to be able to
> put it on show for people to see. (420)

Similarities at the symbolic level were emphasized by those respon-
dents who used mythological stories as vehicles of communication.
One person sustained a dialogue through the ages by investigating
and interpreting an artist's use of a particular iconography. Her knowl-
edge of mythology, iconography, and a specific artist's biography al-
lowed her to create stories that communicate the intentions of the art-
ist (though the artist may have existed in another era). Her storytelling
links together symbols from various cultures in an effort to maintain a
dialogue across the centuries. For this curator, an apple took on not
only those meanings we ascribe to it today but significances that have
been left behind by even the most distant cultures: "You know, an art-
ist takes an apple and paints it because it's round and it's a volume and

it's red, and all that. No. Apples, too, have meaning, you know. And, since Genesis [laugh], it's true" (123).

The second kind of dialogue did not necessarily cross the boundaries of time, but it did cross the boundaries of space. Several curators who described their interactions with modern works emphasized the sharing of feeling states or an understanding of an artist's work that could be achieved only through the process of communication. One woman described "the joy of sharing an experience . . . sharing some feeling states that have to be, that just have to be similar. But it's entering into communication with an artist and being there together in some way. It's wonderful!" (105). For her, as for many others, sharing did not always happen instantaneously. In fact, it was a challenge that required a lot of work.

> The challenge is to communicate, to put yourself in front of a work of art you've never seen before, and it's work, it's a lot of work to be able to enter into a dialogue with the artist, and to ferret out those things that you think that the artist is speaking about, and trying to get out to the public, and to know that you have some success in that, via this dialogue, is very rewarding. (105)

Another person who talked about communication was less concerned with the rewards and challenges of understanding a work. She described the process as one of "finding a soul I could communicate with in a world where people are so very different, and it's difficult to feel totally comfortable with very many people" (106). This woman was more interested in the quality of the dialogue.

> It is an experience of finding something that I can respond to at my most profound level, as a human being. And it's always the *quality* of the communication rather than what is being said, because, often, what is being said is really different. But the most direct quality of communication that this person has, either through luck or skill or intelligence or whatever—a combination of all those things—managed to embed

> himself or herself into an object or a structure or work of art,
> to the extent that he is, he has divided himself into a person
> and a network of art. (106)

Certain people responded to works of art without viewing the artist
as mediator. For some of them the most important aspect of encoun-
tering an object was relating to the world that was portrayed by the
artist rather than to the fact that a particular artist was making a state-
ment. In these cases the artist's intentions were bypassed as the work
was viewed as a reality that could pull you inside:

> [This still life is] just a wonderful painting, you can taste the
> oysters, you can smell the lemons, see that that eel is prob-
> ably just right out of the river. You can get a sense of that
> kind of a metallic, coppery taste of oysters. It's a very, well,
> I guess it's a *sensual* painting. (133)

One woman was fascinated by the possibility of substituting one
reality for another. Another spoke of using paintings "to dream with."
A third spoke of Edward Hopper's painting *Nighthawks*: "I want to
know what those people are doing next; I want to know where they
came from and where they're going" (120). At another point the same
woman stated that certain works make her feel that she would like to
inhabit the world depicted. These three respondents seem to be
viewing the work of art, at least partially, as a vehicle for stimulating
fantasy and imagination.

Others experienced a twofold process in which they allowed the ob-
ject to stimulate their imagination but then reflected upon themselves
as viewers. For example, one woman described her reaction to Cindy
Sherman's photography by simulating the internal dialogue that took
place as she viewed the work. This woman wondered, "What is she,
what is she doing? What is she about? But also, How am I? What's my
relationship to this? What role do I play as a viewer in this?" (107).

Such self-conscious reflection was also described by a man who saw
his interactions with works of art as important to the development of
his personality. Interacting with art had become for him a means of

questioning himself and his surroundings in order to obtain a greater understanding of different values. Here he describes this process of self-definition:

> I'm going more and more away from buying in a way. I'm more and more interested, for example, in showing, in relating different objects to each other so that you can understand an object by looking at the same object in different [contexts] . . . , in cheap/expensive, in good taste/bad taste, fun/not fun. So, and through making that clear to a person, those different values . . . this person starts getting to know things about, . . . themselves, because you're evaluating yourself—also you're defining yourself. (110)

It was also possible for works of art to stimulate the process of reminiscence or visual association. Although this type of experience was not reported frequently, it was a very important mode of experiencing for at least four of the respondents. Specific colors, shapes, or scenes could evoke certain feelings in them that were associated with memorable experiences. They were able to bring these associations into the dialogue they had with a work of art, thereby enriching their apprehension of the work.

> The feeling when you see that first robin in the snow, sitting in that hawthorn tree, the feeling of hope that might be generated by some little area in some painting just by the colors it might have. . . . Now if I stood in front of that painting, I might remember some sensation of that joy that I felt at seeing that tree of that color. But as living individuals we have so many experiences, so our possibilities, our potential, is so great for having those feelings. You know, the vocabulary is in there, the visual vocabulary, or the sensory vocabulary. Practically, you would almost think without end, hmm? (105)

The dialogue this woman just described does not take place at a verbal level, although she did find words for it. Throughout the interview she emphasized that her world was a *visual* world and her means

of communication was the visual/sensory vocabulary that she had developed in her lifetime. This sense of a visual, explicitly nonverbal, interaction with works of art was most forcefully stated by another interviewee:

> There is a certain danger in being too articulate about these
> things, which may have a certain satisfaction to it all of itself
> and may remove the art experience, the aesthetic response,
> from what the real aesthetic response is, which is, of course,
> silent. It has nothing to do with words at all. (129)

For a few respondents the process of visually experiencing a work of art led to a heightened awareness sometimes described as a loss of self or transportation outside the self. However, these people did not report being transported into the captivating reality depicted within the work as was the case with the woman who wanted to enter the world of Hopper's *Nighthawks*. "Where" they went is difficult to determine. Perhaps it is best to let them speak for themselves on this point:

> I think it absorbs, it involves all of the senses in a unifying
> manner. Art is primarily visual, but it heightens your sense
> of the other, the outside, the thing experienced, and in the
> process, heightens your awareness of yourself, and even
> though you're being fully absorbed and transported by an
> object perceived by the senses, you're losing yourself at the
> same time you become yourself. (123)

The loss of self described by this curator was expressed in different terms by one who spoke of being put on "a plane above things," where a work of art could give him "a sense of the absolute." Only great works of art could convince him in this way, however:

> There are [artists] who seem to raise the experience to some
> kind of—well, I'll use the word—spiritual [realm]. I'm not
> ashamed of it. Some kind of spiritual [realm], so that there
> is conviction in what they depict, whether it be landscape,

> mythology, gods, goddesses, heroes. It's just like Wagner
> . . . there are some times, especially during bad perfor-
> mances, you think "Oh, oh, oh, how silly it all looks," . . .
> and then you realize that these are gods, heroes, and he has,
> somehow his genius has surpassed all that funny make-
> believe and so forth and has reached this plane. It convinces
> you. Yes, this is the realm of spirit and conviction. (115)

The feeling of transcendence was also mentioned in relation to works that could completely engross the viewer. One curator relates that the sense of transport she feels with art parallels her experiences in nature. She contrasts works that can be intellectually, emotionally, and culturally interesting with works that have the quality of provid- ing that transcendence to another level.

> I know that I am committed to art as much as I am, and I ap-
> preciate good art works because I put it in this context of
> something transcendent, although that's impossible to de-
> scribe. It does have to do with this affirmation of a higher ex-
> perience, or a high order. That's all I can say. (123)

It is difficult to say whether the "high order" this woman speaks of is the same as the earlier "realm of spirit and conviction." Although one curator does not mention where this transcendent experience takes him, he is quite sure that it is out of the realm of everyday life:

> Very great objects give one a sort of a transcendent experi-
> ence. It takes you out of the realm of everyday life. You lose
> the sense of where you are and become absorbed in the ob-
> ject. When that happens, whether it's theater, or looking at
> art pictures, or reading a beautiful piece of prose, it moves
> you and transcends you. I think that's part of what art is. It's
> not common experience, it doesn't happen that often, but it
> does happen with regularity. (109)

These transcendent or outside-of-self experiences were not re- ported by every respondent. They were reported only by those people

who talked about very great works of art. Others explicitly stated that they never had experiences of a transcendent quality. These experiences must therefore be contrasted with another view of art that is encapsulated by the following passage:

> I don't think that I have religious experiences in front of works of art very much. I get very excited about things, but what I've found is that when you know a field, or know a group of objects, and have a certain interest in them, and one that you don't know comes along, that's really good, that's exciting. To see it for the first time and to know it for the first time extends your picture of possibilities within a given medium, or a way of making objects, or whatever. But then once you've incorporated that, it becomes part of your knowledge of the field, not that it's going to get worse as a work of art in your mind, but it maybe isn't going to be as exciting. I think this is a constant experience that I have or that any curator has. (402)

A middle ground between these two views is expressed by the following respondent, indicating that the two may not be utterly irreconcilable:

> The art world is not an ivory-tower world. I mean there's nothing in the art world that isn't somehow a reflection or a variation on what people consider to be the real world—politics and whatnot. So it's no escape. It's just a . . . I think a very . . . it's essentially a positive way of focusing on the world. (103)

The communicative aspects of the aesthetic experience have thus come full circle. We began with communication across the boundaries of time, from era to era or culture to culture. From there we looked at communication across interpersonal boundaries, that is, from artist to viewer or vice versa. Communication within personal boundaries took us into the minds of the viewers as they contemplated fantasy, past experiences, or their own development through time. Finally, we

concluded with the transcendent experience, which is as much an immersion of the self as it is a loss of the self in an ageless, perhaps timeless, realm of the absolute.

A literal-minded positivist critic might object that none of these experiences actually involves real communication, since they all take place only in the minds of viewers as they focus attention on the art object. But the fact that this interaction is purely intrapsychic does not make it any less real. That such experiences do exist provides convincing evidence for the capacity of human consciousness to transcend the limitations imposed upon it by objective conditions. With the help of information, imagination, and empathy, the viewer can in fact share the dreams, the emotions, and the ideas that artists of different times and places have encoded in their work.

SUMMARY

A welter of differing, complementary, and sometimes contradictory views on the aesthetic experience has been presented in this chapter, and that is as should be. Our attempt has not been to pigeonhole the exact nature of the aesthetic encounter but to point out some of the consistencies within the variation and to describe the crucial dimensions along which these encounters seem to vary. In the following chapter we briefly explore our findings a bit further, attempting to test this conception against a somewhat broader population.

One of the most cherished aspects of the aesthetic experience is that it expands the viewer's world by stimulating fantasy and imaginative reflection. Works of art suggest alternate realities beyond the audience's familiar world. Even after repeated encounters, a painting such as Hopper's *Nighthawks* can prompt a viewer to wonder what the people in it will do next, where they came from, and where they are going.

A Quantitative Analysis
of the Aesthetic Experience

THE INTERVIEWS with museum professionals provide support for the theory that the aesthetic experience is a specific form of that more general enjoyment people report when they become deeply involved with opportunities for using their skills—be they sensory, intellectual, physical, or emotional in nature. Like other kinds of flow experiences, encounters with works of art present feasible goals which can be reached by using and refining perceptual skills, a wide range of knowledge, and emotional sensitivity. The application of these skills to the challenges presented by the work of art results in a deep involvement in the transaction, which leaves the viewer in a state that is experienced as autotelic—that is, intrinsically rewarding.

In these respects what one feels when looking at a work of art is similar to the experience of a tennis player playing in a close match, a chess player competing in a tournament, or a surgeon performing a difficult operation. The specific aspects that differentiate the aesthetic experience from these other forms of flow include the obvious characteristics of the form of works of art—that is, the visual dimension—and perhaps more important, the fact that works of art serve as bridges for the communication of deeply felt experiences from artist to audience, from culture to culture, and from one historical period to later ones. These elements are unique to the aesthetic encounter and differentiate it from other enjoyable experiences.

The interviews suggested the unique quality of the aesthetic experience, but we wished to have more easily quantifiable data concerning the similarity between the aesthetic experience and other

forms of flow. This would allow us to answer such questions as: Do the majority of experts in aesthetics—here represented by museum professionals—actually recognize these structural similarities with the flow experience? Do they report that the challenges of the work of art are important, that the use of their skills is important, that setting goals and getting feedback are integral elements of the aesthetic encounter? And are there differences among experts in this respect, differences attributable to their age, sex, previous training, or present professional specialty within the field? Only by collecting more systematic information from a sample of museum professionals could such questions be answered.

THE PROCEDURES OF THE STUDY

SAMPLE · The museum professionals who had participated in the previous interviews, as well as a number of others not involved in the initial studies, were contacted and sent a short questionnaire which they were asked to complete and return by mail. A total of fifty-two questionnaires were returned, constituting 62 percent of the target population.

In order to find out whether various characteristics of the respondent influenced how he or she responded to the questionnaire, the following background variables were taken into account:

Sex: 50 percent males, 50 percent females;

Age: The sample was divided in four approximately equal groups: twelve respondents under thirty-four years of age; thirteen between thirty-five and thirty-eight years of age; thirteen between thirty-nine and forty-five years of age; and fourteen over forty-six years of age;

Level of education: Twelve respondents had a B.A. degree or less; twenty-four had an M.A. or its equivalent; and sixteen had doctoral degrees;

Academic fields: Respondents were educated as follows: ten were trained in fine arts, thirty-five in art history, and seven in other fields;

Experience: 25 percent had been working in the museum field for less than five years; 27 percent between six and ten years; 27 percent between eleven and seventeen years; and 21 percent for over eighteen years;

Current field of specialization: Historical art (in this case broadly defined as extending to the mid-nineteenth century) for twenty-three respondents, modern or American art for eleven respondents, and other fields for eighteen respondents; this last group included curators of photography as well as professionals in the education departments of the various institutions;

Positions: The respondents occupied the following positions: fifteen non-curatorial staff (generally in education departments); eighteen assistant curators; thirteen curators; three assistant directors; three directors;

Institutions: At the time of the survey, twenty respondents worked at the Art Institute of Chicago, twenty-one at the J. Paul Getty Museum in Malibu, and eleven in various other smaller museums in the Chicago area or as curators of corporate art collections.

 Given these characteristics, the sample seems to be reasonably representative of experts working in the museum field. It was important to get a broad representation in terms of such variables as age, sex, education, and occupation in order to answer the question as to whether the aesthetic experience is reported in similar terms by experts regardless of their background and specialty, or whether the structure of the experience varies according to perspectives conditioned by background variables.

INSTRUMENT · The questionnaire consisted of three parts (see Appendix B). Part A simply asked for respondents' backgrounds and current professional responsibilities. Part B included fifteen items describing different dimensions of the aesthetic experience. Respondents were asked to indicate whether, on the basis of their own ex-

perience, each item was "never true," "sometimes true," or "always true," on a 1- to 5-point scale (1 equaled "never true," 5 "always true"). Part C asked respondents to indicate whether they agreed or disagreed, on a 6-point scale (6 indicating the most agreement), with seventeen items concerning "opinions about art."

The items constituting parts B and C of the questionnaire were derived largely from the interviews reported earlier. They were intended to tap as broadly as possible the structure of the aesthetic experience (in part B), and in part C the various approaches to works of art, namely the perceptual, the cognitive, the emotional, and the communicative approaches, which had emerged as important from the analysis of the interviews.

THE STRUCTURE OF THE AESTHETIC EXPERIENCE

When the answers to part B of the questionnaire were analyzed, it became obvious that the respondents endorsed very strongly those items that reflected the similarity between the aesthetic experience and flow. The importance of challenges and skills, of clear goals and feedback, of transcendence of the self in the encounter with works of art was generally recognized. In terms of the dimensions of experience, it was unanimously agreed that the aesthetic transaction included at least three of the four main elements: feelings, visual processes, and factual knowledge. The importance of communication was not as widely endorsed, perhaps in part because of the poor wording of the item.

The unanimity among the responses was the most impressive aspect of the results obtained with this part of the questionnaire. It was as if the many respondents had agreed in advance among themselves how to answer the various questions. Neither age, nor sex, nor previous training, nor present specialization made any difference in the weight given to the various items. This unanimity in describing the aesthetic experience is especially noteworthy when compared to the sometimes quite sharp differences in the answers to part C, where,

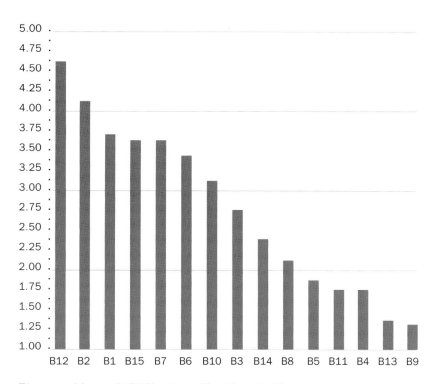

Figure 1. Means of "B" Variables—Total Sample (N = 52)

as we will see later, background characteristics play an important role. It appears that while the structure of the aesthetic experience tends to be universal, whether the approach to the experience is primarily based on knowledge, on emotion, on perception, or on communicative elements is much more variable and dependent on background factors.

THE IMPORTANCE OF CHALLENGES IN THE AESTHETIC EXPERIENCE
Three of the fifteen items in part B of the questionnaire were intended to measure whether or not challenges were relevant to the aesthetic experience. Of these, item B12, "The final word is never said. A good painting will never be used up," was the one item most strongly endorsed by the sample (see Figure 1).

The mean response on this variable was 4.6, as close to "always

true" as any of the items scored. Every subgroup rated this item highest (see Figures 2–4). Curators endorsed it somewhat more strongly than directors and assistant directors; and older respondents more than younger, but the differences were not statistically significant.

The next item measuring challenge was B1, "The pieces that have some sort of challenge are the ones that stay in your mind," and this too was strongly endorsed. Its mean score was 3.7, the third most highly rated item, close to "often true." The respondents with B.A.'s were more likely to endorse this item than were the holders of higher degrees.

The third relevant item was B8, which measured challenge in a reverse fashion: "After thirty seconds' worth of looking, I have absorbed what it has given me." Respondents were expected to disagree with this item, and in fact the mean score on it was 2.3, or slightly above "occasionally true." Curators of modern art endorsed it somewhat more strongly than those of historical art, the corporate curators more than the staff of the Getty Museum, and holders of B.A.'s more than Ph.D.'s, but none of the differences were significant.

This pattern of response suggests that all experts agree that for a work of art to provide an aesthetic experience it must carry a complex load of information for the viewer to unravel. There seems to be a slight trend among people with more training, more experience, an involvement with premodern rather than modern art, and more curatorial responsibilities to agree with the importance of this dimension more strongly, although challenge appears to be so crucial to the encounter with art that the differences in this respect are minimal.

THE ROLE OF SKILLS IN THE AESTHETIC EXPERIENCE · Three of the fifteen items were designed to measure the importance of skills in the transaction with art objects. Of these B2, "I trust my own personal opinion," was endorsed very strongly, second highest in the whole set of items. The mean score was 4.1, or a little above "often true." Directors and assistant directors felt slightly surer of their judgment than the curatorial staff, the older more than the younger respondents, but

again the consensus was so strong that none of the possible contrasts between groups approached statistical significance.

Disagreement was expected with the second skill item, B11, "I am often afraid of not making the right response." In fact, the mean score on this item was 1.6, or half-way between "never" and "occasionally true." A very slight but insignificant advantage appeared in favor of curators of modern art, and of older respondents.

The third item dealing with skills was B4, again worded in a negative direction: "My knowledge and training are kept out of the aesthetic experience." This item was the second lowest ranked of the set, with a mean of 1.3, or very close to "never true." The higher the respondent's academic degree, the more likely he or she was to disagree with this statement.

Contrary to what the lay opinion might hold, experts consider the use of skills an integral part of the aesthetic experience. They have confidence in their opinions, in their ability to respond to the challenges of the work of art. The aesthetic experience is not a gratuitous epiphany; viewers must bring their knowledge and training to the encounter with the work of art.

SETTING GOALS FOR THE AESTHETIC EXPERIENCE · The interviews suggested that experts often set specific goals when examining a particular work of art—for example, making sure that the piece is an original, or dating it, or establishing its place in the artist's oeuvre. Clarity of goals is a condition for flow experiences in general, but is it really a widespread characteristic of encounters with works of art?

Two questionnaire items were intended to measure whether setting goals was seen as part of the aesthetic experience. One was endorsed quite strongly by the expert respondents, but the other was answered in a way that upset expectations—one of only two such items among the fifteen. Upon further inquiry with curators who had completed the questionnaire, it seems that the wording of this item had been confusing, which might have accounted for the way it was answered.

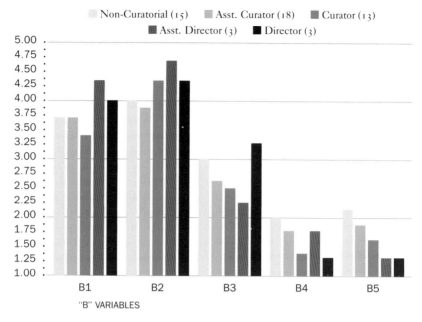

Figure 2a. Mean Level of Response to Items Describing the Aesthetic
Experience by Curatorial Rank

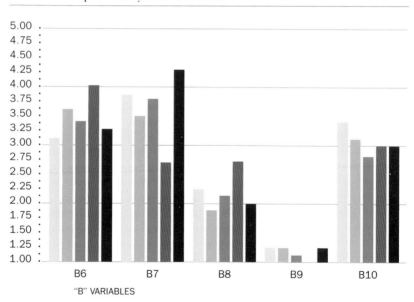

Figure 2a. (continued)

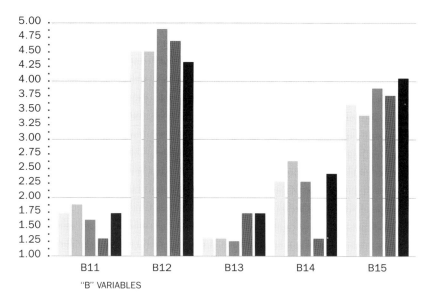

Figure 2a. (continued)

Item B15, "I have a rather clear idea of what to do when approaching a work of art," was the fourth most strongly endorsed item, with a mean of 3.6, closer to "often" than to "sometimes true." Directors endorsed this statement most strongly, assistant curators the least. Respondents trained in fine art rather than art history and those involved with modern as opposed to historical art were more likely to endorse it, yet again the differences among groups were too slight to reach statistical significance. The general agreement with this item would indicate that experts in the field tend to set goals for themselves before they have an aesthetic experience.

The next item measuring goals was B7, "In approaching a work of art, I never set some goal or objective I wish to achieve through the experience." We expected that respondents would disagree with this statement. Instead, its mean score was 3.6—as high as B15, the other item measuring goals, despite the fact that the two were intended to have been worded so as to be mutually exclusive. Because this was the only contradictory finding in the entire questionnaire, we pursued its

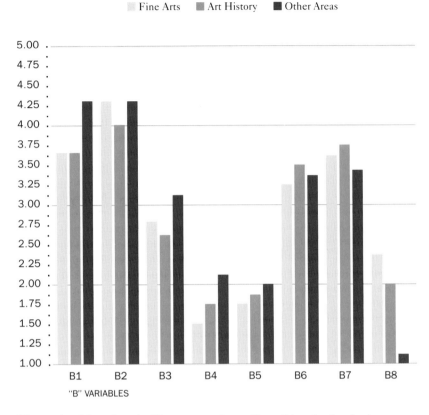

Figure 2b. Mean Level of Response to Items Describing the Aesthetic
Experience by Field of Training

meaning with a group of respondents. They told us that the item was
confusing in that it implied agreement with an approach that treated
the experience with a work of art simply as a means to some other
goal, which had certainly not been the meaning intended. Their point
was well taken, and we prefer to think that the unexpected result is
due to a faulty formulation of the item rather than to inconsistency
either in the theory or in the responses.

Despite the lack of clarity on this issue, we might conclude that set-
ting goals for the aesthetic encounter is an integral part of the expe-

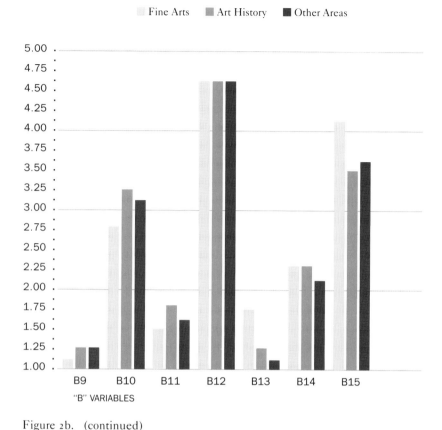

Figure 2b. (continued)

rience of experts confronting works of art. It is likely that the inability to have an aesthetic response is often the result of a lack of goals in the aesthetic encounter. Most people, when confronted with a work of art, simply do not know what to do. Without a goal, a problem to solve, they remain on the outside, unable to interact with the work. They do not even know what responses to make, what emotions might be appropriate to have. It is true that an idealized version of aesthetics claims that beauty will move the members of the audience regardless of their inclination, almost against their will; according to this belief viewers are passive recipients of the aesthetic message who

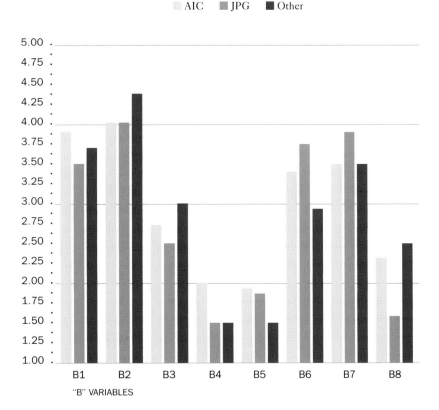

Figure 3a. Mean "B" Variable Scores by Institution

will be affected by what they see regardless of their prior knowledge or disposition. Needless to say, the present perspective disagrees with that position.

THE PROCESSING OF FEEDBACK · Enjoyable activities are character-ized in part by the constant awareness of whether or not one's actions are approaching the goals set at the beginning of the activity. For in-stance, the tennis player receives information instantly after each shot about how well he or she is doing; the surgeon knows how well the op-eration is proceeding; and the musician hears the notes as they are played and knows whether they sound as they should. This constant

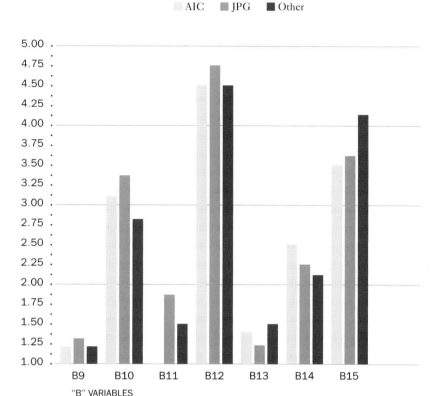

Figure 3a. (continued)

feedback forces attention to be focused on the activity to achieve the depth of concentration that is so integral a part of the flow experience. But is this common feature of what makes an activity enjoyable also present in the aesthetic encounter? There are reasons to doubt it, since the work of art is a static, passive target, and hence unable to give feedback to the viewer in any obvious way.

The interviews with museum professionals suggest, however, that experts are able to confirm their hunches during the aesthetic encounter. The expert viewer is able to direct feelings, thoughts, or perceptual impressions at the work of art, which then bounces back information and thus provides feedback to the viewer's initial reactions.

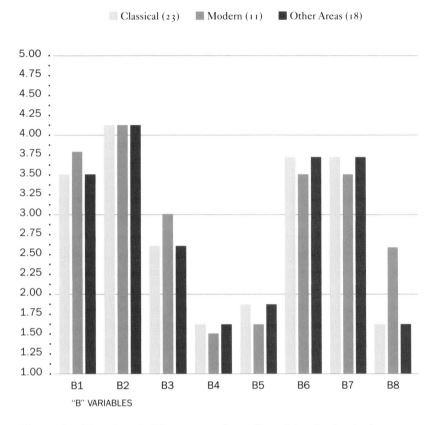

Figure 3b. Mean Level of Response to Items Describing the Aesthetic
Experience by Area of Specialization

There is nothing mysterious about this process: in the same sense one
might say that a rock gives feedback to the geologist who is testing its
composition, or that stars give information to the astronomer who is
analyzing their light.

In the questionnaire, we included one item to measure whether
feedback was in fact an important part of the aesthetic experience. It
was B6: "After I have a reaction to an art object, it is important to be
able to check my first impression through further 'tests.'" Despite
the rather scientistic-experimental formulation of this item, it was
quite strongly endorsed by the sample, receiving a mean score of 3.4,

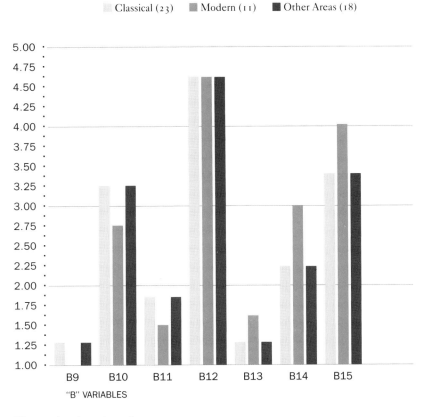

Figure 3b. (continued)

or about half-way between "sometimes" and "often true." No significant differences by subgroup were noted, although holders of Ph.D.'s tended to endorse this statement slightly more than other respondents.

From this it might be concluded that the ability to generate feedback is a relatively important but apparently not necessary element of the aesthetic experience. In this context we should like to make a point about the questionnaire in general, in order to place these and the other results in their proper perspective. No one, and especially not people whose professional lives revolve around art, would be expected to check statements concerning art as "always true." In fact,

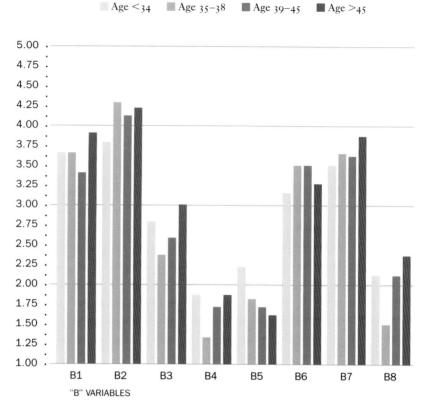

Figure 4a. Mean "B" Variable Scores by Age Group

not even physicists would say that the most basic experimental conditions in physics were "always true." The extremes on a questionnaire scale serve as points of reference; they are expected to be used only very seldom. Thus when an item is scored as being on the average "often" true, we might take it to mean that it is seen as an important dimension of the experience in question.

THE TRANSCENDENCE OF SELF AND OF EVERYDAY LIFE · Deep involvement in any activity causes the participant to feel that he or she has been transported into a realm of experience that is different from normal life. The sense of self tends to disappear as a person is caught

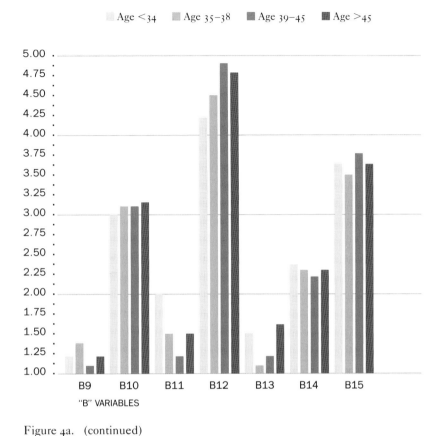

Figure 4a. (continued)

up in the action, and the confusing cacophony of everyday life is filtered out, leaving a well-ordered, manageable world in which to act. This is the feeling of the musician enveloped in the sounds of her performance, of the mountaineer engaged in the restricted world of his climb, and presumably of the viewer confronting the form of reality created by an artist.

Certainly the interviews suggested that transcendence of the everyday was an important aspect of the experts' aesthetic experience. To ascertain how important this was, we included two items in the questionnaire. Item B5 was worded, "Art is the affirmation of concrete reality and should not be aiming at any 'higher' order or expe-

rience." It was expected that respondents would disagree with this statement, and in fact it was scored on the average 1.7, or less than "occasionally true." Curators of modern art and older respondents were especially likely to disagree with the statement. The second item was B10: "Art gives a sort of transcendent experience that takes you out of the realm of everyday life." The mean score on this was 3.1, or slightly above "sometimes true." Art history majors, curators of premodern art, older respondents, and holders of Ph.D.'s tended to agree with this statement, but as with all the items in part B of the questionnaire, not to the extent of reaching statistical significance.

These results confirmed our expectations, even if not as strongly as anticipated. In any case, experts tend to agree with the transcendent nature of the aesthetic experience. Further in-depth inquiry into this matter definitely seems warranted.

CAN ANY OF THE DIMENSIONS OF THE EXPERIENCE BE LEFT OUT?
The interviews had made it clear that encounters with works of art involve several discrete dimensions of consciousness. Some experts emphasized the formal aspects of works of art and therefore the visual qualities of the experience. Others stressed the importance of emotions and claimed to respond most to the feelings embodied in works of art. Still others mentioned the importance of thinking as a means of enjoying the aesthetic experience. Finally, communication with the artist, the culture, or the historical period seemed the most important component of the interaction with works of art for some experts. The question was whether these approaches are mutually exclusive, or whether they are all involved to a greater or lesser degree in every encounter with works of art.

The questionnaire results suggest the latter alternative. Four items were designed to determine whether experts would agree with statements to the effect that visual qualities, emotional content, communication, or thought could be removed from the aesthetic encounter. Two of the four items were unanimously rejected, indicating that feelings and visual qualities are necessary to the aesthetic experience.

The item suggesting that thought is dispensable was also rejected, but not as strongly, presumably because its wording was ambiguous. Finally, the item assessing the importance of communication was not endorsed, but the wording here was so extreme that it might have caused respondents to hesitate to agree with it.

Item B9 read: "Feelings have no place in my encounter with the art object." The mean score was 1.3, or as close to "never true" as for any of the fifteen items. Respondents trained in the fine arts and curators of modern art were especially adamant in rejecting this statement. Item B13 was: "The purely visual qualities of the art object are relatively trivial and have little impact on the aesthetic experience." The disagreement with this statement was almost as total as with the previous one, for a mean score of 1.4. Respondents trained in art history, curators of historical art, and older respondents were most likely to disagree with it. The pattern here is clear: experts agree that both feelings and visual qualities are indispensable to the aesthetic experience.

The next item was B14: "In the course of the aesthetic experience, it is difficult to know whether one's thoughts or feelings are relevant to the work encountered." The mean score here was 2.3, or slightly above "occasionally true." Unfortunately this statement was not as well formulated as the others. Because it combined "thoughts" and "feelings" in the same sentence, it is not a clear test of the rejection of the knowledge-based approach to art. The importance of communication was measured by item B3: "Sooner or later I get to know exactly what the artist meant to convey in the work." The average score on this item was 2.2, or just above "occasionally true." In this case, the word *exactly* was apparently too strong for most people to agree with the statement. When we spoke to a group of curators after the questionnaire had been completed, they confirmed that it was the extreme wording that kept them from agreeing with this statement more.

Emotional sensitivity, visual training, knowledge of art, history, and culture, and empathy for what artists communicate—these are the

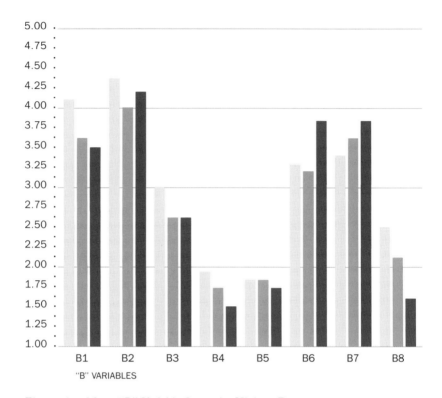

Figure 4b. Mean "B" Variable Scores by Highest Degree

basic skills that experts use to decode the information embedded in works of art. The analysis of the questionnaire responses suggests that experts feel that at least two of these, feelings and visual skills, are necessary for the aesthetic experience to occur. The evidence for the indispensability of knowledge and communication is less conclusive, but this might be due in large part to a weakness in the questionnaire itself.

CONCLUSIONS ABOUT THE STRUCTURE OF THE AESTHETIC EXPERI-ENCE · Part B of the questionnaire strongly confirms that what experts mean by the aesthetic experience resembles in crucial ways the in-

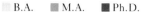

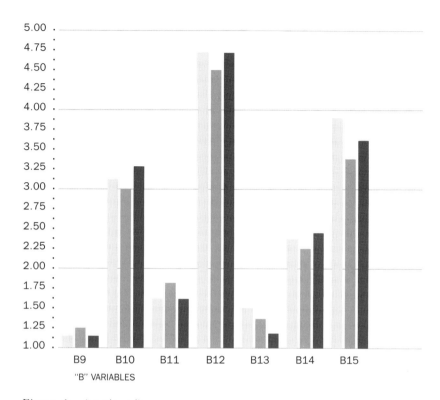

Figure 4b. (continued)

trinsically rewarding, autotelic state of consciousness identified in other contexts as flow. The answers of the fifty-two respondents agree very strongly that the perception of challenges in the work of art and the use of skills in responding to it are very important dimensions of the aesthetic experience. The skills involve sensitivity to feelings incorporated in the work, ability to analyze visual qualities, and—less clearly established by this part of the study—they involve knowledge and communication with the artist.

Like other flow experiences, confronting a work of art involves setting clear goals and receiving feedback from the interaction with the work. And the interaction is felt as going beyond the experi-

ence of everyday life, as being a more ordered and more intense form of living.

A few discordant notes marred the harmony of this scheme. Three of the fifteen items appeared a posteriori to be flawed. Items B3, B7, and B14 were either ambiguous or worded too strongly, therefore making it difficult to assess what respondents thought about the importance of setting goals, of knowledge, and of communication in the aesthetic experience. No empirical investigation is perfect, and one can learn from mistakes as well as from successes. In this case, future studies should focus especially sharply on these three issues to establish whether they are indeed as important as the others.

In many ways the most startling aspect of the findings was the unanimity in the pattern of responses. There were only minimal differences by subgroup such as age, gender, position, previous training, and current specialization. Apparently none of these variables influences how one experiences an aesthetic encounter. In other words, the structure of the aesthetic experience seems to be universal: regardless of one's background or approach to art, what matters when one faces a work of art is to use formal and emotional skills, within a context of goals and feedback, to unravel the complexities of the work. When such conditions obtain, the state of consciousness that transcends ordinary life that we call the aesthetic experience takes place.

As we will see in the next section, this unanimity no longer holds when experts are asked to express their opinion about the relative importance of various approaches to art. When asked which dimensions of art they pay most attention to—or, which of the challenges contained in a work of art they respond most readily to—experts give different responses depending on their background and present involvement in the field. Thus while the structure of the aesthetic experience appears to be essentially similar regardless of the person who does the experiencing, the content of the experience will vary depending on the person's skills and therefore on the kinds of chal-

lenges the person is sensitive to in the work of art. Whether a person will respond most to the colors in a painting, or to the art historical puzzles the painting presents, or to the emotional tensions it contains, depends to a large extent on how the person was trained, what his or her age is, and on what the professional responsibilities are.

THE FOUR MAIN DIMENSIONS OF THE AESTHETIC EXPERIENCE

The interviews and part B of the questionnaire as reported in the previous section suggested that the major challenges presented by works of art (cognitive, communicative, perceptual, and emotional) are indispensable to the aesthetic experience. But are these challenges equally important, and do different experts see them as having the same importance?

To answer these questions, the responses to part C were grouped into four clusters, first to see whether any of the dimensions of the aesthetic experience was preferred over the others, and then to see whether the experts' backgrounds made a difference as to which type of challenge they responded to most.

It was found that the four dimensions of the aesthetic experience were all strongly endorsed by the sample. Although knowledge was rated slightly higher than the other approaches and emotion slightly lower, the differences were very slight. However, there were strong disagreements among the experts about how important they deemed these dimensions to be. The greatest differences related to the relative importance of communication, knowledge, and emotion. There were no statistically significant differences concerning perception or the formal qualities of the work.

The curators' gender made no difference—men and women responded very similarly. But age, type of training, highest degree earned, and present professional position all influenced a respondent's opinion about art. Most influential were the variables indexing the experts' current professional activity: What institution individuals

work in and what their current professional responsibility is best predict whether they think that knowledge, communication, perception, or emotion is the most important dimension of art.

It follows that while experts in the field of art share the same phenomenological response to the works they encounter, they do so for different reasons. The statement "This is a great work of art" might mean something quite different depending on who says it. One person's response could be based primarily on a visceral emotional reaction, while that of another might reflect mainly an art historical appreciation. Yet the underlying experience would be described in both cases in very similar terms.

THE FOUR CLUSTERS · To establish the importance of the four dimensions of the aesthetic experience, the items in part C of the questionnaire were combined in the following clusters:

Knowledge · Item c1: "You can get so filled up with knowledge that you don't have time for a genuine response to the work" (score reversed).

c6: "The more information you bring to a work of art, the more interesting it is going to be."

c9: "I don't need to be confronted with a new way of seeing or of understanding the world in order to have an aesthetic experience" (score reversed).

c16: "Knowledge of the historical and biographical background of an object generally enhances the quality of the aesthetic experience." The scores on these four items were added up for each person (after reversing the negatively worded items), and then divided by four, to obtain a mean knowledge score. The individual mean scores were then averaged for the sample as a whole and for the different subgroups to be compared.

Communication · Item c2: "The object must contain the inherent beauty created by the artist."

c5: "A great work of art represents the ferment and energy of a whole age."

c8: "Art must be made by people, because the communication of human experience is an essential aspect of the aesthetic encounter."

c14: "A great work of art helps the viewer share the sensibilities of people from other ages, other places."

Responses to these four items were averaged for each person to get a mean communication score.

Perception · Item c7: "Great art can be appreciated simply along a visual dimension; knowledge and feelings sometimes get in the way of experience."

c10: "Objects often seem to reach out and grab me; the aesthetic experience sometimes is like being hit in the stomach."

c15: "Formal qualities, like balance and harmony, are often irrelevant to the quality of a work of art" (score reversed).

These three variables were averaged as above to obtain a perception cluster score.

Emotion · Item c4: "It is sufficient for me to respond with emotional feelings to a work of art to satisfy my appetite for beauty."

c12: "The works of art I like do not necessarily stimulate an emotional response in me" (score reversed).

The average of these two items yielded an emotions cluster score.

THE RELATIVE IMPORTANCE OF THE FOUR DIMENSIONS · When the four ways of approaching works of art were compared with each other in terms of the scores experts gave the four clusters, each one of them was endorsed (see Figure 5). The sample as a whole rated the knowledge cluster highest: 4.2 on a 6-point scale, or "true." Two other clusters were also closer to "true" than to "untrue": communication (4.0) and perception (3.6). Emotion (3.5) was rated on the average exactly between "true" and "untrue."

One might conclude from these results, at least provisionally, that for this sample the knowledge content of a work of art is more impor-

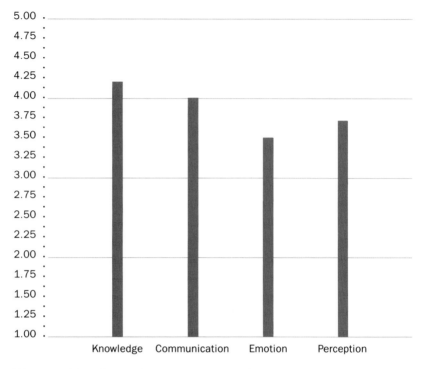

Figure 5. Mean Level of Endorsement of the Four Dimensions
of the Aesthetic Experience Total Sample (N = 52)

tant than its emotional impact. A certain caution in interpreting these results is in order, since they could be based on differences in the wording of the items in the four clusters rather than in the underlying dimensions they were intended to measure. This caveat does not apply, however, to the next set of findings.

The Knowledge Dimension · Do characteristics of museum professionals influence whether they see knowledge as being a relatively more or less important aspect of the aesthetic encounter? Figures 6 through 9 report how different groupings of the respondents rate the importance of knowledge. When an analysis of variance (ANOVA) is applied to the data, it indicates that three of the seven contrasts are statistically

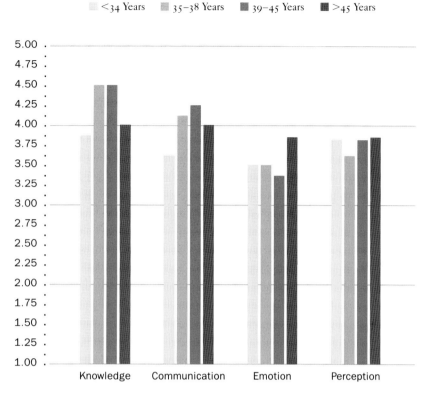

Figure 6a. Endorsement of Major Dimensions of the Aesthetic Experience by Age

significant. Following the usual conventions in reporting the results of statistical analyses, the significance of a finding will be illustrated by its probability value, or *p*. The p-value indicates the probability that a particular result could happen purely by chance. Thus, the smaller the p-value, the more likely it is that the results are genuine. When $p < .01$, there is less than one chance in 100 that the result is due to random chance; when $p < .05$, there are less than 5 chances in 100. Therefore the $p < .01$ finding is more solid than the $p < .05$ finding. A result is usually considered to be statistically significant when the probability of its random occurrence is less than .05, although p-values as high as .1 (or 1 in 10) are accepted as marginally significant.

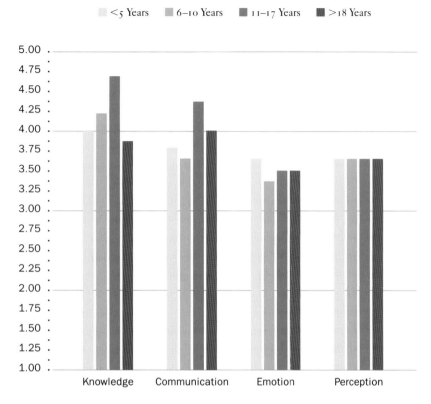

Figure 6b. Endorsement of Major Dimensions of the Aesthetic Experience by
Years in Curatorial Field

In this sample, the largest difference in the rating of the knowledge cluster (ANOVA p<.01) is due to field of specialization, with curators of premodern art endorsing the importance of knowledge most (Mean=4.5), curators of modern art endorsing it least (3.8), and the non-curatorial staff being in the middle (4.1) (see Figure 8a). The second largest difference (ANOVA p<.05) is due to age, with persons in the middle two age cohorts (35–38 years and 39–45 years) rating knowledge as more important than either the younger or the older age groups (see Figure 6a).

The third difference, that of borderline statistical significance

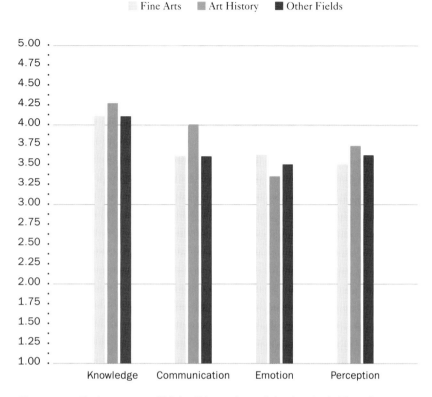

Figure 7a. Endorsement of Major Dimensions of the Aesthetic Experience by
Field of Training

(ANOVA p<.07), is based on level of education, indicating that hold-
ers of Ph. D.'s are more concerned with knowledge (Mean = 4.6) than
either people with M.A.'s (4.1) or B.A.'s (4.2) (see Figure 7b).

These results are in part consistent with what one might expect:
higher education and a specialization in premodern art should indeed
develop skills of a particular type, valued by the academic commu-
nity, which in turn might predispose the viewer more readily to rec-
ognize challenges based on knowledge. The age trend is more puz-
zling: why should the younger and the older respondents be less
interested in knowledge?

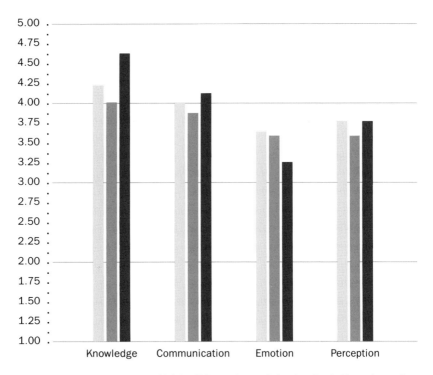

Figure 7b. Endorsement of Major Dimensions of the Aesthetic Experience by
Highest Degree Earned

Communication · Six of the seven contrasts that involve this cluster show statistically significant differences. Thus it would seem that the valuation of the communicative potential of works of art results in the largest divergence of opinion among experts in the museum field.

The largest difference (ANOVA p<.004) is due to position, or to the respondents' specialized function within the museum (see Figure 9). As one would expect, the non-curatorial ranks, largely composed of the museum education staff, believe that communication is an important part of the aesthetic experience (Mean=4.4). To a lesser degree, this belief is shared by assistant curators and curators (3.8 and 4.0). Assistant directors and directors of the same institutions,

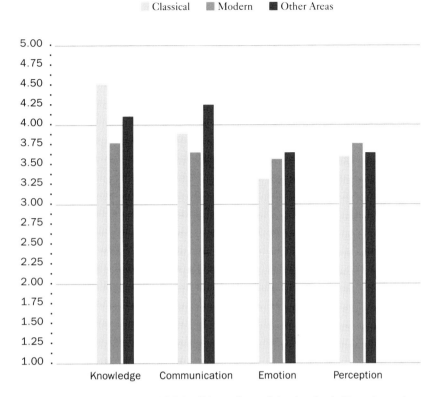

Figure 8a. Endorsement of Major Dimensions of the Aesthetic Experience by
Area of Specialization

however, rank the importance of communication quite a bit lower
(3.6 and 3.3).

The next most significant difference (ANOVA p<.009) is attribut-
able to the institutional milieu in which the experts work (see Figure
8b). In descending order, communication is most highly regarded at
the Art Institute of Chicago, then at the Getty Museum, then at the
corporate galleries studied. Strong effects were also shown by years in
field (p<.01, Figure 6b) and age (p<.03, Figure 6a). The older and
the more experienced the curator, the more he or she believes in the
importance of communication.

Field of training is also relevant: those trained in fields grouped un-

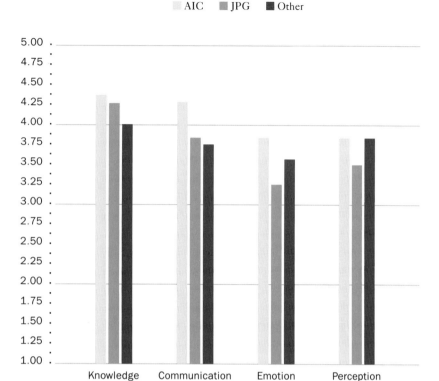

Figure 8b. Endorsement of Major Dimensions of the Aesthetic Experience by Institution

der the heading "Other" are more likely to endorse the importance of communication (Mean = 4.3) than those trained in art history (4.0) or fine arts (3.6). The difference is significant (p<.03, Figure 7a). So is the difference related to current function, or field of specialization (p<.04). The non-curatorial staff is most likely to value communication, then the curators of historical art, and finally those who deal primarily with modern art.

These results suggest a clear yet somewhat contradictory cleavage between educational staff, more experienced experts, and lower echelon professionals on the one hand, all of whom appreciate more highly the communication dimension of works of art, and curatorial,

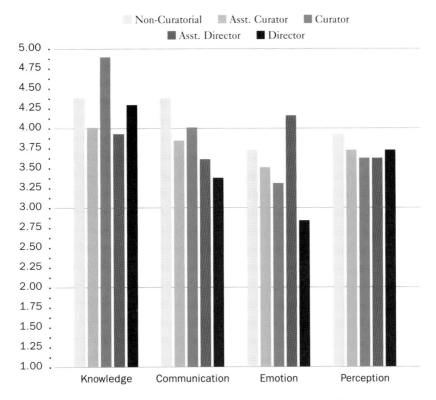

Figure 9. Endorsement of Major Dimensions of the Aesthetic Experience by
Current Position

less experienced, but more highly placed experts, on the other hand,
who place less value on communication. The contradiction stems
from the fact that higher positions in the museum field are usually cor-
related with age and with years of experience. Here, however, posi-
tion is related negatively to responsiveness to communication,
whereas age and experience are related positively. Least sensitive to
the communication dimension would be a young museum director
trained in fine arts, with little museum experience (admittedly, an ex-
tremely unlikely combination). The greatest potential conflict in this
respect would be with an older museum educator trained in the
humanities.

It is also possible that what we have called communication is, or is perceived to be, less important for some *kinds* of art than for others: modern art, for example, relies less on imparting information than the art of earlier periods; likewise decorative arts such as furniture may inherently be less involved with communication than, say, historical painting.

Perception · We discovered no significant differences between any of the groups compared in Figures 6 through 9 regarding perception and the aesthetic experience. Apparently the visual qualities of works of art are appreciated equally by all of the experts, regardless of their background or current status. On this score there is a widely shared unanimity. The perceptual dimension is clearly indispensable to all those working in the field.

Emotion · Unanimity is less pronounced, however, regarding the importance of feelings to the aesthetic experience. The largest difference, as with the dimension of communication, is attributable to the respondents' position (ANOVA p<.002, Figure 9). Non-curatorial staff hold emotions to be quite important (Mean = 3.9), whereas directors find it relatively unimportant (2.8). The three assistant directors depart from the linear trend by valuing emotion more than anyone else (4.2). The culture of the institution also plays a role (ANOVA p<.02): emotions are valued most at the Art Institute, least at the Getty Museum (Figure 8b). Finally, the person's field of specialization is involved: curators of premodern art are least susceptible to the emotional content of art (ANOVA p<.04).

HOW RESPONDENTS' BACKGROUNDS RELATE TO AESTHETIC DIMEN-SIONS · A different grouping of the results already reviewed highlights the connections between the backgrounds of the respondents on the one hand and the four approaches to art on the other. Looking at the data this way more clearly shows how such variables as age or field of specialization influence the way experts look at art. Before looking at those characteristics that do make a difference, however, it is

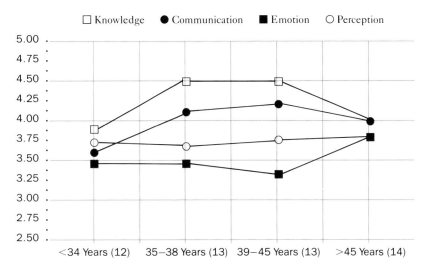

Figure 10a. Relationship between Age and the Aesthetic Experience

important to mention one that does not. Usually, men and women do not give the same kinds of answers on questionnaires that measure beliefs and opinions: sex differences are the norm rather than the exception. In the present study, however, male and female experts gave essentially the same responses; not one of the items showed a significant effect due to gender. Given the fact that it seems to make no difference either in the structure or in the content of the aesthetic experience, gender will not be mentioned again as a factor in this study.

Age · Figure 10a shows the pattern of responses by the four age groups. It seems that both the youngest and the oldest respondents hold the four approaches about equally strongly. In the middle years (35–45), however, there seems to be a polarization: knowledge and communication are strongly prized, while perception and emotion are relatively devalued. For the older respondents especially, there is a very slight gap between the importance of knowledge and emotion. For the middle group, that gap is about four times as large, in favor of knowledge. Whether this is a trend related to aging per se or whether

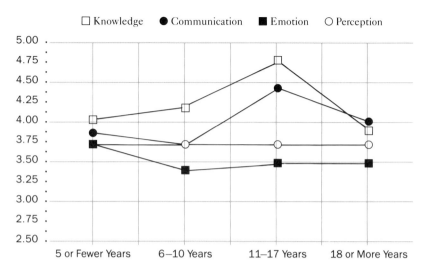

Figure 10b. Relationship between Years in Field and the Aesthetic Experience

it is because of one-time ideological peculiarities of the cohorts studied cannot be ascertained by a cross-sectional study; only a longitudinal follow-up can determine whether persons currently in their mid-thirties will devalue knowledge and revalue emotion ten years from now. Two of the four dimensions were affected by age at a statistically significant level: knowledge and communication.

Years in Field · The trend here is similar to that noted for age (Figure 10b). The largest polarity is for those who have been working eleven to seventeen years in museums; they are responsive to knowledge and communication to the detriment of perception and emotion. Those who have worked fewer or more years have a more balanced view. The only dimension not significantly affected by years in field is communication.

Level of Education · This variable also affected only one of the dimensions: knowledge (Figure 11a). As one might expect, people with the higher degrees place a greater value on knowledge and a lesser value on emotion than those with lower degrees. There was no difference

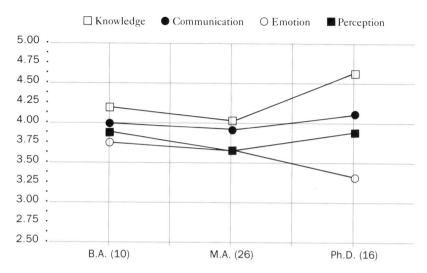

Figure 11a. Relationship between Highest Degree Earned and the Aesthetic Experience

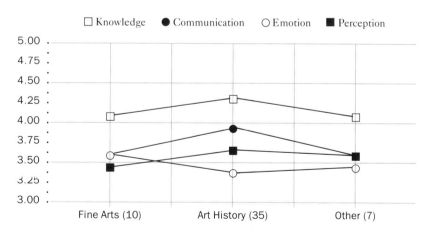

Figure 11b. Relationship between Field of Training and the Aesthetic Experience

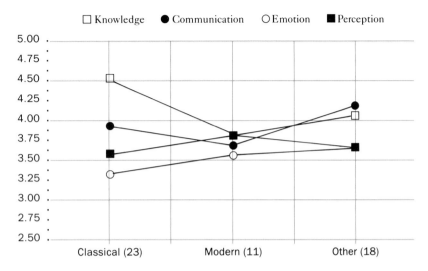

Figure 12a. Relationship between Area of Specialization and the Aesthetic Experience

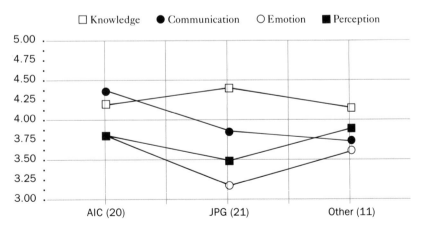

Figure 12b. Relationship between Institution and the Aesthetic Experience

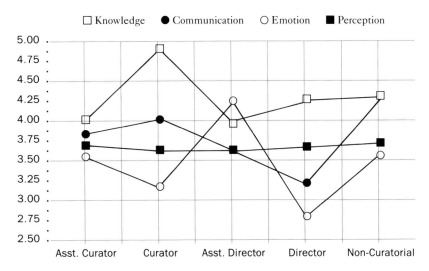

Figure 13. Relationship between Position and the Aesthetic Experience

between holders of B.A.'s or M.A.'s in their views of the aesthetic experience.

Field of Training · Whether one's formal education was in fine art, art history, or some other field made a difference in the importance of communication (Figure 11b). This dimension was a matter of indifference to those with a fine art background and uppermost to people trained in other fields, usually the humanities or the social sciences. Emotion held a relatively low place for those trained as art historians.

Current Field of Specialization · The field of art an expert is currently working in has the strongest relationship with the dimensions of the aesthetic experience (Figure 12a). Three of the four approaches are significantly affected by it: knowledge, communication, and emotion. Curators working with historical art differ from all the rest in being strongly polarized: they value knowledge very highly and emotion very little.

Institution · The importance one gives to communication and emotion (Figure 12b) is related to where one works. The staff at the Getty Mu-

seum replicates the pattern reported above for curators of premodern art: they value knowledge very highly and downplay emotion. Communication is the supreme value at the Art Institute.

Position · This variable shows the most complex pattern of all (Figure 13). This is in part because of the small numbers in the groups at one end of the scale: with only three assistant directors and three directors generalizations are very dubious. In any event, position affects two of the dimensions of experience: communication and emotion. Curators and directors are distinguished by their preference for knowledge over emotion.

SUMMARY OF THE ANALYSES

Our analysis reveals three clusters of characteristics that differentiate approaches to works of art. The first is what we might call the "Getty" cluster, associated with an art historical training, curatorial responsibilities, and a specialization in premodern art. It involves a pronounced emphasis on the cognitive challenges contained in works of art and a relative disinterest in the emotional challenges. The second cluster is the "Art Institute" cluster, associated with a humanistic training and non-curatorial responsibilities. It appears in tandem with an emphasis on the importance of the communication dimension of works of art. Finally, a "corporate" cluster is associated with a specialization in modern art and resembles the pattern of response given by museum directors; it involves an almost equal valuation of all the dimensions of experience, with a preference for knowledge and a coolness toward emotional content.

On one level, these groupings of responses simply reproduce the characteristics of our sample and thus reflect the historical differentiation of museums in contemporary America. It is not surprising, for instance, that the responses of the Getty Museum staff and the responses of historical art curators are similar, since the Getty Museum concentrates its collecting on pre-twentieth-century art. Neither is it strange that the Art Institute, an urban institution that prides itself on

its educational mission, should emphasize its communicative functions. And it makes sense that corporate curators should respond as do specialists in modern art, because most collections of this type focus on contemporary works. That they should also answer like museum directors could be explained by the fact that corporate curators usually have few, if any, staff members and therefore actually cover functions filled in museums by the directors.

On a deeper level, however, these patterns tell us something about the various ways that individuals construct the aesthetic experience. People approach art with different skills. Some of these might be genetically determined, others are the result of accidents of early conditioning, whereas other skills might be developed by the individual as the result of personal predilections cultivated with self-conscious discipline. In any case, some people develop a very keen eye and therefore are unusually responsive to the harmony of lines, of colors, of shapes and masses. Although all experts agree that one cannot respond to works of art without a sensitivity to formal qualities, some people see this dimension as far more important than others. Some people are particularly sensitive to delicate nuances of feeling, and they will scan objects in order to decode their emotional content; for them the emotional response is crucial in the aesthetic encounter. People whose special skill is the ordering of facts will be engaged by the cognitive puzzles contained in works of art; for them the most interesting challenges involve questions of attribution, historical evaluation, or technical reconstruction. Finally, there are people who are skilled in mediating meanings, or communication. For them the most important challenge is to decode the message contained in the work of art and make it accessible to audiences whose background might preclude recognizing it.

Fortunately, works of art contain enough information to satisfy each of these four approaches, and presumably still others that went unrecognized in the present study. Works of art are so complex that many different skills can be brought to bear on the challenges they present. Each one of these approaches seems to be a legitimate way

of interacting with works of art—and each one eventually leads to the same point, namely, the intense involvement characteristic of flow experiences.

What skills a person develops, however, influences the professional path he or she will take within the occupational structure of the museum world. A person interested in communication, for instance, is less likely to enroll in fine arts training and will more likely be schooled in the humanities or the social sciences. Later on, such a person is more likely to become a museum educator than a curator. A person who values knowledge seems more likely to continue his or her education to the doctoral level and then specialize in some kind of scholarship. Different museums will also attract individuals with skills appropriate to the mandate of the institution: experts who especially value the emotional content of art, for instance, might be less likely to work for the Getty Museum.

CONCLUSION

We have seen that the tendencies gleaned from the interview were to a large extent confirmed by the questionnaire study. The curators' responses to the quantified items suggest that the aesthetic experience is related to other forms of enjoyable flow experiences, relying as it does on the use of skills to match situational challenges within a field of action delimited by clear goals and constant feedback. Like other flow experiences, it provides a sense of transcending everyday reality, a deep involvement with a more ordered and intense world. These characteristics of the aesthetic experience were unanimously endorsed by experts regardless of how they had been trained and what they did.

At the same time, the questionnaire showed that the experts' backgrounds and present involvement with art make a difference in terms of which aspect of the aesthetic encounter they respond to most. Individual museum professionals develop different skills and therefore become sensitive to different challenges in the works they view. In

terms of valuing formal qualities there is no difference: all experts value this dimension equally. But the importance of knowledge and emotion, and especially the importance of communication, appears to be debatable; on these dimensions experts vary depending on their age, previous training, position, institutional affiliation, and especially on their current area of specialization. Knowing what these biases are should help avoid latent misunderstandings and conflicts in the museum environment.

The results reported in this chapter are, of course, not to be taken either as definitive or exhaustive. Given the state of the inquiry, they are more like the first tentative insights in a fledgling field of research. It is possible, for instance, that a more detailed questionnaire with many more items would have revealed a more complex set of approaches to the aesthetic experience. That this is probably not the case is suggested by the fact that the much more intensive interviews did not reveal qualitatively different issues from the ones that were included in the questionnaire. The limitations of the present study are more likely to consist in the narrow range of institutions, experts, and time periods considered. Within the museum world alone, curators at smaller museums outside the major metropolitan areas might have different views of the aesthetic encounter. Art critics, collectors, and historians are almost certainly going to have different emphases in their approaches. Ten years from now the emotional function of art might become much more salient and the importance of knowledge decline, or vice versa. Despite these limitations, however, it is probable that in the main these findings are going to remain true over time. In any case, they should indicate the way for future studies that will develop knowledge in this important field of human experience.

HENRI ROUSSEAU
(French, 1844–1910).
A Centennial of Independence,
1892. Oil on canvas,
112 × 157 cm (44 × 61⅞ in.).
Malibu, J. Paul Getty Museum
88.PA.58.

The aesthetic encounter inevitably involves the realization that art is made by human beings to communicate the entire range of human thought, feelings, and conditions down through the ages. In the interviews conducted with museum professionals, no one element was described as being so central to the aesthetic experience as the human quality of art. One respondent spoke of "the way in which a work of art allows you to have a sudden appreciation of, an understanding of, the world. That may mean your place in it . . . that may mean . . . [the] ability to suddenly let go of ourselves and understand our connection to the world."

CHAPTER 4

The Form and Quality
of the Aesthetic Experience

IN THE INTRODUCTORY CHAPTER of this report, we presented a conceptual model of the aesthetic experience. There, we drew attention to the striking similarities between the description of the aesthetic experience as put forth by Beardsley and the flow concept. We argued that the flow model provides a number of conceptual tools for understanding the nature and conditions of the aesthetic experience. In this chapter, we explore the implications of the flow model and Beardsley's work. This investigation will attempt to do two things: first, to elucidate further the form of the aesthetic experiences described in the preceding chapter; and, second, to expand the flow model in such a way as to account both for the unique qualities of the aesthetic experience and to explain why the experience takes the form it does.

THE MODELS OF AESTHETIC INTERACTION

A number of the museum professionals we interviewed were able to provide a summary of the form of their interactions with works of art. Despite their variation, these summaries provided considerable insight into the nature of the formal aspects of an aesthetic encounter. The following succinctly and clearly stated quotation reflects a generally held opinion, providing a good ground for further discussion:

> I think there's the initial response, and then there's a kind
> of curiosity as to what there is in the picture that gave you
> that response, which means that you're going from the
> whole picture down to . . . maybe it's the way that cherry is
> painted over there in the corner that is really knocking me

> out. I think that as you begin to figure out where it's coming
> from, that does tend to, I mean that's a more intellectual re-
> sponse than your first response. But I think that if you've ex-
> plained it to yourself in some way, that it's still then possible
> to come back and see it again, maybe not exactly the way you
> first saw it when you were crazy about it, but I don't think it
> hurts to have more information. (120)

What is exemplified here is a movement, clearly dialectical in nature,
between two central components of the aesthetic experience as it
would be understood in terms of the flow concept: the merging of at-
tention and awareness on the art object and the bringing of the view-
er's skills to bear on the challenges that the work presents. The ex-
perience is one of an initial perceptual hook followed by a more
detached, intellectual appreciation that returns the viewer to the
work with a deeper understanding.

Explained this way, such an account clearly holds that it is the ar-
resting and the focusing of attention that comes first, which brings a
number of challenges to the viewer's consciousness, to be met there
with whatever array of skills he or she may have. Given the over-
whelming number of virtually identical accounts in our interviews, we
do not doubt that this is in fact the way in which the temporal flow of
the aesthetic encounter is phenomenologically understood by our re-
spondents. However, the logical extension of such an account is that
there is something inherent in the work of art that begins the process.
While there is some measure of truth to this assertion, we cannot en-
tirely accept such a viewpoint. This is simply because, as the inter-
view material has shown throughout, the evidence argues against the
same object evoking identical responses from any two viewers.

The flow model offers an alternative concept that, while it encom-
passes the experience as it is subjectively understood by the respon-
dents, allows us to explain the initial hook without a wholesale
recourse to the formal properties of the object. The relationship be-
tween challenges, skills, and the attentional dimensions of the flow
experience does not have the strict temporal sequence implied by the

account above. Rather, it is dialectical, a spiral if you will, in which new skills open up new areas of challenge, which, as we have noted, facilitate the merging of attention and awareness. In the encounter with the aesthetic object, attention will be fully focused only when the challenges and skills are in balance. And completing the cycle, but at a higher level, this very focusing of attention develops new skills.

The implications of this concept are broad, but before we extrapolate further, it will be helpful to return to a more descriptive level in order to develop fully the concepts of attentional focus and challenge, skills, and discovery within the context of the interview material.

THE FOCUSING OF ATTENTION · Both Beardsley and Csikszentmihalyi agree that one of the central features of the experiences they describe is a focusing of attention on the object. Beardsley, as we noted, lists object directedness as the one essential feature of the aesthetic encounter, and in the introduction to this report, we elaborated on why this is also necessarily true for the flow experience. As discussed in relation to the perceptual qualities of the encounter, this may initially strike one as something of a truism—one must of course focus attention on the object one is perceiving. Yet in another sense we are discussing here a different order of attention. On the one hand, it takes focus to an extreme rarely experienced in the course of everyday life:

> There's nothing like it. I just get totally wrapped up in it. I mean, a bomb could fall next door and I'd be oblivious to it. I can get so wrapped up with an object, looking at the vase painting, or studying the object, whatever it might be, that you're unaware of the phone ringing or people coming in the door, you just get so wrapped up. It's a total escape. (420)

On the other hand, it is a kind of attentional focus that, perhaps paradoxically, makes its presence felt. As one of the curators put it, "It absorbs, it involves all of the senses in a unifying manner" (123). In our group, more than 75 percent explicitly said that their aesthetic encounters were significant, in part, because of this sense of attentional focus. This was the single, most highly agreed-upon aspect of the na-

ture of the aesthetic encounter. Yet, like nearly every other aspect, this focusing of attention, this object directedness could take many forms. Thus, while many of the respondents spoke of it as an absorptive experience lasting anywhere from just an instant of intense concentration to "forty-five minutes, more—I don't know" (104), they experienced another kind of attentional focus that was intermittent in nature, in which they felt drawn to an object over and over again and distracted from the task at hand. This kind of involvement is most clearly illustrated by the following instance:

> When the dealer was giving me all these prices for other objects and trying to get me excited about things that he wanted me to be excited about, I kept looking at this little Polaroid of this. . . . And I was really sort of working on other things, but what interested me was this. (108)

We can easily imagine the consternation of the dealer as the curator's attention kept wandering away from the sales pitch to the "little Polaroid" that intrigued her so much (she eventually acquired the piece in the photograph, not any of the others).

The vignette of the persistent dealer and the interested curator brings up another set of issues that are related to, and, perhaps even necessary corollaries of, the attentional-focus issue. Again, both Beardsley and flow theory acknowledge this set of concerns. It is what Beardsley calls "felt freedom" and Csikszentmihalyi calls "limitation of the stimulus field." Neither of these concepts implies that the viewers have no concerns other than the object in front of them. On the contrary, as will be shown later, often the awareness of other kinds of stimuli enhances the aesthetic experience. Rather, the only claim made is that the field of consciousness is restricted to a limited set of relevant concerns. What is relevant will of course vary with both the viewer and the work. These concepts are crucial to understanding some of the central issues of the study, and we will return to them in due course. However, we should clarify with some examples what these concepts mean in actual experience.

The statements quoted above exemplify some aspects of this process, but in our interviews there were numerous additional accounts that highlighted a selectivity in the face of distractions:

> They [the cartoons for Diego Rivera's *Detroit Industry*] were displayed in a very different, very dramatic fashion, so that the gallery was dark except for the light that was directed on the cartoons. There seemed to be no compelling reason for highlighting them in that fashion. What was good about the installation is that they were installed in a gallery with lower ceilings, so that they really did stretch from floor to ceiling, they really looked as if they were just booming up out of the earth. The overly dramatized lighting I just adapted to; I never noticed, or just put it in the back of my mind. (122)

Obviously, this respondent's experience would have been less significant if not for the selective directing of attention. Still, other people found their experiences enhanced when they widened their focus beyond the work of art that was their primary concern. In the following chapter a number of the things that are productively allowed into the stimulus field are discussed in detail under the topic of Conditions. The following excerpt, from a curator speaking of seeing Picasso's *Guernica* in Madrid after never having been very impressed when seeing it at the Museum of Modern Art, New York, gives an intimation of the inclusive side of the selective process:

> I saw it in Madrid and it looked like maybe the best painting I had seen *ever*. And in part it was because of the context I saw it in. You leave the museum and Franco's civil guards are out in the street with their machine guns. And it really had a resonance in that cultural situation that it had never had in the Museum of Modern Art, where it was just a painting, just another painting. And that was a really remarkable experience. I went back to see it on three separate occasions to test myself, to see if it was just a fluke or something. And I mean

it was a fabulous picture. That kind of thing is an unparal-
leled experience. (111)

Both Beardsley's conception of the aesthetic experience and the
flow concept include a final form of attentional focus that, though rare,
is—perhaps because of its very rarity—the most celebrated form of the
aesthetic experience: transcendence or loss of ego. In this final form
we see the first two attentional dimensions brought together and
pushed to their human limits. Attention is so completely focused, so
completely enmeshed in the interaction with the artwork, that the
viewer gives up, at least momentarily, his most human attribute: self-
consciousness. The transcendent encounter with the work of art was
described in detail in the preceding chapter and is both evident and,
to a degree, self-explanatory. Here, we only wish to stress the cen-
trality of this type of experience for a fairly large number of the mu-
seum professionals. More than a quarter of those interviewed indi-
cated that their most significant encounters with art entailed some
form of loss of ego. Yet even this relatively large percentage does not
mean that it is a regular occurrence. Nearly all of those who spoke
about it immediately stated that this happened only infrequently.

Taken as a group, these three attentional dimensions (object direct-
edness, limitation of stimulus field, and loss of ego) are the most com-
mon, if not the central aspects of the aesthetic experience. Eighty per-
cent of the interviewees spoke of one or more of these dimensions as a
primary factor in their most significant encounters with works of art,
and for 20 percent it was the major and distinguishing aspect.

Clearly the concentration of attention is the fundamental process
through which the aesthetic experience is achieved. Yet how is this
concentration itself brought about? Obviously a major component is
the challenge/skill dimension that was introduced earlier. The flow
model includes a concept that serves as a bridge between attentional
focus per se and the phenomenologically less apparent concepts of
challenge, skill, and, in Beardsley's term, "active discovery." What
has been missing so far in the description of the encounter with an

art object is the viewer's being presented with both clear goals and clear feedback.

The combination of clear goals and clear feedback serves to prolong and often to deepen the focusing of attention on the object. In the following passage, one curator describes being confronted with a challenging sculpture installation and the feeling he experienced as he came to understand it:

> All you saw in the gallery were certain very thin strips of wood and cut sections of dowels arranged on the walls and on the floor in such a way that they were not parallel to any of the surfaces in the room—many of them just pointed. They didn't bring any resolve. He also had drawings exhibited. And in the process of looking at the drawings it became clear that the sculpture was simply markers, indicating an invisible, conceptual structure which continued through and beyond the walls of the actual gallery into other parts of the building. And you had only these residual indicators in the gallery to mark that. And it was just wonderful because he took me out of the gallery just as Smithson's "non-sites" had done. (103)

The interaction between the complexity of the work and this individual's own considerable skills is evident here. Certainly the work he described would seem meaningless to viewers who do not have the skills he possesses, and just as obviously, the feeling of transport that he describes at the end would never have occurred for such viewers. Another curator speaks of going to see a retrospective of an artist whose work she had previously thought overblown by the media. Her comments reveal the same process carried out over a period of time:

> You're looking at it all at the same time, and you're looking at individual parts, then as you kind of start associating those things, sometimes you don't put elements together until you're farther away from the exhibition, or you don't realize

> it. What you realize is that, as you put all the pieces together,
> this is a much more powerful statement than you thought
> they were capable of making. (125)

There are many comments similar to these; most of the statements in
the second chapter can be understood as exemplifying the same pro-
cess in a variety of contexts. Suffice it to say at a most general level, as
one curator put it, "The work of art sucks you up, and you get feed-
back at all these levels" (128).

SKILLS, CHALLENGES, AND THE PROCESS OF DISCOVERY

The quotation opening this chapter speaks of a movement from the
initial focusing of attention, the hook, to an exercise of intellectual
and perceptual skills leading to the discovery of why that particular
piece was capable of arresting attention. The contention was made
that the skill and challenge interaction described by flow theory lay at
the heart of the process. It is surely also important in the interactions
just described. Here we wish to discuss the two aspects—skill and
challenge—separately and in more detail.

Expanding on an inference drawn from the preceding chapter, it ap-
pears that on an analytic level, if not always experientially, skills are
compartmentalized in ways that parallel the major foci of aesthetic ex-
perience. That is to say, one can develop a greater emotional sensi-
tivity to works, as was evidenced in the preceding chapter, without
necessarily honing one's perceptual, intellectual, or communicative
skills in the process. A number of people even spoke about conscious-
ness of their deficiencies in certain areas:

> [My friend is a] very sensitive man. And he doesn't do any
> art historical accounts the way I do. He doesn't provide
> stories. He allows them [the viewers] to trust their instincts
> and to come to terms with the work just through the expe-
> rience of standing in front of a painting or a sculpture. Now
> this is something that I don't have an easy time doing, so I
> respect people who can. (104)

We have quoted this person a number of times in the report, for she recounts a variety of deep and moving experiences with works of art—experiences, however, that for her are primarily art historical and iconographic in focus.

Further, it seems that the way in which skills grow is related to the type of skill involved. Thus, reading and talking with colleagues will enhance the intellectual aspect of the aesthetic experience:

> The more I learn about something, the more appreciation
> one has for how it's made, how it got to be where it is. The
> more you see great works, the more you recognize how far
> they've risen above all the rest. It's really an additive pro-
> cess, or should be, and if it isn't, then one should stop. The
> more you see in the course of your life, the better you should
> be at being able to discern what makes great pictures great,
> what makes lesser pictures quaint. It should all make some
> enormous compendium when you're done. (415)

A number of respondents explicitly related what they felt to be the development of a "greater range of emotion" in response to life experiences, as this excerpt shows:

> As you get older, it's really amazing how you change. But, to
> be quite frank, I fell in love with a man. I think that had a
> lot to do with it. Just the feeling of finally really sharing
> my life with someone, where I could share the artistic ex-
> periences I've had, or aesthetic experiences I've had, with
> another human being on a very personal and intimate
> level. (106)

Many of the museum professionals developed the idea that matura-tion itself—encompassing everything from simply growing older to having children—contributes to sensitivity to works of art.

By and large, the vast majority of the respondents agreed tha "looking" contributed most to the development of skills: continue

exposure to and interaction with works of art develops the ability to
have meaningful encounters:

> It used to be much more gratifying to me, purely on an in-
> tellectual level. The experience itself hasn't changed—the
> direct, primitive communication—that hasn't changed. But
> how I *appreciate* it afterwards has changed. I used to say,
> "I've been enriched intellectually through this experience."
> Now, I feel I've been enriched both intellectually and emo-
> tionally, because I really feel that as I get older and as I see
> more and become more of a connoisseur, in the sense of
> sheer numbers of things seen, refining out good design from
> bad design or good composition from bad composition,
> pleasing color from unpleasing colors, I feel that I have more
> of an emotional range and more of an experiential range to
> appreciate things. (106)

> That's one of the real pleasures of age. I feel my experience
> is getting more mature. Not to be confused with more in-
> tense, better and worse—that's not the point. But one begins
> to feel you are bringing to bear a certain perspective. Years
> of looking at these things begins to build up a sort of quali-
> tative index. And I think you develop confidence in your
> own taste. I can remember being very confident when I was
> young, but it was based on nothing but arrogance. Now, in a
> way, I think I'm humbler, but I have more confidence that,
> yes, I'm judging in the context of a number of things I've
> seen. And maybe I'm a tiny bit wiser. I get a sense of plea-
> sure out of that. It's humbling because you realize, well, an-
> other ten years of looking, and think how much more intel-
> ligent a response you might be able to have. (128)

The skills of which these and many other respondents spoke have
changed, often dramatically, over the years of looking, thinking, and
experiencing. None of the interviews gave us the impression that the

speaker had arrived at a set of skills, or a level of expertise, that he or she felt would be sufficient. As one of the curators quoted above stated, if one's skills don't continue to change, you might as well quit. Rather, each of them, even those who were most interested in obtaining answers to art problems, presented an image of an individual whose critical framework was still open, still in the process of refinement and of becoming more complex.

THE CHALLENGES OF THE AESTHETIC ENCOUNTER · Since the interaction between the object and the skills that the viewer brings to it determines the nature of the challenges presented by a work of art, then the staggering diversity of possible challenges immediately becomes apparent. The level and type of challenge will be different for every viewer and every work; they are integral parts of the aesthetic encounter, regardless of its specific content.

In the preceding chapter, the entire section devoted to approaches that concentrated on solving the problem, "cracking the code," for example, indicated ways in which the work of art presents a direct challenge to some viewers. Others found the whole realm of art to present one enormous challenge:

> I think of the history of art as being the peak of the pyramid, because art itself is such a difficult thing to quantify. It's such a shadowy thing—you think you've got it, but you often don't. The appreciation and the study of art, the understanding of it, requires a knowledge of so many corollary fields. You have to know literature to know the visual arts, but you don't always have to know the visual arts to know literature. You have to understand history, philosophy, intellectual history, and all these things to make sense of the visual arts. (127)

Perhaps the most eloquent statement of the inherently challenging character of the work of art is the following reflection on the nature of the encounter at a general level:

I think you can become habituated to a work if you see it all the time, and it becomes harder and harder to open up to it and explore it, fresh, each time. People say a great work of art continues to yield things, and I think that's true, there are so many possible ways of perceiving it that all work. And you're not contributing them all yourself, they're really there, it's discovering them, that's what makes it fascinating. But I think you use up your repertoire of skills and abilities to notice things at that particular stage in your life, and in your development about that particular work. Then you have to get it back. (416)

Challenge, whatever its form or scope, is seen here as one of the primary structural qualities of the aesthetic experience.

THE PROCESS OF DISCOVERY · In the interviews with rock climbers, dancers, composers, and others that resulted in the original formulation of flow theory, a number of respondents spoke of the process of discovery, usually of the discovery of their own potential, their own unrealized skills. In the interviews with museum professionals, however, the process of discovery, as Beardsley has suggested, emerges as a central component of the aesthetic encounter. Sixty-three percent of the curators discussed, usually quite cogently, the process of discovery as a contribution to their significant encounters. Like challenges and skills, the content of discovery varies widely across the respondents. Its nature as an underlying structural component is evidenced by the fact that it is a persistent concern despite its variation in content. Moreover, the content of the various discoveries closely parallels the four major foci of the aesthetic encounter: perceptual, emotional, intellectual, and communicative. Several clear instances of this process have already been presented to illustrate these four dimensions in the preceding chapter. Yet a number of responses are clearly concerned with the process itself, apart from any content that it might entail. The attempt here will not be to detail the

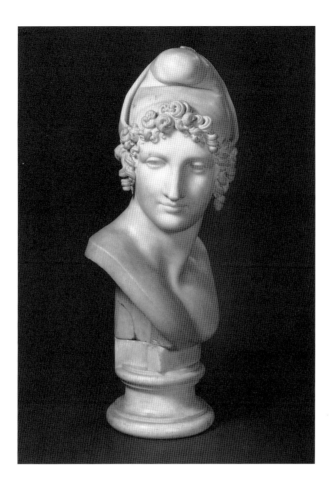

Almost everyone can appreciate the subtle delicacy of this bust of Paris by Canova. But is the intensity of the aesthetic experience enhanced if the viewer is aware of the theoretical issues involved in the Neoclassical movement and has read the correspondence between Canova and Quatremère de Quincy regarding this work? Our studies show that while art historical knowledge may not increase the delight first experienced in encountering the object, it does provide layers of meaning that increase the challenge for the viewers and hence may make the experience more complex and enduring.

various contents but to give a sense of the importance and general form of the process.

> It seems to me that maybe in order to have an aesthetic ex-
> perience of any kind, I have to put myself mentally into a
> certain posture vis-à-vis the thing to be experienced—a cer-
> tain attitude, a certain intellectual stance. And this stance
> involves letting go of what I know, or think I know, and being
> open to the experience itself. (416)

Although we have already presented many similar excerpts, the next quotation is one of the clearest accounts of how challenges, skills, and the process of discovery interact in the encounter with a work of art:

> Sometimes I spend time with an object, and after that time
> it leaves me cold. I don't have any real feeling for it. That
> tells me that I don't think it has enough power. But with this
> object [a portrait bust], each time I came back to it, I saw
> something new in it. I also was doing a fair amount of re-
> search on it, and everything I found out impressed me and
> made me more interested in it. So each time I looked at it
> with new eyes. I got photographs of comparative busts. Part
> of the exercise there was to see how this bust stood up to the
> other, the comparable, one. And I thought this one was bet-
> ter in many ways. (109)

Discovery in this instance is directly related, not to say confined, to the art object itself. At the opposite end of the spectrum, one of the most moving responses that we encountered described the process of discovery in very broad, very human terms. Though this curator be-gan with a specific art object, the nature of the discovery and the pro-cess of discovery went far beyond the art world to existence itself:

> There's that wonderful Cézanne *Bathers* in the Philadelphia
> museum, one of the large *Bathers*, which in its insistence on
> an underlying structure in nature, and its insistence on the

informality of the scene, gives you in one glance, an aes-
thetic glance, gives you that great sense of a scheme, not
necessarily rational, but that things come together. . . .
[That insight] is the way in which the work of art allows you
to have a sudden appreciation of, an understanding of, the
world. That may mean your place in it, that may mean what
bathers on the side of a river on a summer day are all about,
that may mean a quick metaphor for decisiveness and what
it means poetically, that may mean that ability to suddenly
let go of ourselves and understand our connection to the
world. These are often fleeting and difficult things, but to
achieve a sustained state of that kind of insight, it seems to
me that art in its best form allows you to do that. (133)

THE UNIQUE QUALITIES OF THE AESTHETIC ENCOUNTER

Why is discovery so important in the aesthetic encounter, compared
to other activities that produce flow? To answer this question, it is
necessary to consider two other factors that emerged from our study,
one existential, the other structural. Discussion of these qualities will
lead directly to the attempt to describe, in terms of a formal model,
the way in which all of the preceding factors interact in the aesthetic
experience.

THE HUMAN QUALITY OF WORKS OF ART · Besides the property of at-
tentional focus, the one element described as central to the aesthetic
experience was the human quality of art. Nearly 75 percent of the cu-
rators discussed this topic in one way or another. Some were as explicit
as the following:

I: Is there anything that makes the visual arts different from all
of the arts, I mean, including music and theater? Different
from things like landscapes for you?
R: I suppose, initially, no. But in the long run, yes, because the
arts are man-made, and so they have to be understandable in
a way that nature doesn't have to be understandable. You

> can't place any conditions on mountains and streams. You
> can place conditions and have expectations of things that are
> human creations. (412)

Others were more indirect, not necessarily making the human factor an a priori condition in describing how the human qualities that went into the work were essential to what they were able to get out of it: "There were certain things there that were in the work, which were presumably in the mind of the painter as well. I mean, let's assume that the picture is an expression of him, as your response to it is an expression of yourself" (120). Regardless of the context in which it was expressed, the centrality of the human quality of art to these individuals' experience was clear: "[It is] the joy of sharing an experience that you realize you're sharing with another human being" (105); and "In some way they have to reach me or have some kind of endowment of a human quality, whether it be intellect or emotion, to make the point" (112). Another curator refused to draw a distinction between mass-produced objects and fine art and defended this stance by referring to the human element involved: "Maybe I'm not distinguishing between art and something else, because it's what human beings are doing, no? What he's creating. What we do out of the raw materials that we get, that our life is" (110).

Finally, another respondent pointed toward the reason that the human quality of art contributes to the centrality of the process of discovery: "The intrinsic qualities of it are of a certain dimension. There are certain qualities it evokes because of the inevitable connection we make between ourselves as human beings and this as an image of a human being" (127). What this quote makes clear is that such discoveries are more important because they hit so close to home. The entire range of human thoughts, feelings, and conditions has been represented in art through the ages. The aesthetic encounter inevitably involves some realization that humanity is communicating with humanity. There are also far more discoveries and connections to be made here than, say, in rock climbing, where the challenges pre-

sented by the encounter are less personal and more similar to one another than are those presented by the aesthetic object.

THE TEMPORAL ELEMENT · The encounter with an aesthetic object also differs structurally from other activities that engender the flow experience in that, though the experience continues through time, the stimulus for that experience does not. Thus, while a climber faces new configurations of available holds, pitch, and obstacles with every move, someone standing before a painting or sculpture is confronted with an object that physically does not change. Yet many times and in many ways, these museum professionals have talked about "seeing new things" or "reaching new understandings" in their encounters with works of art. If the work is not changing, these revelations, these insights and epiphanies, must come from changes within the viewer. To understand this phenomenon, one must return to the concept of the dialectical interplay among the challenges that the work presents, the framing of those challenges in terms of the goals of the viewer, and the impact of skills on that interchange. However, the important dimension of the human quality of art now becomes most salient. As noted throughout this report, the four major dimensions of the experience of an art object (perceptual, emotional, intellectual, and communicative) also define the major types of challenge; they define as well the major categories of skills that the viewer develops and brings to the encounter. And if one were to define the principal elements of human consciousness, what better, more inclusive set of variables could one use than sensing, feeling, thinking, and communicating? The resonance that has already been noted between emotions in the work and one's own emotional experiences is in fact not limited to emotion but encompasses all four of these dimensions. Thus, the aesthetic interaction is not simply between the viewer and the work but includes a third aspect that represents all of the perceptual, emotional, intellectual, and communicative factors that went into the creation of the work. For convenience, we will refer to this aspect as the artist, but it necessarily includes all of the sociocultural factors that in-

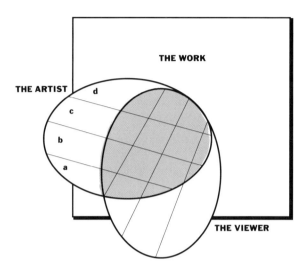

Figure 1. Model of the interaction in the aesthetic experience

fluenced the work in an indirect fashion. This can be more clearly il-
lustrated with a diagram of the components.

In Figure 1, the two interlocking ovals labeled The Artist and The
Viewer represent the sets of dimensions—perceptual, emotional, in-
tellectual, and communicative (a, b, c, and d)—that produced the art
object as well as the configuration of abilities in those same dimen-
sions that the viewer brings to the work. The degree of overlap will
determine the nature of the encounter. That is, the greater the over-
lap (up to a point), the more completely the viewer will be able to en-
gage the work. Yet the area that does not overlap is precisely the area
that constitutes a challenge to the viewer's skills. If there were com-
plete congruence, there would be nothing that was not already known
and the object would hold no interest. If there were no overlap what-
soever, there would be no point of entry, nothing to allow viewers to
exercise their skills. There are also parts of the work that do not in-

tersect with the sphere of the artist's dimensions. These areas are the aspects of a work that transcend, in one way or another, the artist's intention and the limitation and conventions of his or her historical period that yet are open to interpretation and understanding by the beholder. This may be one of the less intuitively obvious aspects of the conception, but it was mentioned by a number of the respondents. The following excerpt states quite well how this aspect follows directly from more obvious concerns:

> I'm interested in what the artist attempted to communicate by creating a work of art, and I'm also interested in its meaning in the context of his whole life's work. And I'm interested in determining what it means by various sources—documentary, reading theoretical treatises of the time to try to determine what artists thought they were doing by creating a work of art, what their position was in society, and how art fit into this. And political dimensions to works of art. And perhaps this is getting a little bit on dangerous ground, but also, the undocumented aspects of it, what did it mean that the artist might not have been aware of? How did it relate to impulses, creative impulses that might not have been conscious? (417)

The reason for the unique temporal nature of the aesthetic encounter is clarified by the relationships represented in the diagram. The work as a visual stimulus and the qualities of the artist and the culture that contributed to its particular form function as two distinct yet intertwined points of attentional focus between which the viewer must move. During the encounter the viewer focuses attention on the work and finds that his or her skills are either able or unable to meet the challenges presented. Attention must then be shifted, for however brief a moment, to the configuration of elements that produced the work. In other words, the skills of the viewer and the challenges provided by the work are potentially complementary. If the two are mismatched, they provide the impetus to revise or expand some as-

pect of the configuration of skills of the viewer, who can then return to the work with, as one curator put it, "new eyes." The two spheres will now share more common ground, and as a consequence, the work will offer new challenges. This entire process may take a moment, or it may extend over years of continued interaction. What is most important is the fact that a work that always maintains some element of itself beyond the viewer's range of skills is clearly the kind of work that will retain the ability to change, at least experientially, through time.

The balance of challenge and skills essential to the flow experience is here seen to lie at the heart of the aesthetic experience as well. It is the distinctive quality of human connectedness that constitutes the unique set of challenges present in the aesthetic encounter, and at the same time, gives form to the skills the viewer brings to the work. The interaction between those qualities that are apprehensible in the work in the first moment of the encounter and those that still provoke viewers to revise or expand their skills accounts for the continued investment of attention in a temporally stable object.

We hope that the existence of the separate dimensions involved in the interaction between object and viewer has been amply documented in this report. But to leave them simply as a catalogue of important elements would beg the question of why, despite the variety of forms it can take, the aesthetic experience can be talked about at all. Sixty-seven percent of the respondents were able to call to mind a significant encounter with a work of art with little or no hesitation, and more than 80 percent described the experience of art as something very different, very special, compared to the rest of their experiences. Yet nearly 85 percent also claimed that there was no common aesthetic experience, and most of them uttered statements as explicit as the following:

> You mean one specific sort of aesthetic experience that we all
> have? No, I don't. I think we all have aesthetic experiences,
> but each one is different. Each person is different; each day
> each person is somewhat different. No, I don't think there is,

and I'm glad there isn't. That's why I've never been very
keen on museum education, in the way that it's handled, as
a matter of fact. I think they try to standardize something
which is a unique experience for each person. Making it the
[fast food] of the art world. (410)

The fact that the structural properties of the aesthetic encounter can
be described separately from its content helps to make sense of this
paradox. The model of intrinsically enjoyable activity—the flow ex-
perience—circumvents the danger of the dimensions of experience
becoming no more than a laundry list by integrating the components
into a unified, if complex, whole. This integration is, of course, only
possible through the expansion of the original model to include some
of the unique properties of the aesthetic encounter that were revealed
in the course of this study. In the next chapter, the model will be em-
ployed as a framework for understanding ways in which the aesthetic
experience can be facilitated.

View of staircase with *Régulateur*
and Renoir's *Mother and Children*.
New York, Frick Collection
A 1574.
Photo courtesy the Frick
Collection.

The quality of the aesthetic experience is strongly
influenced by the context in which the object is en-
countered. Exhibiting an art object involves opti-
mizing two antithetical principles: the fact that
focusing on a single object facilitates the concentra-
tion necessary for the aesthetic experience to occur,
and the fact that a varied visual context enriches the
quality of the experience. In the opinion of several
museum professionals, the Frick Collection is one of
the most successful installations in terms of provid-
ing a meaningful relationship between works of art.

C H A P T E R 5

Facilitating the Aesthetic Experience

IN 1913 CLIVE BELL wrote: "To appreciate a work of art we need bring with us nothing from life, no knowledge of its ideas and affairs, no familiarity with its emotions," because it held within itself "a world with emotions all its own" (p. 27). The "significant form" contained in the work of art was sufficient to initiate the aesthetic experience.

Since that time, however, because of developments in contemporary art but also because of the realization of the naivete of essentialist theses such as Bell's, it has become clear that the appreciation of art is not so natural and easily achieved (Dziemidok 1988). Sociologists have argued that aesthetic experiences can only take place within the conventions of an art world (Bourdieu 1987), and psychologists have shown that viewers from different cultural and educational backgrounds respond to the same work of art very differently (Child 1965; Haritos-Fatouros and Child 1977). The museum professionals we interviewed certainly brought much knowledge and familiarity with the art world to their encounters with works of art. The model developed here to describe the aesthetic experience explains why this is necessarily so.

As previous chapters have suggested, the responsibility for the creation of the aesthetic experience is not solely in the hands of the artist. There are any number of ways that the experience might be set in motion. All of these ways, however, ultimately depend on the interaction between the skills of the viewer and the challenges that the work pre-

This chapter was first drafted by Mark Freeman, Barbara Glaessner, and Jeanne Nakamura.

sents. This might involve evoking art historical knowledge, exploring basic human emotions, learning about social history, or provoking the viewer's imagination. All of these entrées can be effective regardless of whether the art object in question is contemporary, premodern, or a product of another culture.

In this chapter, ways of facilitating the aesthetic experience will be explored. In the first part of the chapter, some of the conditions that enhance the experience will be discussed, such as the nature of the environment in which viewing occurs. Then, those conditions that help the challenges of the work to emerge more clearly will be reviewed. And finally, we will consider possible ways of sharpening the skills of the viewer.

In the second part of the chapter, we will discuss the possibilities for taking concrete steps to enhance the conditions described in the first section, so that the viewers' attention is more easily focused, challenges are clarified, goals and feedback are produced, and skills are encouraged to grow. By reflecting on how conditions for public viewing of art can be improved, perhaps we will take a step toward expanding the frequency and intensity of aesthetic experiences within the context of museums.

The intent of this chapter is not, however, to provide a how-to manual for enhancing the aesthetic experience. We simply want to review the theoretical issues and some of the implications suggested by the theoretical model, as they are illuminated by the interviews with museum professionals. It will be up to the readers to decide how to apply these suggestions concretely, either to their own encounters with works of art or to the design of museum environments.

THE CONDITIONS OF THE AESTHETIC EXPERIENCE

Many of the conditions affecting the aesthetic experience discussed by those we interviewed were tied to their professional reponsibilities, as well as to the particular objects they handled. Without ignor-

ing these specific professional concerns, we have attempted as much as possible to describe those conditions that might contribute to facilitating the aesthetic experience at a more general level.

Environmental conditions are of paramount importance for the aesthetic experience and will be fully discussed. The question of which properties of aesthetic objects may challenge viewers is less extensively treated, because preceding chapters have already raised many of the relevant issues. The largest part of our attention will be concentrated on the viewer. This is partly because what the viewer must bring to the work is perhaps least obvious, and partly because it is the condition elaborated upon most often in the interviews, and in large part because many of the respondents stressed that no matter how optimal the physical environment for viewing art objects may be and no matter how commanding the objects themselves are, the fundamental problem of motivating the public to go to museums in the first place remains. In turn this presents the challenge of providing fertile enough conditions for viewers to encounter works of art with interest, confidence, and the anticipation of a positive and enjoyable experience. Before carrying these ideas any further, let us examine some of the conditions for the curators' own aesthetic experiences, with the hope that they might point the way toward those of others.

THE AESTHETIC ENVIRONMENT · The environment in which it occurs is perhaps the most basic condition for aesthetic experience. In principle, of course, this could be anywhere; coming across a mural in a run-down part of a city may strike the viewer as quite a "wonderful kind of a celebration of human potential" (123). Yet more often than not, for the general public as well as for museum professionals, the encounter with a work of art takes place within the context of the modern art museum or gallery: the "clean, blank, spacious environment which is made for art" (123). One respondent speculated that this is the best atmosphere simply because we have become conditioned to it, and most respondents felt that such an environment focused atten-

tion on the work itself and limited the competing information that a more ornate setting might contain. This situation embodies the initial condition of freedom from distraction.

However, it is also possible that viewers not conditioned to the antiseptic installations of modern museums may feel uncomfortable and self-conscious in such an environment. Paradoxically, the clean blank space could turn attention to the self rather than to the work of art, and itself become a distraction. Whether a spare or densely appointed environment is more conducive to involvement with art is a point that simply cannot be decided either in principle or in the absolute.

The same conflict is true for another important dimension of space, namely, its scale. Here the contrast is between impressive monumentality at one end of the continuum and cozy familiarity at the other. Some museum professionals definitely prefer a people-sized forum for viewing:

> Some of the greatest spaces to look at art in have been places like the Phillips Collection [in Washington, D.C.], which is set up like a big home where the pictures are displayed in domestic scale, and there are couches and places to sit. You are not led into the museum in awe at these huge granite spaces. Most museums are set up like the most imperial of the Roman monuments, meant to inspire awe and fear and loathing. And to impress everyone with how powerful the board of trustees [laugh] might be, or how much money they were able to raise. (103)

> I like the Whitney a lot. Because it's manageable in size. Each floor seems adequate to give justice to a period or style. It seems nicely sized for me. I like the Detroit Institute of Arts. I always have a good experience there because it's sprawling enough so that you can always find somewhere to be by yourself. (122)

At its best, the whole of the museum contributes to, and in some instances becomes part of, the aesthetic experience:

> Walking into that building was walking into a museum that absolutely sang to me. This was a place where there was a director, a staff, that understood how to preserve and use objects and make it a pleasant experience. Everything was absolutely correct: the placement, the lighting, the attention to detail, the sense that they had a wonderful series of very important pictures, but they weren't dramatized into box-office successes. They were simply there, cleaned, restored, and made accessible in this very proper fashion. The collection said it, the building said it, the whole manner of presentation. (101)

As one curator put it, "The primary responsibility of the museum is to create a context in which the object has, aesthetically, the best chance of speaking" (128). Unfortunately, whereas the context may be invariant, the audience is definitely variable. Thus the best context for one viewer may make another feel uncomfortable. One person, highlighting the complexity of the problem, put the issue quite directly:

> I guess there are as many answers to that as there are people, or situations. I think that one can influence the way a person sees an object by manipulating its environment. Why do people come to museums to see things? I think some of them are acutely aware of the setting and the environment and the lighting and the mounting of objects, where others are completely oblivious to that. A little bit of information will often help people look at objects, but whether they're looking specifically at the object setting, I don't know. (413)

A monumental space that will inspire one person to attend religiously to the objects it contains may well distract and overwhelm the next person. If the goal is to establish a connection between viewers and

the objects displayed, an effective environment may be one that tries to accommodate different attentional styles, rather than one informed by a single vision, no matter how exalted it is.

Another condition basic to the aesthetic experience is the amount of time available for viewing and being with works of art. Aesthetic experience, while spontaneous in certain instances, often requires a period of maturation. "The more time that you live with a painting, or with a sculpture, whatever, the more time you have to see it, to find things. If you just walk by a painting, you're not going to get anything out of it, anything at all, seeing takes time" (105). How much time it takes will of course vary tremendously across encounters. What is important is that the viewer be able to control the length of the interaction. "I like to decide how much time I spend with a work of art. I like to be in control of that. Sculpture requires the time involved in walking around it. You can stand in front of a painting for forty-five minutes and think about it. Which I've done" (104).

Both place and time contribute to the focusing of attention necessary for the aesthetic experience to occur. To achieve such concentration requires at least an initial freedom from distraction. Although distractions mentioned by the museum professionals ranged from tacky architecture to street noise, foremost among them were the "hordes of people" that all too often constitute the audience of the modern museum, especially in the context of blockbuster exhibitions. Viewing may well be possible in these circumstances, but the type of experience we have been describing probably will not be. Truly *seeing* art, as opposed to merely viewing it, is for most respondents a "solitary activity . . . it's private, it's quiet . . . it's never happened in a crowded room" (103).

Aside from this problem of crowds, there are also those distractions associated with the fact that viewing art is often an eminently social activity, that a museum is a place in which to be seen as much as a place to see. "Going to openings," one person laments, "drives me crazy, because it's a social atmosphere that really doesn't go with looking at work. It's very hard to look at work in a social context" (104).

Echoing the sentiments referred to above, one curator stated that viewing art is "almost something you have to do privately" or perhaps "with a friend or with the artist there" (105). Anything more only detracts from the integrity and intensity of the aesthetic experience.

How to reconcile this need for privacy with the financial imperatives and social responsibilities of museums is one of the greatest challenges that administrators of these institutions face. It is a quandary similar to that faced by directors of national parks and trustees of other public resources: by increasing the popularity of the resource, they risk destroying what made it valuable in the first place. Two positive goals in this case cancel each other out. One must either decide to restrict access to what should be a shared good or attract as many people as possible and dilute the quality of the experience in the process. Neither choice in this dilemma is particularly attractive.

For many of those interviewed (nearly 50 percent), the juxtaposition of particular works of art was an especially important precondition of the aesthetic experience. For this group, the way works were related to one another was far more salient than such considerations as lighting, height, and labeling. Very often the aesthetic experience for these people involved more than one work, with juxtapositions highlighting relations among different objects being frequently noted. In one particularly "brilliant" contrast, there was "a sense of two entirely different worlds and points of view being expressed" (120). How striking combinations focus attention and present new challenges to the viewer is summed up in the following recounting of an experience at a Carnegie International Exposition:

> What they did was to install the show in such a way that artists of contrasting temperaments and formal characteristics were in confrontation with one another. I just mentioned [Anselm] Kiefer, who's one of the great neo-expressionist painters, with very dramatic landscapes and enormous scale. Very rhetorical, very interesting artist, and very dynamic. In the same room, they had work by an artist named Robert Ry-

> man, who works in a very pure style, kind of a second-
> generation minimalist. . . . And it was amazing to me to see
> the way these two artists worked in the same room. Nor-
> mally, you would expect that Kiefer would just completely
> overwhelm Ryman. And, much to the contrary, Ryman held
> up very well as a quiet—poetic almost—disciplined kind of
> visual experience. And the opposites worked remarkably
> well. (111)

Many respondents found other ways of structuring relations among works, other than dyadic juxtaposition, to be significant. An installation by a single artist can be particularly illuminating, not only because "the more you see by one person, the richer your vocabulary becomes" (105), but also because of the deepened awareness and understanding that a whole series of interrelations can provide. Apparently central to all the kinds of relations described by those interviewed is that this structuring, rather than imposing an order or specific idea on the viewer, is a vehicle for an autonomous construction of meaningful experience; the experience is facilitated rather than dictated. There is, in other words, a great deal of room left for active discovery, and the nature of the challenges and the necessary skills are not preordained.

THE AESTHETIC OBJECT · Without going into detail about the obvious importance of formal qualities, it must be noted that "a balance and harmony of form" (115), even "beauty," is at the center of a good many of the experiences reported (almost 40 percent). Whatever these terms refer to, well over a third of the curators apparently use traditional criteria of evaluation to facilitate their aesthetic experiences. A related aspect is one that many of the respondents termed *craft*, or the importance of things being "well done." One curator notes her "first reaction" on seeing a new piece: "If it's sitting here on the table, I'm liable to pick it up and turn it around, look at it and see if it's well painted, and how high the relief lines are, and how well preserved different parts of it are, whether there have been any restora-

tions" (413). Her concern and way of approaching objects were ones that most of the curators found absolutely critical. Thus, the object must present perceptual challenges to the viewer, or the ensuing encounter will be impoverished by an entire dimension.

Perhaps the most paradoxical attribute of objects in relation to the aesthetic experience is what we came to refer to as *determinability*. One person succinctly stated the problem: "People look at a book and know that you can't tell it from the cover. Paintings give the *illusion* that you can see them in one second. And that's just totally not reality; it takes a long time to *actually* see a painting" (132).

And yet without at least some measure of that illusion, at least initially, the viewer cannot become engaged with the work. Determinability might best be understood as the perceived opportunity to find, on a fairly direct level, some point of entry into the object. In terms of the flow model, we might best think of it as the relative balance of challenges and skills at the levels of meaning, intention, and interpretation.

The demise of craft in contemporary art has been related to the lack of determinability:

> My reaction when I look at a work of art probably depends on whether I understand it or not, and how much I understand it. And I feel that contemporary art—I must not be understanding—I look at it and I think it's crude, it looks unskilled; people seem to be making up in scale for what they lack in talent. (113)

In other words, indeterminacy is sometimes understood as a lack of skill on the part of the artist. Thus it is imperative, for some, that works of art contain something akin to a determinable meaning: "If you understand it, and you know where it fits in, and what it's trying to tell you, and what it represents, then your appreciation of what you see is greater" (113). In referring to the idea of determinability as a condition of aesthetic experience, these respondents conveyed the idea not of some wholly contained answer to a given work, some uni-

vocal meaning, but that of a relatively circumscribed field of interpretive possibilities. As one curator pointed out, "You can look at and appreciate something from a different standpoint than I could look at something and appreciate it, but we're both getting at what the kernel of the object is. I may do it one way, you may do it another" (130).

The emphasis on determinability as a condition of the experience highlights the structural importance of challenge: it is not enough that the work be beautiful and complex, but there needs to be a balance of challenge and skills in the encounter. A work that for a given viewer is indeterminate in its meanings is mismatched with that viewer's skills. The balance of challenges in the work with the skills of the viewer determines the all-important point of entry for the aesthetic experience:

> I remember [Yves] Klein paintings that seemed to me immediately accessible, were immediately wonderful: had that sort of "knock-you-back-and-lift-you-off-the-feet" sense to them. You have an immediate emotional or intellectual connection with the painting; it doesn't put you off, or you don't have to work into it or you don't have to work out to it, or, like in some paintings, have to work down to it. You come right in at the right level. (133)

The object not only has to be accessible to interpretation, but it also must express a human presence within it. At a most basic level, it has to convince the viewer that it is portraying something real, and the primary way it can do this is to "create some emotion" (115). "They have to reach me," as another person put it, and through this very process "some kind of endowment of a human quality, whether it be intellect or emotion," comes to light (112). Or, as yet another person commented, there is the need for "finding something that I can respond to at my most basic, but most profound, level, as a human being" (106).

Moving beyond the purely personal or individual presence behind the art object, the larger cultural or historical context emerges in the encounter with particular works. This context is less a concrete rep-

resentation than a kind of summary of a different world, with its own ethos and modes of being. An example is the curator (108) for whom the Art Nouveau ewer summed up the entire age.

Throughout each of these ideas, we might note, runs not only the broadly conceived idea of expression but also that of communication, the idea that the condition for aesthetic experience here is bound up with relating to and interacting with a fundamentally human creation. Perhaps this human dimension of art explains why many individuals likened their aesthetic experiences to interpersonal dialogue, friendship, and love.

While the dimensions reviewed above are of unquestionable significance to many, the issue of challenge emerges most strongly. It is not enough, apparently, simply to be affected by an object, to be initially captivated by it; it is important that it serve, in some sense, as a provocation as well, an opportunity for the viewer to enter into the work and deal with it over time, not feel that a cursory involvement is sufficient.

A point that we, and the museum professionals, made time and time again, is that the best examples of objects containing such challenges are works whose meaning appears to be inexhaustible:

> There's a Rembrandt in [the Frick Collection] and I know that every time I go to it, it always has the same magnetic attraction for me. Although sometimes I'm looking at different things within it . . . I know that that is a painting I probably will never use up, in part because it's such a complicated painting, in terms of the depth of emotion of the artist who made it. . . . Other works, thirty seconds' worth of looking, you've really absorbed what it has to give you. (101)

In an obvious corollary, it seems that the fact of inexhaustibility, of multivocality, was for many the key element in distinguishing great from average works. Whether or not the work is relatively easy or relatively difficult, whether one has encountered it previously—even repeatedly—or for the very first time, the most central condition is what possibilities it holds for the viewer. It is these possibilities and the

provocation they contain that make these particular objects and their associated experiences significant and memorable.

For experts, the art object also contains challenges that specifically address their professional skills. Professional involvement, which might seem obstructive to aesthetic experience, is most often spoken of quite favorably, as a deepening experience in a way that may be unique for this particular group.

"The visual impact may be one of the first things," as one person states, but the experience

> is never just based on the visual quality. It is based on the
> research and knowledge of the validity of the object, the cor-
> rectness of the object. Doing the research, and trying to find
> out what this is, and was it really made then, and what do we
> really have here, what are we talking about, how was it
> made, is this how things were made at that period—all of that
> comes into play. It's not just an automatic thing. (108)

More generally, there is also the challenge of being able to place the object within a broader context, within a larger, more comprehensive frame of reference. The experts' encounters, in short, involve developing a relationship with the object that may surpass the relative fleetingness of nonprofessional aesthetic encounters. How to make this deeper relationship with works of art available to the casual museum visitor is seen by many museum educators as their main challenge.

THE VIEWER · Thus the skills of the viewer—what it is that he or she needs to bring to the aesthetic encounter—are very much at the center of what leads to aesthetic experiences. Although there was no wholesale agreement among the respondents as to what these skills are, there was considerable consensus as to the centrality of the issue:

> I think there is [an aesthetic experience], but I don't know
> how to describe it, or what would produce it. What affects
> your eye—and your self—differs from what affects someone
> else. But that's what makes it interesting. In the long run all

you can really do is from your own experience, making your own choices. And not care about what scholarly thing may be said about this or that. You have to honestly go with what's coming through your experience, through your eye. (134)

No matter how optimal the viewing conditions might be, and no matter how great the objects are, there remains the problem of how the viewer might best approach the work of art and benefit from the encounter. Some of the more obvious skills for experiencing works of art are training and education. A number of respondents saw these as critically shaping their capacity to interact with and enjoy works of art.

Some museum professionals refused to generalize from their own experience about the value to the general public of academic training: "I don't think that a trained art historian necessarily . . . has a more complete aesthetic experience," says one respondent, although it may be "slightly different . . . it might be intellectualized in a slightly different way than [that of] a person who didn't have these associations with history. Perhaps the untrained, the non–art historian, would have associations with more personal types of history." Nevertheless, for better or worse, she also notes that "there will be more intellectual engagement in front of an object about which one had a great deal of knowledge"; it will have added to it "a different, another dimension than the experience before an object about which one had very little knowledge" (123). It may be important here to note the tension between "different" and "more" or "better." There were, however, numerous examples of both extreme viewpoints:

I would even argue that there are many art historians who don't have aesthetic experiences. They respond to objects intellectually, but they often aren't moved by the beauty of a work of art. In many ways, it becomes an intellectual exercise. (417)

I think the experience that people have depends enormously on what they are bringing to the work of art and what they are looking for. And to a certain extent that means

> knowledge. I think it's a highly individual thing. The reason
> that there is a certain amount of, let's say, agreement of judg-
> ment among professionals about certain things is that they
> are bringing a certain similarity of experience and knowl-
> edge to looking at the thing, and looking for similar things.
> Seeing works of art means much to many people, and I don't
> think it need mean that much to that many people. I think
> lots of people live perfectly happy lives without ever going
> into a museum. (402)

Most respondents, however, were unwilling to put aesthetic experi-
ences into ranking order as a function of how much training is brought
to them, but acknowledge that it is all but inevitable that training adds
something, an extra dimension of engagement and understanding. Or
as another person puts it, it is simply undeniable that "your education
has a huge impact on how you see something" (107).

Despite the obvious importance of knowledge and education, there
is more at stake than the mere application of knowledge. As one cu-
rator notes, "You can teach how something is composed, categorize it,
and show where it came from and the importance of the patronage and
the personality of the artist and all these different facets," but all of
these things "in themselves wouldn't necessarily make somebody en-
joy or appreciate a work of art." What does happen is that "at some
point . . . somehow . . . people sort of click on, and they suddenly
begin to really love the process of looking at a work of art" (109).

Informed experience is a good term to characterize the process by
which exposure to works of art gradually transforms the nature—and
the experience—of aesthetic interactions. Informed experience in-
volves developing the ability to see as well as developing understand-
ing. Many of the interviewees saw the two processes as intimately re-
lated. As one person said of "really seeing, it's not something that just
happens instantaneously in front of a work," but rather comes from a
"long process of accumulating information" (104). As many of the re-
spondents noted, it is a cumulative process, and a multidimensional
one that necessarily has the visual image at its base:

One has to have a storehouse, one has to learn to do that, one
has to have that visual baggage in order to begin to appreci-
ate other things, because it's the interconnections between
things, the serendipitous connections that one can make that
really begin to get you interested in looking at more things,
this whole fabric begins to develop. (412)

"To use a corny phrase," as another person puts it, "before you fly
you have to walk." Viewing art is not only a receptive process, he ex-
plains, but a creative one as well:

and the one way you become creative as a viewer is to keep
going to exhibits, going to the galleries, going to the shows,
read the art journals and magazines, prepare yourself as
much as possible, and you'll be amazed at how much more
you'll enjoy looking at art if you have that kind of back-
ground. (119)

Similarly: "It's very important that people read and educate them-
selves before going into a museum. . . . One should realize that, just
as when you go to an opera or a concert of classical music, you can gain
more by knowing something about the period in which the music was
written" (101).

Knowledge means educational experience combined with seeing.
"They can't know the art from simply reading about it. They have to
go and look at it too. . . . What you really have to do is . . . reading,
you have to figure out the history, the past. But then you've got to go
and look. And just look and look and look until you think your eyes
are going to fall out. And then you go back and read some more. . . .
It has to be a constant thing. You can never feel that you've reached a
level that you don't have to do one or the other anymore" (101).

Beyond knowledge and visual experience, there are the more fun-
damental conditions of "how you're brought up, with what kind of
ideas, and what you're confronted with . . . in your life" (110). What
you see and experience will always and inevitably be a function of who
you are. But what seems to matter most is the history of visual and

aesthetic experiences itself, the recurrent engagement with works of art in an intimate fashion. A number of the curators, when discussing the impact of their professional careers on their ability to experience art, spoke of the advantage of "living with" works of art. One person maintains that such extended and intimate opportunities to interact with works, to be with them daily, ultimately "makes you see a lot better" (107). Or, as another put it,

> as one learns to look, as one learns to notice details and to be able to keep those details in one's mind, to make a summary judgment, as it were, of an object, then one can begin to make quality judgments. It's not easy to do, to look at a piece of sculpture or painting and remember the bits. It's not easy to keep all of those things in your mind. (412)

One person supplied a useful illustration of the diversity of perspectives concerning these issues of knowledge and experience in conjunction with her description of a visit to one of her favorite exhibitions. For her, in fact, the situation is quite the opposite of what we have seen in the above statements:

> I don't know anything about that material, I mean I've never taken a course in it [and] part of me doesn't want to know. It's possible to keep things fresher if you don't go into them. And I can't think of anything that makes me feel better than walking through those galleries and looking at that material. . . . I don't have any of the art historical number that comes into my head while I'm looking at it. (120)

Unlike those who speak of a dialogue with an artwork, a few others prefer to be captivated by the work, overcome by it, seduced. It may be interesting to consider how this engagement with the essentially unknown may serve as a break or release from interactions that are so imbued with knowledge that the additional information detracts from the freshness of the work itself.

After calling attention to the ways in which knowledge influences

one's response to works of art, we move more fully into those psychological and existential skills that are "in the person" of the viewer. These include physical attributes as well as attitudes, motivations, and whatever else may influence the task of seeing. A surprising number of the people we interviewed (nearly a third) spoke of their own "natures." Thus, one person stated that while she was "basically a person interested in words and abstract conceptions and narrative forms and things," and her analysis of these subjects was a function of her "natural talent," at the same time she also believed that she had "a gift for analyzing visual arts and two-dimensional, three-dimensional things. . . . I have a very good eye" (106). Similarly, another person is convinced "it's something that many people have inherently; it's not something that they need to learn" (109).

The most nativist of the opinions were framed rather like the following:

> I think it's something which certain people are born with. An eye can be cultivated, but you have to have something there to begin with. And it can be fine-tuned, let's put it that way. And there's piles of education and exposure on top of that, but there is a kernel. There's a drive, there's the education, but there's something in the personality as well. (409)

Others present the same point in more elaborate forms:

> I have four children now, and each one of them, from day one, just started looking around. The oldest is now fifteen and as soon as she was born she started looking around the delivery room. . . . She sees things and she's taking it all in, and she's checking it all out. I think that *I* probably had a predisposition just to look around . . . and think about it and whatnot. (103)

> Some people are visual and some people's abilities lie in other forms of intellectual pursuit. I happen to be visual. It

Works of art that push the limits of both our definition and understanding of art may evoke strong negative reactions when first encountered. The response of many curators and collectors to the work of Julian Schnabel shows how responses can change and, more importantly, how trying to respond to the challenge of new and different works can enhance one's appreciation of all works of art.

would be fair to say that I make quicker visual connections
than other people do. (126)

Although it is unclear just how many respondents would be willing to date their present capacities to the delivery room, it is clear that some implicitly believe they possess gifts that are innate.

Somewhat less overtly nativistic in orientation, others simply note that they are "visual people." Whether by virtue of their genes or through experience, they feel they use their eyes better than other people do. It is perhaps for this reason that while an art historical background appears to some to be an absolute necessity, there are others who believe that their own abilities more than compensate for whatever knowledge-based background they do not possess.

Some curators spoke of another set of inborn skills that is not necessarily visual:

> There are people who have more or less sensibility. Meaning
> sensitivity, I suppose. I think it depends on their tempera-
> ment, their spirit, and certainly their eye. I do not think that
> it is a prerogative of educated people. I presume that if one
> has the ability to make visual connections that an education
> helps a great deal, and I think the most important education
> is probably looking: the more one sees the more able he or
> she is to put it in context and to establish a rapport with it.
> But I do not believe that everybody is able to respond. I be-
> lieve in a certain degree of elitism, I might as well admit it.
> But the elitism doesn't have to do with anything except the
> development of one's sensibility. (135)

Over and above the native skills that the viewer may possess, his or her frame of mind in approaching works of art is mentioned as another important condition. In reflecting on their own experiences, several respondents emphasized the need to look at art actively in order to experience it fully. And this, as one person quite adamantly insisted, was no small task. A major problem in dealing with the viewing public

that art professionals such as himself had become all too aware of was just how passive the use of the sense of sight can be. Indeed, like a number of other people we have quoted, he believed that there are "good eyes" and "bad eyes," or as another person put it, "tin eyes." But a number of the museum professionals, rather than attributing the various capacities of their "eyes" to nature, attributed them instead to culture and the specific forms of stimulation it offers:

> I see it all the time. Students can remember facts and figures and names, but they don't even know how to begin to re-member images. They don't know how because they've never had to do it. (412)

> I'd say most people don't have a very good eye, they have not developed their visual faculty very well. And the reason for that, especially today, [is that] we're obliterated, literally, by images all the time—TV, movies and videos, newspapers and magazines—just constantly barraged by things. One's eyes have become very much a passive instrument, one very seldom has to make any active, visual judgment or effort with one's eyes. You really have to be very consciously in-terested in getting something, in making a personal inter-pretation of something, visually, which I don't think very many people are. (111)

The contemporary viewer is simply not interested and attentive enough to face the challenges presented by the art object. If some-thing is to be gleaned from the encounter with a work of art, explained one curator, "you've got to confront it, although maybe that's a little bit harsh or aggressive a word. You have to stand in front of it. You have to *look* at it, number one. And *see* it, number two. But that's a big word, to 'see' it" (105). Once more, it is almost as if the viewer has to have courage enough to undertake the task of dealing with ob-jects seriously and attentively; it is only then that the aesthetic ex-perience can occur:

> Part of it is that you have to be open to the possibilities. You
> have to be able to put part of yourself aside and allow the ex-
> perience to take place. Very powerful works of art put people
> off; they get very defensive, get very verbal about them. And
> that's an indication of how strong the statements are. To
> have that aesthetic experience, there has to be a willingness
> to experience, an openness to experience. (133)

Another person notes that it is essential that he be in the "right
frame of mind" when looking at works of art. "As long as there isn't a
lot of competition for what I'm looking at," whether internal or ex-
ternal, the possibility of aesthetic experience will exist. "Some-
times," he goes on, "I'll be in sort of a distracted mood and come
around the corner and see something that is just so searingly beautiful
that it pushes out every other thought." But for the most part, he in-
sists, "I have to gear myself up to look; I have to say okay, I'm going
into this show or to this exhibition" (107).

Another skill for "just noticing what's there" is "a certain amount of
curiosity" (120); the viewer needs not only to attend to the object but
also to want to attend, to be interested in it:

> I think people should just bring curiosity and a feeling
> that they're looking forward to doing this rather than they're
> dreading it . . . that it's going to be pleasurable and not be-
> cause they need to see it to talk about it with their friends or
> it's a school assignment or there's some kind of duty or pres-
> sure. I mean, we have enough duties and pressures, and I
> don't think seeing the latest art exhibition should be a duty
> and a pressure; it should be a pleasure. (106)

Curiosity, in this instance, is again a condition for experience; one
must want to find out about the object, to explore it, to know it inti-
mately as well as what it is about. Yet in another sense curiosity is a
skill that the viewer both has in some measure from the start and de-
velops over the years. Curiosity about a work of art cannot be vague

and diffused but must be focused—with the kind of focus that follows from knowledge and experience. What we also see here is that the encounter with works of art needs to be motivated from within. Thus, in the words of another person, "The optimal experience is when you set out to go see something in particular and you make a point of going. . . . For example, people make what you'd almost have to call pilgrimages to see certain works of art" (111). They go, in other words, with a definite aim in mind: to see something that they want to see, something they are intrinsically motivated to see. "It has to be really done because you want to do it, and not because you're just looking at a work to satisfy the person you're with or whatever . . . to do it for yourself because you want to get something out of it . . . you anticipate that you will get something out of it" (105).

Along with attentiveness, curiosity, and intrinsic motivation is the further condition of the anticipation of reward, the expectation that enjoyment will result from viewing art. Without this reward there would be little rationale for stepping into the museum and for undertaking the effort needed to make works of art come to life. If you want the rewards, the same curator says, it is imperative that "you *work* at it. Again, I keep using that word, but it's true: it's work to get that information out of a work of art. You're only getting out what you bring to it" (105). Another person describes how all of the conditions we have been discussing must necessarily go together:

> Preparation of all kinds has got to be part of the process. It would take several forms, one of which would be [having the] intellectual underpinnings. Then there's also a preparation of yourself, you've got to get yourself together. You choose the moment if you can. You look forward to it, build up the anticipation. It's kind of like good sex: there's a lot of foreplay involved. Besides the formal preparation, there's mental preparation. And there has to be that willingness to let it happen. (133)

Given that the encounter with art often requires both considerable work and the use of a whole range of skills, it should come as no surprise to learn that support is also necessary, some form of encouragement and direction that might lead viewers to engage themselves with a measure of conviction. Role models, for example, may be instrumental in this context, "watching how other people do it, people I respect," as one person puts it. It is important to have "reinforcement from people who have come to believe in me, whom I respect as well—that kind of reinforcement gives me the permission to trust my instincts" (104).

A reciprocal relationship seems to exist between visual confidence, which can be enhanced by reliance on one's own resources, and an openness to new and unknown experiences that confront viewers and cause them to shed any "false confidence" they may possess. Connecting this idea of confidence with the issue of anticipation of reward, one person notes that

> having some measure of success in communicating builds
> your confidence, allows you to open yourself up and relax
> and confront it, confront yourself, literally to stand in front
> of a work and take a deep breath and shake it all off and open
> yourself up to whatever might surface out of that and go from
> there. The viewers [must] feel confident of using their own
> two eyes and knowing that by looking, and with their own
> experiences, they can draw enough information to make it a
> rewarding experience. (105)

While it is imperative that viewers be secure enough in their own aesthetic abilities to be able to confront the work of art comfortably and with the anticipation that some kind of reward will follow, it is also imperative that this security not become so hardened that new experiences (if we can even call them that in such a case) are merely assimilated to the old. In point of fact, it should be clear that this would not really involve security at all but rather insecurity: the flip side of one's

comfort in prejudice is the discomfort attendant on the encounter with the new, the difficult to assimilate. As one curator noted:

> There's a reluctance to feel foolish about something. If you can insulate yourself, or protect yourself from being in that position, or appearing to be in that position—appear, sound as if you are foolish about art—I think that has a lot to do with it. That has something to do with what specialization is about. (130)

To foreshadow a point that will be addressed later in more detail, it would seem that a primary role of the museum is to provide the kind of environment, both physically and educationally, that can supply the viewer with the support and confidence to confront works of art openly and honestly.

POSSIBILITIES

This section will review various ways in which aesthetic experience might be facilitated for the viewing public by drawing on the suggestions and concerns of the museum professionals. Many professionals have asked themselves the question recently posed by Susan Myers (1988): "Are museums getting in the way of the aesthetic experience?" From what has been said above, it follows that the answer must be in the affirmative. This is because any institution that sets as its goal to communicate with an audience of varied backgrounds and differing expectations is bound to disappoint some of its public. As long as the task was defined in terms of narrowly circumscribed elite values, the museum could expect a certain level of viewing skills from its audience, present its material accordingly, and be certain that it had fulfilled its mandate. But if the museum's role is interpreted more broadly as a mission that encompasses all age groups, cultural origins, and social strata, then it becomes extremely difficult to design a program of communication that will be effective and meaningful across a broad range of the potential audience. These "conflicting visions," as

they have been called, are one of the central concerns of the modern art museum (see Zolberg 1981, 1984).

How can a museum help viewers to experience the expanded state of consciousness that a rich encounter with works of art can provide—given that the level of relevant skills in the audience is so variable? Whoever could answer this question would solve one of the central problems facing museum curators and educators. Since there is no definitive answer, we propose possible solutions. One option is to approach the communicative task in a frankly experimental fashion—by specifying the variables involved in installations, by varying them one at a time, and by recording the effects of changes on the audience. Many museums are already embarked in such experimentation. For instance, the staff at the Denver Art Museum, including educators, curators, and members of the publication department, with the help of a J. Paul Getty Trust grant, used ideas from an earlier draft of the present volume to design five experimental variations in labeling for their museum. Some of these labels were extremely innovative and effective in stimulating audience interaction with the work of art. With time, results of similar studies will accumulate, making it increasingly possible for museums to facilitate the aesthetic experience.

At this point, however, we will restrict ourselves to suggestions made by our sample of museum professionals. Beginning with some obvious issues, several called attention to the need for good lighting, for fewer or less intrusive museum guards, for more benches and rest rooms, for areas conducive to calm relaxation, and for refreshments, as well as the need for effective handling of such recurrent problems as crowds and noise. Most generally, they insisted on the importance of eliminating distractions, thereby helping the viewer to see something and benefit from it. Taken together, these suggestions relate to one of the basic conditions of the aesthetic experience: the focusing of attention. If museums could provide a pleasing environment and at the same time prevent intrusions, works of art would have a better chance to make an impact.

More often, however, the predominating concern was with the

viewers' skills: how to provide didactic information and other support for enhancing the viewers' confidence and motivation. Often these goals were directly related to the provision of a psychologically secure environment. Let us now turn to the first of these issues, namely, what kind of didactic information is the most effective.

The kind of prior knowledge seen to be necessary in order to benefit from an encounter with a work of art is in large measure dependent on the respondents' professional responsibilities. Those working in museums with many archaeological artifacts, for instance, have different opinions than those working in museums of contemporary art. For the former, didactic material is deemed necessary simply to allow viewers to know what they are looking at; an unfamiliar object should be identified. In the case of contemporary art, however, some professionals feel that any form of explication should be avoided, for it would relieve viewers of the challenge of coming to terms with the work on their own.

As a curator of ancient art states:

> I like to see more information. For instance, there's a wonderful development of Chinese ceramics from the earliest periods up to the Ming dynasty, and it would be nice to have something of a chronology mentioned, a map of where the centers for producing these porcelains and earthenwares and stonewares are; how it relates to what was going on in Japan and Korea; the impact of oriental art—the blue and white—on what was going on in the West at the same time, and what was going on in the Islamic nations. All those are really important to the education of the museum-goer, and yet you just don't see that sort of thing in the museum at all. (113)

Referring to a specific hall in the museum in which she had until recently worked, she laments that "there really isn't much information; there's no information telling where the reliefs came from, how they fit into the whole palace, what Assyrian architecture was like at that point, what it meant . . . giving palace plans, relating the frag-

ments that we have to what the original looked like." Thus her goals there involved "doing a lot of graphics and maps and palace plans and everything" in order to begin to rectify the situation by supplying the necessary skills for a meaningful experience. "I think it varies," as one person succinctly states, "depending on the material and the degree of unfamiliarity. Some shows really do require more explanation" (101). Another respondent, musing on similar issues, says that for her the optimal conditions

> would have something to do with looking at one thing at a time, in a dark space, where you heard the conversations of the people of the period in the picture talking to each other in the language they were talking, and you had the music that was appropriate to that period, and you had, say, a hundred quotes from writers of the period describing things that had something to do with the object that you were looking at. Although I don't think a great work of art needs it, the more you bring to it and the more you pump into it, the more interesting it's going to be for you. (120)

While didactic information is often desirable, most respondents agreed that it must be presented in an unobtrusive manner, perhaps through discrete computer terminals. Additionally, many thought that museums should also have accessible information, such as a library, as is stressed in the following description of one curator's idea of the optimal context:

R: A pleasant atmosphere, proper space to work in with all the resources you want close at hand. Those things certainly are necessary.

I: O.K. Resources, meaning . . . ?

R: Oh, references, catalogues, photographs of comparable material, other vases. But having all those things close by. It's hard to just run down five miles and flip through the stacks of periodicals or whatever else. That's not optimal. You

> sometimes lose the moment or the momentum or both. This
> suspended by itself is nice, as a type of experience for a
> while, but you also want to look at what goes with it, and how
> does it fit into the overall picture, the context. (420)

It was repeatedly noted that a good museum provides a sort of di-
dactic environment that extends beyond the wall labels and enhances
aesthetic experiences immeasurably:

> Seeing a work of art in [a less comprehensive museum] is not
> going to mean as much as [seeing] the same work here, be-
> cause you have the good companions that surround it and
> make it resound a little bit more. And having a great library
> behind you to stretch your mind about it and what it is doing.
> You need all of those ingredients. (131)

Information of various sorts is sometimes called for, and it should be
presented with a measure of subtlety and sophistication. The main
point is that it be accessible if it is wanted.

For a few respondents, virtually all information is superfluous: "If
people are allowed to just be there and look, that's good enough. If
it's quiet and if there's good lighting," the possibility will exist "for
experiencing [art] on an important level" (104). Convinced that the
genuine work of art can speak for itself, this curator thinks there is
simply no need to have anything else ready for the viewer—not before,
not during, and not after. "I guess if I was going to build an experience
for someone," another person put it, "I'd put one great picture in a
room . . . and that's it, [one] per room." In this way the museum
would be "forcing you to focus in on something" (111). And from his
perspective, this is exactly what it should do. Yet most of the curators
were acutely aware that the presentation of informative material was
not an all-or-nothing proposition:

> You walk a difficult line; sometimes exhibitions are pre-
> sented almost as illustrations to theories. There are some
> shows that you walk through and people are more interested

in reading the text accompanying the show than in looking at the works of art. And to me, that is an imbalance, because your first reason for existing is the care and the presentation of objects, the creation of a visual experience. I have a problem with museums that have gone the way of Walkmans and wands. When you go into those kinds of exhibitions, you often see people walking along, looking down at the wand in their hand, and they're *hearing* the exhibition, but they aren't *looking* at it, or they're being channeled to look at only what they're being told to look at instead of exploring it for themselves. (101)

With these kinds of distractions and without control over what they are looking at, it seems virtually impossible for viewers to achieve anything even approaching an aesthetic experience.

The awareness of this thin line between too little and too much information leads most of the respondents to believe that the presentation of didactic material, if it is not to undermine the aesthetic experience, must be done subtly and with clear goals in mind. One person directly involved in museum education had both exceptionally clear goals and a realistic sense of what could be accomplished:

The challenge of making an audiovisual presentation and putting it in a museum is to take the work of art and find a way of transforming it or abstracting it or doing something with it which makes it accessible to the mind of the person who sees the picture or looks at the sculpture. I think there are very powerful ways that A.V.'s can do that. It can open up aesthetic awareness and perception, I think, in ways that are not generally understood, but are very powerful if done well. If you put somebody in an exhibition—let's say you only have ten minutes to do something that isn't just looking at the work of art—you can read a label, or you can hear a story, or you can do whatever. What I'd do is give them a ten-minute A.V. which takes a whole set of historical ideas and

> aesthetic viewpoints and all these other things and com-
> presses it into a succinct statement which serves as a transi-
> tion for the visitor between the neutrality of walking in, to
> the experience of being engaged with those works of art
> when they're actually in the show—really thinking in rela-
> tion to them. (127)

All these suggestions imply that enough information should be present to set the experience in motion, either by clarifying the challenges of the work or by enhancing the skills of the viewer, but that it not be so heavy-handed that it subverts the opportunity for active discovery. Aside from the more intellectual information provided through labels, audiovisual presentations, or printed matter, a number of museum professionals discussed ways in which, through the presentation or installation of the works themselves, perceptual and visual skills might best be enhanced.

Particularly important in this context is the idea of juxtaposition: "pictures are set next to one another or with objects" in such a way "that it allows one to do a certain amount of comparison" on one's own (101). Likewise, while another person acknowledges that "we normally group objects chronologically or by nationality," which is "probably the easiest and most straightforward way to present works of art," he also points to the possible importance of juxtapositions whereby "people can learn by looking at related objects" across both time and media.

Another frequently mentioned vehicle for facilitating aesthetic experience is education that takes place outside the confines of the museum itself, both in the context of formal instruction and on the viewer's own. One curator sums up the issue:

> I think one of the main barriers in approaching and dealing
> with art is familiarity. We are taught how to read, and we
> were taught language, and we can recognize those words and
> sounds. And these are skills which we learn in school, but

> we don't learn visually how to read a painting or how to look
> at art. And that kind of compositional study is a way of read-
> ing the painting. Then, of course, one can read it culturally
> and in terms of the society of the time that the artist lived.
> And one can read it intellectually in terms of the ideas and
> work from there. But there's always some aesthetic end to
> it, too. (112)

Bringing this problem back to the museum and what its possible re-
sponsibilities are, aside from the display of objects, another person
contends that "It's very much in the interest of museums to be train-
ing or educating their own future public" (103).

Parallel to several of the conditions discussed in the first section of
this chapter, the most basic avenues for facilitating meaningful en-
counters with works of art seem to derive from the interpenetration of
knowledge and experience. If they are to obtain maximum benefit
from the experience viewers simply cannot enter the museum empty-
handed; they need skills, especially visual ones, and they need prac-
tice. One respondent in particular stressed the fact that education, in
concert with the museum experience, can also assure that the viewer
does not *leave* the museum empty-handed. This person indicates one
of the primary motivations for seeking to facilitate the aesthetic
experience:

> The one thing the museum is trying to develop is a sense of
> personal taste on the part of its audience . . . develop some
> knowledge and with that knowledge some confidence in the
> individual that his taste can exist, and it's important. I call it
> visual literacy. If you can't read, you know that you're defi-
> cient. If you can't make aesthetic distinctions, people are
> less immediately aware that there's something deficient. But
> if people don't develop that confidence, they're deprived of
> a tremendous source of pleasure. And they're deprived of a
> tremendous way of expressing their identity, of taking pride

> in and molding the environment they live in, the objects
> they surround themselves with. They become prey to all of
> the materialistic, advertising forces which are constantly
> telling everyone what they should do. I would much rather
> see that we were giving them a little confidence and a little
> interest in the fact of developing their own tastes; to me that
> would be much more important than sending them away
> with knowledge of a bit of art history. (128)

As this discussion indicates, confidence is perhaps at once a prereq-
uisite for and a result of meaningful interactions with works of art. To
engender both the experience and the confidence, what the viewer
seems to need above all is that sense of support, security, and trust
that we earlier found to be the most basic precondition for aesthetic
experience.

In addressing this issue, we may find it useful first to consider some
of the negative conditions decribed by the museum professionals.
"Where so many people get into trouble" is that "they're looking for
these neat little packages that will spell things out for them and make
it instant love or instant hate or whatever it is" (119). The viewers
themselves, this person indicates, are inclined toward being formulaic
when dealing with works of art; they want answers, solutions to the
frequently baffling things they are confronted with. "It's a scary thing
to do," as another person puts it, "because you're never sure if you're
right." Yet even the recognition, noted above, that "there is no ab-
solute, one, right level on which to read a painting" often cannot
lessen the anxiety of dealing with art objects "alone."

To this group of professionals, it is painfully evident that people
come to these encounters "with a lot of cultural hang-ups, particularly
in the area of contemporary art . . . they're hostile about it . . .
they're not ready to look or give in at all" (112). And insecurity and
hang-ups can often harden into prejudices, even outright rejections.
So many people, says another curator, "are afraid that they're not hav-

ing the right response," even though—at least from her perspective—
"it doesn't matter." As she puts it,

> Who cares? The sad thing is that a lot of people don't have
> the response because they don't think that they're supposed
> to, or they don't think that they're allowed to, or they don't
> think they know enough to. And really, it's real simple; it's
> just like looking at a sunset or something out the window.
> You have as much right to look at a work of art as anything
> else. And all that stuff that gets in the way is what seems sad
> to me. (120)

Another person agrees that "a lot of people are intimidated or feel like
'Oh, I don't get anything out of this, but maybe I should.'" There is
also that "very scared attitude," the inability to believe "that it's an
instructive, enriching experience." Some visitors, she continues,
seem to feel that "they're going to be tested on their knowledge or
something like that" (106), the anticipation being that they cannot
help but fail. To state an extreme: "Some people get so set in their
ways" that they become "welded" to "very tacky, tasteless things be-
cause they've never been given the benefit of liking what they like at
any period in their life—they've always been looked down at as 'Oh,
you can't possibly like plastic flowers!'—they get defensive . . . these
objects become offensive things to them rather than constructive
things." What must be done, she says, is "break that cycle." She in-
sists on "stopping the defense mode" so as to "continue the cycle of
learning and improving throughout a lifetime" (106). We will examine
now how this might be done.

It is necessary to "get people confident enough to enter art's pres-
ence and interact in the presence without worrying; somehow mu-
seums have to instill that confidence in people and the ability to trust
in their own two eyes, their own, and no one else's. And that's a hard
job" (105). Nevertheless, museums must try to "reach that audience,
to put them at ease, to make them feel that what they have is more

than enough . . . making them feel confident somehow, coming in and entering it on whatever level; you know, 'whatever they have is great.'" In a word, the museum should try to support viewers, let them know in some way that they are not necessarily as devoid of the capacity to experience as they may think.

"I have the feeling," another person muses, "that they are standing around surrounded by this very aggressive material, thinking, 'What is it I'm supposed to be thinking about this?' I mean, we live in a very self-conscious culture and there's the illusion that everybody is informed about everything. But I really think what they're informed about is like the last twenty minutes." Thus, she suggests that it may be useful to try to link up the new with the already known, for instance "to look at Frank Stella and think about Caravaggio," which is exactly what she has done in her own slide presentations. In this manner she can "add solidity to what the present is and also bring an object from the past up into the present" (120). Rather than trying to use the present as an anchor, as curators who spoke about connecting art to life experiences suggested, in this instance it is the past that is used. With its solidity—and indeed legitimacy—it may serve to render the new as less alien and distant.

This is especially needed, she notes, for "special" exhibitions, where "we get the same crowd you get at the Cubs game. . . . I feel as though if you can provide some kind of context for that or to open up what the exhibition is about for them, that that is a useful kind of activity." Because there is a lot of content to deal with, this educator deems it necessary to make it "less mysterious and more accessible to people." In all honesty, she indicates, "I don't believe people fall in off the street and have aesthetic experiences, I really don't. I think they need all the help they can get. . . . Hopefully in the end, the ultimate experience is the experience with the real works of art" (120).

A further problem is that "most people," as one respondent believes, "are really much more interested in art information than they are about the art itself. They'd rather know all the intimate details of Picasso's relationships with his mistresses and wives than try and un-

derstand what was so revolutionary about Cubism or collage or assembled sculpture" (103). The trick, he says, is "trying to find ways to push the possible as far as I can go without turning people off," even if it means using cartoons and the like. "I try to find ways of trying to let people know that serious things can be discussed sometimes in a lighthearted way." Most important, it is essential to take any and all measures that can prevent people from feeling "at a loss." In these few statements, we can see the issues of attention, prejudice, the hook, as well as the recurrent need for confidence and security, all emerging in full relief.

In a similar fashion, one expert noted that she herself would "rather look at one type of work than another." She asks:

> Why shouldn't I give the benefit of that to another person, even if they may prefer looking at clown pictures than de Kooning. But okay, let's give them the best clown pictures then. And then maybe because of that, they will be able to look at de Kooning. You know it's always a step up: you can't really start . . . you have to learn how to crawl before you can ever walk. (106)

For this person, the aim is not to meet viewers halfway, as it has been for many of the others, but in fact to meet them all the way, to take them strictly on their own terms. Most professionals holding this view did *not* believe that people ought to stay there, of course, looking at cartoons and clown pictures. But it may be that this egalitarian ethic is, in some instances, the prerequisite for any development of the necessary skills at all. In almost subversive fashion, perhaps viewers of the type being described here can be shown the way only after their own interests and needs have been fully met and reinforced.

As one corporate curator tells it, you have to be able to compromise all the time:

> You have to deal with bad art, you inherit bad taste, people with bad taste, and you have to somehow go from where they

are. You can't walk in a museum and say, "Well, if you don't
like this, you obviously aren't educated, that's all, and come
back to me when you are." . . . I mean people come in and
they'll say, "I hate, I really hate abstract art." And I go,
"Well, do you like Cézanne? Do you like this?" And I'll show
them a Cézanne . . . and I'll say, "Well, that's very abstract
if you think about it, you know," and talk about the trans-
lation of a three-dimensional to a two-dimensional surface
. . . you start to think of ways to deal with that encounter,
not threaten people. (125)

In conclusion, what do these interviews suggest about how the mu-
seum environment may facilitate the aesthetic experience? The gen-
eral outlines of a conceptual strategy are fairly clear.

First, the museum should communicate to the viewers that viewing
art is its own reward—a chance to embark on an adventure that will
challenge their senses, their emotions, and their knowledge. Within
this general goal, and depending on the viewer's level of skills, a num-
ber of more specific and graduated challenges might be provided, in
recognition of the fact that without a sense of purpose the encounter
with objects, and therefore the entire museum visit, is bound to be
diffused and unsatisfying.

Second, the viewer ought to be made to feel that there are no right
or wrong responses to the objects displayed. Instead of being a place
that promotes one correct way of responding, the museum should try
to encourage a sense of adventure, of openness. After all, the artists
who created the works on display more often than not were them-
selves iconoclasts searching for new values and new forms of expres-
sion. At the same time, it should be made clear that viewing art is a
complex, challenging proposition.

To help the public develop the skills necessary to make the expe-
rience rewarding, the museum should—in a departure from the tra-
ditional museum presentation of art objects that implies only art his-
torical information is relevant—provide a diversity of tools that

highlight the perceptual, the emotional, the cognitive, and the communicative content of the works. While basic art historical data may be sufficient for the expert, it fails to address the needs of the vast majority of the public. It is important that these tools—ranging from audiovisual aids to labels—be readily available, but it is even more essential that they do not distract the viewer from the encounter itself.

And finally, the optimal installation of art objects would help induce the flow experience in the viewer by promoting concentration and avoiding distractions. It would seek to relieve members of the public from self-consciousness, from concerns about time, hunger, and fatigue. It would take into account the visitors' need for controlling their own end of the interaction by allowing choices in terms of space, time, privacy, and information. It would find ways to provide feedback to the viewers' responses, thereby making it more likely that the dialogue between person and object will continue and become more complex.

In principle, these strategic requirements for enhancing the aesthetic experience are quite clear. How to put them into practice within the institutional constraints of a modern museum obviously poses a number of very difficult problems. But perhaps this blueprint, together with the ingenuity and perseverance of professionals in the field, will help museums to take their cultural mandate one step further. In addition to being repositories of past excellence, they might then become dynamic workshops in which the consciousness of an increasing proportion of the public is enriched by more complex experiences.

Cycladic Harpist. Aegean,
circa 2500 B.C. Island marble,
35.8×9.5 cm (14⅛ × 3¾ in.).
Malibu, J. Paul Getty Museum
85.AA.103.

A knowledge of the historical and cultural context
in which a work of art was produced generally en-
hances the quality of the aesthetic experience. For
example, this Harpist carved in Greece approxi-
mately 4500 years ago is not likely to appeal to the
untutored eye because at first glance it appears
crudely made even though the object radiates
strength and serenity. If the viewers are aware of
the provenance and function of such funerary statu-
ettes, however, they are more likely to be impressed
by the relative sophistication of the object and will
devote enough attention to it to begin reaping the
benefits of its art.

CHAPTER 6

Conclusions

THIS STUDY was undertaken in order to arrive at a better understanding of what constitutes the aesthetic experience, so as to make it possible for more people to derive a more intense enjoyment from the use of their visual faculties. What have we learned as a result of this systematic inquiry?

Perhaps the basic contribution of this study is to suggest the importance of conceptually separating the *content* of the aesthetic experience from its *structure*. Past thinkers have recognized the universality of the structure of the experience, remarking on the ubiquitous centering of attention, sense of clarity, wholeness, freedom, and other qualities that characterize the experience. From these similarities they erroneously concluded that the content of the experience must also be universal. If a particular philosopher encountered the work of art primarily on a formal level, he ascribed the power of arresting attention to the formal qualities of the work. If another approached the object mainly in terms of emotional empathy, he would conclude that it was the emotional charge of the object that produced the experience—and so forth for the other dimensions of experiencing, such as the intellectual or the communicative, with all their numerous variants.

In other words, a certain monolithic intransigence has characterized previous approaches, each of which has claimed to hold the keys to the aesthetic realm. It is clear why this happened as long as the content of the experience was not differentiated from its dynamic structure. But as soon as the two are seen as separate issues, it becomes much easier to see that while the felt quality of the experience may

be the same for every aesthetic encounter, the details that make the experience possible are infinitely varied.

The consequences of this change in perspective are far from being of academic interest only. A major implication is that we are free to be as eclectic as possible in approaching art and in educating people to appreciate it. The criterion for the aesthetic encounter is not the adherence to a canon of essential attitudes—be they formal, historical, religious, sociological, emotional, or any other. Any or all of these will do. The criterion for the aesthetic experience is the experience itself, however it is arrived at.

This claim might prove to be liberating, but if this were all we learned from the study, it would not be much. Fortunately, we have also come to a more detailed understanding of what the structure of this experience is like, what makes it possible, and how it changes over time. This knowledge, in turn, gives us a better idea of how to maximize the frequency and the intensity of the aesthetic experience.

To summarize the results of this investigation, it will be useful to give a possible basic definition of the aesthetic experience. On the basis of what we have learned, we can define it as an intense involvement of attention in response to a visual stimulus, for no other reason than to sustain the interaction. The experiential consequences of such a deep and autotelic involvement are an intense enjoyment characterized by feelings of personal wholeness, a sense of discovery, and a sense of human connectedness.

Note that this definition only deals with what we have called the structural elements of the experience, rather than with its content. The content enters the discussion in terms of two sets of preconditions that make the experience possible: the challenges contained in the object and the skills of the viewer. As has been detailed in Chapter 2, the challenges of art are mainly of four types: the formal structure of the work, its emotional impact, the intellectual references it carries—its art historical, cultural, historical, and biographical implications, and the communicative possibilities it presents—and the op-

portunities it creates for a dialogue with the artist, his time, and within the viewers themselves. Without this content there would be nothing to arrest the viewer's attention, and consequently there would be no experience.

The questionnaire results reported in Chapter 3 have shown that while the structure of the aesthetic experience is rated in similar terms by all the museum professionals regardless of age, training, and present professional specialty, the relative emphasis on content varies considerably. Thus the quantitative data confirm that while the same dimensions—such as clarity of goals, feedback, the perception of challenges, the use of skills—are equally important parts of the aesthetic experience, the actual stimuli that will trigger the experience are very different for different people. For example, the curators of premodern art trained in art history may tend to perceive the challenges of the aesthetic encounter mainly in terms of knowing more about the object, while art educators may see the challenges as communicating the content of the work to a wider audience.

Corresponding to these varied opportunities for action are the skills the viewers possess. These will allow interpretation of and reaction to the challenges contained in the work. A certain amount of visual discrimination seems to be indispensable. The theoretical model suggests that a person with only rudimentary perceptual skills, a person who has never exercised visual discrimination to compare, contrast, and evaluate visual stimuli, will be unable to derive an aesthetic experience from any but the most simple forms. Only when challenges and skills are nearly in balance does attention become focused. Consequently, a complex work of art will engage only a person who has developed complex visual skills. Probably for this reason, the questionnaires have shown that all museum professionals, regardless of background or present specialization, equally endorse the importance of formal responses to the art object.

Emotional responsiveness, knowledge of the period, of the culture, and of the artist, a familiarity with techniques and schools of art, a willingness and an ability to communicate with the work and its

contents are the other skills viewers must have in order to interact with the opportunities presented by the art object. None of these skills is essential, but they all can enhance the experience. The depth or complexity of the aesthetic experience—but not its intensity— depends on how many of these dimensions are used in the interpretation of the work.

There seems to be a developmental trend in the interaction with works of art, a trend that unfolds in similar stages during the course of a person's life. It appears that many people are first attracted by the visual impact of the formal qualities of objects, such as an unusual and strong shape or a vivid color combination. Biographical references and emotional content are often the second step. Intellectual challenges are usually discovered later, and sometimes unwillingly. Some people apparently resist using intellectual skills to interpret objects, for fear that attending to historical or sociological dimensions may interfere with the sensory interaction, disrupting the concentration necessary to sustain the experience. From this they deduce that an intellectual approach is antithetical to the real aesthetic encounter. While this might be empirically true in their cases, it is certainly not true in principle, for when people become confident in their intellectual skills, they can seamlessly integrate the intellectual dimension of interpretation with the perceptual or the emotional dimensions, without becoming distracted and thus disrupting the experience. In fact, when these different skills are brought to bear on the object simultaneously, the experience becomes inevitably more complex and profound.

However, a related study of art collectors (Robinson 1988b) suggests that there is no exact sequence of development a person must follow to become an expert in art. What type of art one begins with, and for what reasons, does not seem to matter. One person's fascination with art may be the result of long-standing family tradition, another's the result of a fortuitous accident. One person may start responding to emotional qualities in the work and then become interested in its historical dimensions, while another may start out being intrigued by the personality of an artist and years later develop

sensitivity to the technical qualities of certain works. In other words, in terms of content there does not seem to be any clear-cut sequence of how a person becomes an expert in art.

There is, however, a very interesting and important pattern that distinguishes collectors in terms of the structure of their aesthetic development. To put it simply, some people never change the way in which they respond to works of art. Year after year, they see the same challenges, and they do not develop new skills. Other collectors, however, begin to see new possibilities in works of art as their familiarity with them increases, and they gain mastery in new areas of expertise. Collectors of this type tend to have more complex responses to art (that is, they relate to more dimensions of the work), and their responses tend to be organized in aesthetic frameworks held together by a personal project rather than by social conventions. Thus one might say that development of expertise in art consists in leaving open the possibility of experiencing new dimensions of art objects.

In certain domains such as mathematics, or science, logic, and even morality, psychologists claim that learning must proceed by certain irreversible steps. For instance, in mastering numbers one must first learn to operate with concrete quantities before learning to manage abstract ones. Therefore it has been customary to expect that all development must be sequential and irreversible. At the very earliest stages of aesthetic appreciation, in the first years of life, there might indeed be such clear-cut steps in the development of aesthetic responses. It seems, for example, that the first criterion small children everywhere apply to a drawing is whether it is messy or not. If it is messy, they dislike it; if it is not, they like it. But such simple distinctions are soon overshadowed by the complexity of challenges works of art present. With young adults, it does not seem to matter whether a person is most responsive to the cognitive, the expressive, or the visual elements of art. What does seem to matter, however, is whether this responsiveness is personally meaningful, and whether it becomes progressively more complex with time.

If all of this is true, the aesthetic experience can be taken as one

form of flow, or optimal experience, related to many similar experiences that share the same structural attributes—deep concentration, a sense of control and freedom made possible by a balancing of challenges and skills, and a continuous development of meaningful complexity—experiences that follow immersion in religious rituals, in athletic competition, or in the performance of music or playing chess, in fact, any of a great number of structured interactions with the environment that result in deep enjoyment. Why, then, are these experiences so enjoyable that they are pursued for their own sake?

At some point neuroscientists will no doubt identify a chemical change somewhere in the central nervous system that takes place whenever we enjoy what we are doing. When that happens, most people will say, "Oh, I see, enjoyment is nothing but a matter of biochemistry. It is caused by chemical changes in the brain." Such a molecular explanation unfortunately will not be very illuminating, because an equally justified inference would be: "A chemical change in the brain is caused by enjoyment." A relationship between, say, endorphin levels in the brain and a subjective sense of joy would not tell us much about the experience. A more pertinent account might identify the adaptive significance of enjoyment within an evolutionary framework. At this point we can only speculate, but it is worth considering what that connection might be.

Every organism must be motivated to carry out actions that will ensure its survival. The most common mechanisms that have evolved to motivate living organisms are pleasure and pain. In the human species the two most basic survival necessities, eating and reproducing, have become connected through evolution with feelings of pleasure. This connection ensures that individuals will be motivated to remain alive and reproduce, thereby allowing the continuation of the species. Presumably, animals that did not develop this association between eating or sexual activity on the one hand and pleasure on the other—and that had no other means of ensuring that these activities would be carried out—had fewer incentives to grow and to multiply and therefore had a lesser chance of surviving.

But feeding and reproduction are certainly not the only survival parameters for such a complex organism as a human being. Humans have prospered as a species only because they have been able to find opportunities in environmental niches to which they were not originally adapted. The human presence in the world has taken the forms of a constant discovery of new challenges and a concomitant urge to develop new skills. It may be suggested, therefore, that the human propensity to find challenges and to develop skills is the result of this process having become linked with an enjoyable experience, just as food and sex have. Of course this does not explain how the linkage has come about, but it does suggest why the flow experience, based on a balancing of skills and challenges that inevitably leads to higher levels of complexity, is so enjoyable.

To identify the commonalities between the aesthetic experience and the flow experience is only the first step. The next question becomes: What differentiates the aesthetic from other kinds of flow experiences? Clearly the peculiar nature of the challenges contained in art objects and the skills required for interacting with them define the specific quality of the experience. Aesthetic enjoyment differs from other kinds in that the skills required are interpretive and lead to a sense of unfolding discovery—a discovery, to be precise, of human experiences. The visual arts provide this sense of discovery in the form of concrete objects that embody human action.

All flow experiences lead to a more intense interaction with the environment, to a development of potentialities: in sports a person becomes more disciplined and increases his physical fitness; in chess the discipline leads to heightened rational processes and a keen competitive edge. The aesthetic experience develops sensitivity to the *being* of other persons, to the excellence of form, to the style of distant historical periods, to the essence of unfamiliar civilizations. In so doing, it changes and expands the being of the viewer.

It is not an exaggeration to say that these features of the aesthetic encounter have a vital bearing on the survival of the human species. While reason and science help us to know and control the environ-

ment, they are not particularly well suited for helping us to understand ourselves and one another. Total involvement in an aesthetic experience forces viewers to confront their emotions and values and provides a taste of sharing the essence of other beings, other ways of life. If evolution—as distinct from technical progress—is to continue, then the aesthetic experience will play a central role in it.

Of course none of this means that the only way to achieve this state of consciousness is by looking at works of art in museums. As so many of our museum professionals have stressed, a person with skills in visual interpretation can be involved by forms in any context—the subway or a Mexican village will do as well as the National Gallery. Yet museums have the responsibility to preserve the best challenges art can provide and to develop the potentials of viewers to appreciate them.

To increase the number of people who can respond to the challenges of art and to increase the interpretive skills that heighten the experience is no easy task. The intensity of enjoyment so evident in the interviews of these professionals is rare. It can be achieved only by those fortunate enough to have an extraordinary sensitivity to visual stimuli, or by those who have invested much time in looking and interpreting what they see. Most of us are not so lucky; many are born with "tin eyes" and lack the time to learn how to see. The development of potentialities in every domain requires investments of time and energy that must come at the expense of some other achievement. Chess masters must constantly hone their skills at the game and have little opportunity to do anything else; good musicians must constantly rehearse to stay in good form. Art, said Emerson, is a jealous mistress.

Given that there are so many competing goals to strive for, is it realistic to hold out hope for an increase in visual literacy for the general population? We might take the Roman saying, *Ars longa, vita brevis* (in addition to its more traditional interpretation) to suggest the futility of expecting large numbers of people to develop their aesthetic skills when faced with the shortness of life. Yet the enhancement of self that

the aesthetic experience uniquely provides is too important for any culture to neglect.

The structural model of the aesthetic experience, already so often invoked in these pages, suggests some principles for how that experience might be optimized. In the first place, we have seen that concentration on the object is essential. No matter how great the works of art displayed, they will not be able to engage the viewer as long as there are distractions competing for his or her attention. The most obvious task of museums is to provide ways for this intense concentration to occur.

But even stillness and focus are not enough to attract viewers' attention to the object, unless they have clear goals or some idea of what to expect from the encounter. The goal of most visitors is simply to "do" the museum, to walk through it so that they can say they have been to it, nodding on the way to those familiar objects that justify the institution's renown. It is what one of the curators aptly termed a "Rolodex" approach. Few visitors plan to meet the challenges of the artwork, to wrestle with the meaning it contains. Even so, occasionally a piece may arrest the casual visitor, forcing him or her to come to terms with one or another of its dimensions. But trivial goals tend to set up expectations for superficial encounters, which prevent the experience from progressing very far. It would be difficult for a museum to transform the viewers' goals through direct didactic intervention. It seems more effective to change the expectations of the audience by installations subtly designed to suggest dimensions of challenge that the viewer might recognize and respond to. Traditional displays might unfortunately reinforce the expectation that all the audience has to do is parade in front of the objects.

But supposing that a work does arrest the passerby; often that involvement will be aborted for lack of clear feedback. What the curators call self-confidence and assurance in the art encounter is a sense of control based on knowing how to read the feedback to one's interpretive moves. Each feeling, each response to the object can be

tested by looking for new evidence that will confirm or call into question one's first impressions. Yet this process of discovery requires confidence bred of experience and training—precisely the skills that the layperson lacks.

Eventually the argument comes back to the same conclusion: without skills to recognize the possibilities contained in the artwork, the experience will remain shallow. Without sensitivity to the power concentrated in a well-made object, without interest in the feelings embodied in it, without curiosity about the existential context from which it sprang, even the most moving work will remain mute. Just one of these skills is enough to launch the experience, but in the absence of any, not much can be expected.

The difficulty museum educators face is that they cannot plan for a universal hook to engage the attention of the visitors, whose skills are diverse and generally unknown. Therefore, they cannot plan for a point of entry that would bring the challenges of the work of art into balance with the undeveloped skills of the various viewers. Aiming for the average is sensible but largely unsuccessful, because there are in reality few average persons, or at least they are average in very different ways. A better strategy is for the museum to provide as many bridges as possible between the viewer and the art, drawing on all the dimensions that the work contains, from the historical-anecdotal to the starkly formal. But this bridging between skills and challenges must be done in an unobtrusive way that will not diminish concentration on the work itself.

If these suggestions sound like instructions for how to square the circle, the impression is not far off the mark. It is extremely difficult to lead a person to experience something he or she has no interest in or has no abilities for. In a culture as concerned with the bottom line as ours is, people feel that investing effort in the pursuit of material goals makes sense, but that such frills as the appreciation of art should come naturally. As one curator heatedly complained about the casual way in which people assume that he has special expertise:

No, it is, it is so sad sometimes. These naive and trusting people have been brought up—I don't know how . . . that it is possible to . . . "You know, I have so much trouble deciding what's good and what's not good, and I would like to buy for investment." That's the first thing that riles me. Oh, I'll give you the typical comments that people make. "Oh, and you have such wonderful tastes." That's another thing that makes my bile rise [laugh]. It's not a question of tastes. "Oh, could you just sit down and tell me and explain to me how . . . " And then, in a way, that is very condescending because I . . . Damn it, I worked very hard to reach that point. . . . And I read great, huge, thick books when I should have been doing [other] things. And I, I worked for it. (115)

To develop fully the skills necessary for aesthetic interpretation is hard work. Few people can be expected to develop the required discipline. But the chances for expanding the boundaries of the self that art provides are too valuable to let them pass by. There is no question that the life of every member of society would be impoverished if the skills for encoding human experience in works of beauty, and the skills for decoding it, were lost. We would then be sentenced to live within the limits of our actual existences, blinded to the meanings embodied in the work of those who have struggled to find new ways of construing our experiences, of those who have tried to create order in the human condition.

From these interviews with expert practitioners of the aesthetic experience, we have learned to understand more clearly the vast potential for communication across sensory modalities, persons, and ways of being that the work of art is capable of releasing when a prepared consciousness encounters it. We have also learned more about the intensity of experience thus generated and about how its dynamics change with time and experience. And finally, we tried to

develop a systematic beginning toward understanding how to make this experience, and the conditions necessary to sustain it, more generally available.

Yet whatever contribution this study has made is only a first step in a long process aimed at better understanding. Even the great variety of interpretive skills represented by museum professionals does not exhaust all the potential approaches to works of art. Artists, art teachers, critics, and the public at large might bring to light different ways again of encountering works of art—and the claim that the aesthetic experience enriches life, convincing as it is, will have to be more accurately tested. While further evidence is desired, this study has shown, through the words of men and women who have dedicated their lives to caring for works of art, that the aesthetic experience is one of the most ingenious vehicles for making life richer, more meaningful, and more enjoyable.

Interview Questions for
Museum Professionals

Version 4CU (museum professionals)

a, b, etc. indicate probes to be used if topic not covered in main question

A. BACKGROUND AND CAREER INFORMATION

(try to keep Q's 1 and 2 to 20–25 minutes total)
(note, getting a C.V. would be extremely helpful)

1. We'd like to start out by getting an idea of how you came to be in your present position. Perhaps you could give me a brief sketch of the course of your career, maybe beginning with your education and leading up to your present position. (probe to be sure to get: special training—i.e., internships and prior positions)

 1a. (if necessary) How was it that you first became interested in this profession?

 1b. (if necessary) How did you come to be involved with the particular (period, style, type—whatever) of art that you deal with in your position here?

2. Could you explain a little about your position here?

 2a. Day-to-day?

 2b. What are the more long-range aspects? (from this question it will be necessary to note some aspect of their job that could be used as the topic for question A4, e.g., if they plan shows or deal with acquisitions)

3. What aspects of your work here do you find most rewarding or most satisfying? Why? (probe for aspects of challenge, meaning)

3a. (if response primarily non-art) What aspect of working with the art objects or works is most rewarding?

3b. (last resort) Does your actual experience of an artwork enter in?

3c. Perhaps you could talk about something you've done recently to illustrate this.

4. One last question about your present position: You said that [*acquisitions*] are part of your work here. Is there some [*piece that you are particularly interested in acquiring for the collection?*] Could you tell me why you think it's important? (in general, we are after some kind of idea about goals and values; also, try to disentangle scholarly from personal/aesthetic)

B. GENERAL DEVELOPMENT OF INTEREST IN ART

1. Maybe we can go back once again and you can give me a brief review of the course of your interest in art in a more general sense. Perhaps we can begin with an account of when it was that you first became interested in art. Are there any particular experiences that really stand out for you?

C. EXPERIENTIAL ASPECTS

1. Perhaps now we can change our focus somewhat. I wonder if you could talk a bit about an encounter with a work, or set of works, that you've had recently that was particularly significant for you?

(if work is not from collection, try: Maybe before we start talking about this specifically, you can describe when it was, what the work was, and the context in which you came into contact with this work?)

[Note: if response is impersonal and/or focused on the audience, probe for the presumed nature of the audience experience, then re-

focus on the personal—i.e., "What about your own experience of this work (show)?"]

 1a. Perhaps you could begin by describing your initial response to the work.

 1b. Did your experience change in any way?

 1c. What do you think it was about this experience that makes it particularly memorable? (probe for carryover, something taken away, connection to non-art experiences, etc.)

**If work is not from the collection of the Art Institute of Chicago, ask after above discussion: Is there perhaps a work in the museum's collection that has had a similar effect on you? I wonder if you could show it to me (either in the catalogue or in the installation) and we could go through your experience of it together? (repeat probes 1a, b, c)

2. Do you have this kind of experience often?

 2a. Across all of these experiences, what kinds of things seem similar to you? (probe for 1. situation or types of work, and 2. experience)

3. Do you have this kind of experience in contexts other than art-related ones? (probe: Is there anything else you do or are involved in that gives you a comparable kind of experience?)

 3a. What makes your experience of art special relative to these kinds of experiences?

4. If we could focus just on art again, do you feel you have experienced works in this way throughout the entire course of your career, or is this something that you have had to develop, or that has changed somehow through your lifetime?

 4a. Do you think that there have been particular experiences that helped you develop either some special skills or your general sensitivity to art?

D. DISCUSSION OF AESTHETIC EXPERIENCE IN GENERAL

1. So far we've talked mostly about your own interactions with art. Given your experiences, do you have a sense that there is a general way of experiencing art, or an "aesthetic experience"?

 1a. Do you think that the experience varies depending upon the person or the work, or some other factor?

2. Do you think that there is an optimal way of interacting with or experiencing a work of art?

 2a. Do you think there are any essential conditions for such an optimal experience? (i.e., innate sensitivity, training, good art, etc.)
 2b. If you could have complete control of all the elements involved, how do you think you would go about arranging the ideal aesthetic experience?

A P P E N D I X B

Aesthetic Experience
Questionnaire Form

THE UNIVERSITY OF CHICAGO ART & EXPERIENCE PROJECT

PART A.

Please return this page with the questionnaire. (If you could attach a copy of your C.V., it would be helpful.)

NAME: SEX:

AGE: HIGHEST DEGREE EARNED:

INSTITUTION: FIELD:

AREA OF SPECIALIZATION:

PRESENT POSITION:

YEARS IN THIS POSITION:

PREVIOUS EMPLOYMENT (PLEASE INCLUDE DATES):

NOTE: This page will be marked immediately with a personal identification number and detached from the rest of the questionnaire so that your answers will remain anonymous.

There are, of course, no "right" or "wrong" answers to the questions that follow; they are designed to reflect your subjective perceptions and responses. The questionnaire should only take a few minutes to fill out. Please return it in the stamped and addressed envelope we have attached. Your time and your help are gratefully appreciated.

PART B.

The following items refer specifically to "aesthetic experiences" that come about as a result of encounters with artworks—however broadly defined. Please try to recreate in your mind some of the most special and rewarding aesthetic experiences you have had. Which of the items below are true, and which are not true of such experiences?

	Never True	Occasionally True	Sometimes True	Often True	Always True
1. The pieces that have some sort of a challenge are the ones that stay in your mind.	☐	☐	☐	☐	☐
2. I trust my own personal opinion.	☐	☐	☐	☐	☐
3. Sooner or later I get to know exactly what the artist meant to convey in the work.	☐	☐	☐	☐	☐
4. My knowledge and training are kept out of the aesthetic experience.	☐	☐	☐	☐	☐
5. Art is the affirmation of concrete reality and should not be aiming at any "higher" order or experience.	☐	☐	☐	☐	☐
6. After I have a reaction to an art object, it is important to be able to check my first impression through further "tests."	☐	☐	☐	☐	☐
7. In approaching a work of art, I never set some goal or objective I wish to achieve through the experience.	☐	☐	☐	☐	☐
8. After thirty seconds' worth of looking, I have absorbed what it has given me.	☐	☐	☐	☐	☐
9. Feelings have no place in my encounter with the art object.	☐	☐	☐	☐	☐

	Never True	Occa-sionally True	Some-times True	Often True	Always True
10. Art gives a sort of trans-cendent experience that takes you out of the realm of everyday life.	☐	☐	☐	☐	☐
11. I am often afraid of not making the right response.	☐	☐	☐	☐	☐
12. The final word is never said. A good painting will never be used up.	☐	☐	☐	☐	☐
13. The purely visual qualities of an art object are relatively trivial and have little impact on the aesthetic experience.	☐	☐	☐	☐	☐
14. In the course of the aesthetic experience, it is difficult to know whether one's thoughts or feelings are relevant to the work encountered.	☐	☐	☐	☐	☐
15. I have a rather clear idea of what to do when approaching a work of art.	☐	☐	☐	☐	☐

PART C.

Please indicate the extent of your agreement or disagreement with the opinions about art listed below.

	Abso-lutely Untrue	Very Untrue	Untrue	True	Very True	Abso-lutely True
1. You can get so filled up with knowledge that you don't have time for a genuine response to the work.	☐	☐	☐	☐	☐	☐
2. The object must contain the inherent beauty created by the artist.	☐	☐	☐	☐	☐	☐
3. In the best works of art, you get a sense of order, of everything coming together in a new or different way.	☐	☐	☐	☐	☐	☐
4. It is sufficient for me to respond with emotional feelings to a work of art to satisfy my appetite for beauty.	☐	☐	☐	☐	☐	☐
5. A great work of art represents the ferment and energy of a whole age.	☐	☐	☐	☐	☐	☐
6. The more information you bring to a work of art, the more interesting it's going to be.	☐	☐	☐	☐	☐	☐
7. Great art can be appreciated simply along a visual dimension; knowledge and feelings sometimes get in the way of the experience.	☐	☐	☐	☐	☐	☐

	Abso-lutely Untrue	Very Untrue	Untrue	True	Very True	Abso-lutely True
8. Art must be made by people, because the communication of human experience is an essential aspect of the aesthetic encounter.	☐	☐	☐	☐	☐	☐
9. I don't need to be confronted with a new way of seeing or of understanding the world in order to have an aesthetic experience.	☐	☐	☐	☐	☐	☐
10. Objects often seem to reach out and grab me; the aesthetic experience sometimes is like being hit in the stomach.	☐	☐	☐	☐	☐	☐
11. The quality of execution, the look and finish of the materials, are extremely important in determining my response to the work.	☐	☐	☐	☐	☐	☐
12. The works of art I like do not necessarily stimulate an emotional response in me.	☐	☐	☐	☐	☐	☐
13. Dealing with art is no different than dealing with any other commodity.	☐	☐	☐	☐	☐	☐

	Abso-lutely Untrue	Very Untrue	Untrue	True	Very True	Abso-lutely True
14. A great work of art helps the viewer share the sensibilities of people from other ages, other places.	☐	☐	☐	☐	☐	☐
15. Formal qualities, like balance or harmony, are often irrel-evant to the quality of the work of art.	☐	☐	☐	☐	☐	☐
16. Knowledge of the historical and biographical background of an object generally enhances the quality of the aesthetic experience.	☐	☐	☐	☐	☐	☐
17. Art works help one to con-nect different ideas, differ-ent feelings, that hadn't been brought together before.	☐	☐	☐	☐	☐	☐

PART D.

Please rank the three items from the list of 17 items above that most closely reflect your opinion about the aesthetic experience.

Rank #1 Item # _____
(Agrees most strongly)

Rank #2 _____

Rank #3 _____

REFERENCES

AHMAD, P. J. 1985. Visual art preference studies: A review of contradictions. *Visual Art Research*. 11:100–107.

ANWAR, M., and I. CHILD. 1972. Personality and esthetic sensitivity in an Islamic culture. *Journal of Social Psychology*. 87:21–28.

ARNHEIM, R. 1954. *Art and visual perception: A psychology of the creative eye.* Berkeley: University of California Press.

———. 1969. *Visual thinking.* Berkeley: University of California Press.

———. 1971. *Entropy and art.* Berkeley: University of California Press.

———. 1982. *The power of the center.* Berkeley: University of California Press.

BAUMGARTEN, A. 1936; first published 1735. *Reflections on poetry.* In *Aesthetica.* Edited by B. Croce. Rome: Bari.

BAXANDALL, M. 1972. *Painting and experience in fifteenth-century Italy.* Oxford: Oxford University Press.

BEARDSLEY, M. C. 1982. *Some persistent issues in aesthetics.* In *The aesthetic point of view.* Edited by M. J. Wreen and D. M. Callen. Ithaca: Cornell University Press.

BELL, C. 1913. *Art.* London: Chatto & Windus.

BENJAMIN, W. 1968; first published 1936. The work of art in the age of mechanical reproduction. In *Illuminations.* Edited by H. Arendt, translated by H. Zahn. New York: Schoken.

BERLYNE, D. 1966. Les mesures de la préférence esthétique. *Sciences de l'art.* 3:9–22.

———. 1977. Psychological aesthetics, speculative and scientific. *Leonardo.* 10:56–58.

BOURDIEU, P. 1984. *Distinction: A social critique of the judgment of taste.* Cambridge: Harvard University Press.

———. 1987. The historical genesis of a pure aesthetics. *Journal of Aesthetics and Art Criticism.* 46:201–210.

CABELL, J. 1919. *Jurgen.* New York.

CAMPBELL, D. T. 1976. Evolutionary epistemology. In *The library of living philosophers.* Edited by P. A. Schlipp. La Salle, Ill.: Open Court.

CASSIRER, E. 1957. *Philosophy of symbolic forms.* New Haven: Yale University Press.

CHAMBERS, M. 1987. Improving the esthetic experience for art novices: A new paradigm for interpretive labels. Interim report to the J. Paul Getty Trust and the National Endowment for the Arts. Unpublished.

CHILD, I. 1968–1969. Esthetics. In *Handbook of social psychology*. 2d edition. Edited by G. Lindzey and E. Aronson.

CHILD, I., and S. IWAO. 1968. Personality and esthetic sensitivity. *Journal of Personality and Social Psychology*. 8:308–312.

COLLINGWOOD, R. G. 1938. *The principles of art*. London: Oxford University Press.

CROCE, B. 1909; 1st Italian edition 1902. *Aesthetics*. Translated by D. Ainsle. New York: Macmillan.

CSIKSZENTMIHALYI, M. 1975a. *Beyond boredom and anxiety*. San Francisco: Jossey-Bass.

———. 1975b. Play and intrinsic rewards. *Journal of Humanistic Psychology*. 15(3): 352–353.

———. 1978a. *Intrinsic rewards and emergent motivation*. In *The hidden costs of reward*. Edited by M. R. Lepper and D. Greene. New York: L. Erlbaum.

———. 1978b. *Phylogenetic and ontogenetic functions of artistic cognition*. In *The arts, cognition, and basic skills*. Edited by S. Madeja. St. Louis: Central Midwestern Regional Educational Laboratory.

———. 1982. *Toward a psychology of optimal experience*. In *Review of personality and social psychology*. Vol. 2. Edited by L. Wheeler. Beverly Hills: Sage.

———. 1985. Reflections on enjoyment. *Perspectives in biology and medicine*. 28(4): 469–497.

———. 1990. *Flow: The psychology of optimal experience*. New York: Harper & Row.

CSIKSZENTMIHALYI, M., and I. S. CSIK-SZENTMIHALYI, eds. 1988. *Optimal experience: Psychological studies of flow in consciousness*. New York: Cambridge University Press.

CSIKSZENTMIHALYI, M., and R. ROBINSON. 1986. Culture, time, and the development of talent. In *Conceptions of giftedness*. Edited by R. Sternberg and J. Davidson. Cambridge: Cambridge University Press.

DANTO, A. C. 1981. *The transformation of the commonplace*. Cambridge, Mass.: Oxford University Press.

DE MUL, J. 1988. The development of aesthetic judgment: Analysis of a genetic-structuralist approach. *Journal of Aesthetic Education*. 22(2): 55–71.

DEWEY, J. 1934. *Art as experience*. New York: Perigree.

DICKIE, G. 1964. The myth of the aesthetic attitude. *American Philosophical Quarterly*. 1(1): 56–66.

DISSANAKAYE, E. 1974. A hypothesis of the evolution of art from play. *Leonardo*. 7:211–217.

DZIEMIDOK, B. 1988. Controversy about the aesthetic nature of art. *The British Journal of Aesthetics*. 28(3): 1–17.

EYSENCK, H. 1940. The general factor in aesthetic judgments. *British Journal of Psychology*. 31:94–102.

———. 1941. The empirical determination of an aesthetic formula. *Psychological Review*. 48:83–92.

FELDMAN, D. 1980. *Beyond universals in cognitive development*. Norwood, N.J.: Ablex.

FELDMAN, J. A. 1985. Four frames suffice: A provisional model of vision and space. *Behavioral and Brain Sciences*. 8(2): 265–313.

FREEMAN, M., and R. ROBINSON. 1989. The development within: An alternative approach to the study of lives. *New Ideas in Psychology*.

FREUD, S. 1905. Three essays on the theory of sexuality. Vol. 7 of *The standard edition of the complete psychological works of Sigmund Freud*. Edited and translated by J. Strachey. London: Hogarth Press, 1953.

———. 1910. Leonardo da Vinci and a memory of his childhood. Vol. 11 of *The standard edition of the complete psychological works of Sigmund Freud*. Edited and translated by J. Strachey. London: Hogarth Press, 1953.

———. 1914. The Moses of Michaelangelo. Vol. 13 of *The standard edition of the complete psychological works of Sigmund Freud*. Edited and translated by J. Strachey. London: Hogarth Press, 1953.

GADAMER, H.-G. 1975. *Truth and method*. Edited and translated by G. Barden and J. Cumming. New York: Crossroad.

———. 1976. *Philosophical hermeneutics*. Translated by D. Linge. Berkeley: University of California Press.

GARDNER, H. 1970. Children's sensitivity to painting styles. *Child Development*. 41:813–821.

———. 1971. The development of sensitivity to artistic styles. *Journal of Aesthetics and Art Criticism*. 29:515–527.

———. 1972. The development of sensitivity to figural and stylistic aspects of paintings. *British Journal of Psychology*. 63:605–615.

———. 1973. *The arts and human development*. New York: John Wiley & Sons.

———. 1980. *Artful scribbles. The significance of children's drawings*. New York: Basic Books.

———. 1983. *Frames of mind: The theory of multiple intelligences*. New York: Basic Books.

GEDO, J. 1984. *Portraits of the artist*. New York: Guilford Press.

GERSTNER, K. 1986. *The forms of color: The interaction of visual elements*. Cambridge, Mass.: MIT Press.

GETZELS, J. W., and M. CSIKSZENTMIHALYI. 1976. *The creative vision*. New York: Wiley.

GOMBRICH, E. 1960. *Art and illusion: A study in the psychology of pictorial representation*. Princeton: Princeton University Press.

———. 1979. *The sense of order*. Ithaca, N.Y.: Cornell University Press.

GOODMAN, N. 1968. *Languages of art*. Indianapolis, Ind.: Bobbs-Merrill.

———. 1978. When is art? In *The arts and cognition*. Edited by D. Perkins and B. Leonard. Baltimore: Johns Hopkins University Press.

HARITOS-FATOUROS, M., and I. CHILD. 1977. Transcultural similarity in personal significance of aesthetic interests. *Journal of Cross-cultural Psychology*. 8:285–298.

HAUSER, A. 1951. *The social history of art*. New York: Vintage.

———. 1982. *The sociology of art*. Translated by K. Northcott. Chicago: University of Chicago Press.

HEINRICHS, R. W., and G. C. CUPCHIK. 1985. Individual differences as predictors of preference in visual art. *Journal of Personality*. 53(3): 502–515.

JENKINS, I. 1958. *Art and the human enterprise*. Cambridge, Mass.: Harvard University Press.

KANT, E. 1914; 1st German edition 1790. *Critique of judgement*. 2d ed. Translated by J. H. Bernard. London.

KENNEDY, J. M. 1985. Arnheim, gestalt theory, and pictures. *Visual Arts Research*. 11(1): 23–44.

KEPES, G., ed. 1965. *Education of vision.* Introduction. New York: Braziller.

KNAPP, R., L. McELROY, and J. VAUGHN. 1962. On blithe and melancholic aestheticism. *Journal of General Psychology.* 67:3–10.

KREITLER, H., and J. KREITLER. 1975. *Psychology of the arts.* Durham, N.C.: Duke University Press.

LEVY, J. 1986. Cerebral asymmetry and aesthetic experience. University of Chicago, Dept. of Behavioral Sciences, unpublished manuscript.

MACHOTKA, P. 1966. *The nude: Perception and personality.* New York: Irvington.

———. 1979. *The nude: Perception and personality.* New York: Irvington.

MAQUET, J. 1986. *The aesthetic experience: An anthropologist looks at the arts.* New Haven: Yale University Press.

MARCUSE, H. 1978. *The aesthetic dimension: Toward a critique of Marxist aesthetics.* Boston: Beacon Press.

MEYERS, S. 1988. In search of aesthetic experience: Are museums getting in the way? *Journal of Aesthetic Education.* 22(2): 102–107.

MITSCHERLING, J. 1988. The aesthetic experience and the "truth" of art. *British Journal of Aesthetics.* 28(3): 28–39.

NELSON, J. G., M. T. PELECH, and S. F. FOSTER. 1984. Color preference and stimulation seeking. *Perceptual and Motor Skills.* 59(3): 913–914.

PARSONS, M. 1987. *How we understand art: A cognitive-developmental account of aesthetic response.* New York: Cambridge University Press.

PECKHAM, M. 1965. *Man's rage for chaos.* Philadelphia: Chitton.

ROBINSON, R. 1988a. Project and prejudice: Past, present, and future in adult development. *Human Development.* 31:158–171.

———. 1988b. Aesthetic frameworks: Rethinking adult development through an analysis of collectors of the fine arts. Ph.D. diss., University of Chicago, Committee on Human Development.

SAMUELS, C. A., and R. EWY. 1985. Aesthetic perception of faces during infancy. *British Journal of Developmental Psychology.* 3(3): 221–228.

SANTAYANA, G. 1896. *The sense of beauty, being the outline of aesthetic theory.* New York: Dover Press.

SARTRE, J.-P. 1956. *Being and nothingness: A phenomenological essay on ontology.* Translated by H. Barnes. New York: Washington Square Press.

———. 1963. *Search for a method.* Translated by H. Barnes. New York: Random House.

SOUEIF, M., and H. EYSENCK. 1972. Factors in the determination of preference judgements for polygonal figures: A comparative study. *International Journal of Psychology.* 7:145–153.

SPECK, S. 1988. Arousal theory reconsidered. *British Journal of Aesthetics.* 28:40–47.

TOLSTOY, L. 1960; 1st Russian edition 1896. *What is art?* Translated by A. Maude. Indianapolis: Bobbs-Merrill.

VASINA, L. 1982. Sémantické volumenální pole-psychosémiotická a neuropsychologická characieristika (The semantic volumetric field: Psychosemiotic and neuropsychological characteristics). *Sbornik Pracl Filosofické Brnéske.* 31:71–80.

WALTERS, J., and H. GARDNER. 1986. The crystallizing experience: Discovering an intellectual gift. In *Conceptions of giftedness.* Edited by R. Sternberg and J. Davidson. Cambridge: Cambridge University Press.

WINNER, E. 1982. *Invented worlds: The psychology of the arts*. Cambridge, Mass.: Harvard University Press.

WINNER, E., et al. 1986. Children's perception of "aesthetic" properties of the arts: Domain-specific or pan-artistic? *British Journal of Developmental Psychology*. 4(2): 149–160.

ZOLBERG, V. 1981. Conflicting visions in American art museums. *Theory and Society*. 10:103–125.

———. 1984. American art museums: Sanctuary or free-for-all? *Social Forces*. 63:377–392.

ZUSNE, L. 1986. Cognitions in consonance. *Perceptual and Motor Skills*. 62(2): 531–539.

Christopher Hudson, Head of Publications
Cynthia Newman Helms, Managing Editor
Andrea Belloli, Consulting Editor
Karen Schmidt, Production Manager
Leslee Holderness, Sales and Distribution Manager

PROJECT STAFF:
Fronia Simpson, Manuscript Editor
Mary Holtman, Assistant Editor
Leslie Thomas, Designer
Eric Kassouf, Production Coordinator

Typography by Wilsted & Taylor, Oakland, California
Printing by Typecraft, Inc., Pasadena, California